Fine WoodWorking
on Carving

Fine WoodWorking *on* Carving

40 articles selected by the editors of *Fine Woodworking* magazine

The Taunton Press

Cover photo by Ralph Marshall

First printing: September 1986
Second printing: February 1987
International Standard Book Number: 0-918804-52-3
Library of Congress Catalog Card Number: 86-50405
Printed in the United States of America

A FINE WOODWORKING Book

FINE WOODWORKING® is a trademark of The Taunton Press, Inc.,
registered in the U.S. Patent and Trademark Office.

The Taunton Press, Inc.
63 South Main Street
Box 355
Newtown, Connecticut 06470

Contents

Introduction

Everybody knows that woodcarving is easy: you start with a big enough plank or log, and you visualize inside it the shape you want. Then you just chip away all the extra wood. Easy as pie. The carver's art lies in knowing how to remove only that unwanted wood, and not a sliver more, for once it's gone you can't glue it back. You can get somewhere the first time you try it, then you can spend the rest of your life acquiring mastery.

In 40 articles reprinted from the first ten years of *Fine Woodworking* magazine, this volume introduces woodcarving tools and techniques, then moves on to carved lettering, furniture carving, and carving-in-the-round, with logs and stacked masses of wood. Authors who are also craftsmen explore the reasons for their aesthetic decisions as well as their technical ones. There are also inspirational profiles of a number of outstanding carvers.

John Kelsey, editor

Carving Design Decisions

Questions to answer before taking that first cut

by Robert L. Buyer

It has been said that sculpture is the measure used by archaeologists to determine the cultural level of past civilizations. This statement always humbles me and makes me want to produce sculpture of the highest possible quality. Not that my woodcarving will ever find a niche in the great museums of the world, but I sincerely hope my work will be a reasonable statement of some of the concerns of the twentieth century. To this end the design phase of a woodcarving project takes on added importance.

From a practical standpoint, effort spent in the design phase is made up during the execution phase by eliminating mistakes and rework. Having decided to embark upon a woodcarving project, there seems to be a lot of emotional pressure to hurry into making chips. If the project is to be successful and fulfilling, however, some of this enthusiasm and energy must be channeled into the design effort. Some key decisions need to be made before the project is begun. How well we make those decisions could determine the effectiveness of the resulting piece. We are all familiar with sculpture and carvings that, although beautifully executed in certain respects, are lacking in design cohesiveness.

Where do you begin designing a woodcarving?

If you are a professional woodcarver working with an architect, you receive sketches and specifications which describe the environment for the sculpture, the theme or message to be conveyed by the sculpture, and possible sketches suggesting the form of the sculpture. Unfortunately, most of us who are carving for our own enjoyment, or even for a specific exhibit, do not begin with architectural specifications. So we must begin by determining our own specifications, and that can sometimes be difficult to decide.

What's the theme or objective of the woodcarving? Is it to evoke smiles or to inspire some emotion? Where will it be placed? Should the carving hang from a wall or ceiling, or rest on the floor or on furniture? If we can determine a spirit and setting for the carving, we can then go on to make the first design decision: form.

What form should I use?

Knowing the site planned for a carving should suggest the general size and form to be used. If the site is a large wall, the viewing angle is limited to about 120 degrees, height is desirable, and the lighting is good, then a relief carving is suggested. High relief produces greater shadows, and so is capable of being more dramatic and realistic than low relief. Low relief is ideal for simplified or abstract carvings where the ambient light varies.

On the other hand, carvings in the round can be more dramatic and warmer than relief carvings because they can be proportioned similar to natural objects. Moreover, they can be viewed from almost any angle and in almost any light.

In either case, the size and proportions of the carving should be designed to harmonize with its eventual surroundings. Life-size or heroic-size sculptures require large, open display space. Miniature carvings decorate small tables or curio cabinets. Whatever the space available, make sure the sculpture is not crowded and that it stands apart enough to be contemplated separately.

What wood should I use?

Most professional carvers use mahogany and bass (linden or lime) wood almost exclusively. Mahogany is used where a wood-grain finish is required, and bass is used where the surface is to be painted or gilded. Both of these woods are commercially available in kiln-dried stock in a great variety of sizes, and both are soft hardwoods;

Light and shadow at the site can affect the attitude and dramatic quality of the carving. Cartoons by author.

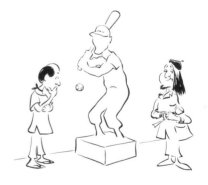

"How did you carve that ball?" Your design must not only be esthetically pleasing; it must also be capable of being produced.

From *Fine Woodworking* magazine (Winter 1975) 1:28-30

that is, they are relatively easy to carve, yet strong enough to survive.

Ideally, the wood should be selected, not from these two species alone, but from all the species available. Wood selection should be based on durability, color, figure, sizes available, ease of working, economic factors, and the finish to be applied.

Almost any of the native fruit and nut woods are good—cherry, apple, pecan, butternut. Walnut is my favorite because of its beautiful grain and rich, dark color. I use cherry from time to time because it's a hard wood that has some beautiful grain and color variations. Pine is another wood I use frequently because it is soft, takes a stain well, and I can give it just about any flavor I choose. Fir and hard pine should be avoided because they are somewhat stringy and tend to sliver, making them hard to work.

The color and figure of the wood must harmonize with the theme and environment of the finished carving. The effectiveness of a finished carving often depends upon how it matches or contrasts with its environment. For example, you would not want a natural oak carving in a room that was paneled and furnished completely in mahogany. You might, however, want to make the carving in matching mahogany, or in contrasting ayous, sometimes referred to as blond mahogany.

The color and figure of the wood should certainly be considered for carvings receiving a natural finish. Dark woods shouldn't be used for an intricate piece with a lot of holes and incisions that show up only through shadows.

Large carvings in particular can be greatly enhanced by the selection of a figured stock. Crotch and burl wood, or quarter-sawed lumber usually have beautiful figure. Figured wood is usually a little more difficult to work due to changes in grain direction, but the results are worth the extra effort.

Esthetically, the grain pattern should not be so strong that it interferes with the lines of the sculpture. That is, if there is too much contrast in the media itself, it can detract from the lines of the piece. However, in a well-rounded, smooth piece you can add interest by having well-figured grain. In other words, make the grain work for you rather than against you.

Jim Thorpe, the World's Greatest Athlete, by R.L. Buyer. In the unfinished state, this 39-inch high sculpture suits the harsh life of this American Indian and leaves open the option of other finishes to suit the final site.

This is true in the construction sense, too. In fragile pieces the grain must be parallel to the direction of the most slender section of the piece to give maximum strength. This often means that a piece must be laid out irregularly or at an unusual angle rather than parallel or perpendicular to the edge of the stock. This is an important consideration in the mechanical strength of the carved piece and affects the carving technique and the size of the stock required.

What surface finish should be used?

First, the surface carving technique used, combined with the finishing material, will determine the reflective quality of the piece. A smooth surface reflects light and suggests sophistication or formality. A mottled surface absorbs light and can suggest crudeness or informality. Variations in surface treatment can be used to indicate hard, cold, smooth materials or soft, warm, mottled materials.

Next, there is the question of no finish versus natural wood color, or painted or gilded finish.

A raw wood finish, that is, no finish, gives a rough, crude, no-gloss appearance that works well in limited circumstances. The theme must require a coarse effect, the site should be protected so the wood doesn't deteriorate, and there should be good lighting because of the poor reflective quality of raw wood.

Natural wood finishes of oil, wax, varnish, etc., are my personal preference, for they offer the greatest variation in treatment, yet still show the wood grain. The choice is both technical and artistic—technical as to the protection desired, artistic as to the darkening and color desired.

With painted or gilded finishes, wood loses its character and identity. Nevertheless, paint or gild may be necessary when it's an outdoor piece that needs good protection. Gild is of course the strongest finish you can use outdoors. It's also good esthetically for contemporary pieces that need its high reflective quality and metallic look.

Paint is used when you need the multiple color to achieve true realism.

Finish also is affected by the wood carved. Hardwoods usually take a high polish whereas softwoods are more difficult to polish and are best used for stained, painted, or gilded carvings.

The choice of finish could also depend on the construction and holding methods used. The dovetailed or pegged legs of a carousel animal would need to be masked by paint, but the appearance of construction joints could enhance other subjects.

"Fetch!" The finish must be appropriate to the style of the carving and can vary in effect for realistic or abstract pieces.

How will the piece be held during carving?

Ideally, we want to design the piece so that it can be carved with minimum effort and without leaving holes or marks that must be covered up. Either we design the piece so the holding mechanism is an integral part or so it can be chopped off. An example of the latter is a relief carving that can be designed with tabs or other holding devices that can be removed by saw when the carving is completed. This eliminates clamp marks on the carving. If tabs are impractical, the relief carving can be glued to scrap stock with several intervening layers of newspaper. The scrap block can then be clamped in place during carving and separated easily from the carving afterwards.

Carvings in-the-round take special care, especially if a natural finish is to be used. The best way is to drill undersize holes where the final mounting will go and attach a piece of scrap wood with screws. The scrap wood can then be clamped in place during the carving. Upon completion, the scrap wood can be removed and the same holes re-drilled to accommodate the final mounting.

Commercially available devices such as carver's screws or work positioners (universal joint devices) can also be used effectively. Carver's screws can be simulated by gimbal or hanger screws with wing nuts. The advantage of these is in the variety of screw lengths available and the added security of more than one screw support.

What support is required for the carving?

The base or mounting design is extremely important. This should not be left until the end of the project, but should be considered and designed as an integral portion of the carving itself. The base not only provides the mechanical support and balance for a carving, but also provides the transition from the carving to the surrounding area. A well-designed base will not detract from the carving and sometimes can provide an extension of information about the subject.

For example, the base for a bird carving can be a formal mahogany stand or can simulate the normal habitat or nesting area of the bird.

Sculptures by Frederic Remington and Charles Russell integrate the figures into a base that characterize the terrain of the "Old West." Carvings of jumping or swimming subjects can be supported on one or more thin metal supports in a way that either simulates the natural environment or emphasizes the fact that the carving is suspended.

Development of the base along with the carving can also provide protection during the construction and carving phase. This is especially true of complex carvings such as birds where the legs must fit into precisely drilled holes. The pieces can be removed from the base for carving, then returned to it for protection between work sessions.

While relief carvings can be fitted with hooks or eyes on the back, larger carvings may require mounting-screw holes that should be concealed with carved plugs. Some of the carvings in the round, especially abstract pieces, can make effective use of overhead wire or chain suspension using ceiling eyebolts or wall-mounted arms.

Do the answers work together?

Now that we've asked all the key questions, do all the answers work together? Do you have the equipment, materials, and skills needed to produce the designed object? If so, then launch the project. If not, back to the drawing board. □

Mother Nature sculpted from life. No two creative, expressive people working from the same plans will ever produce identical works of art.

Tackling Carving

No need for a 'carving set'

by Robert L. Butler

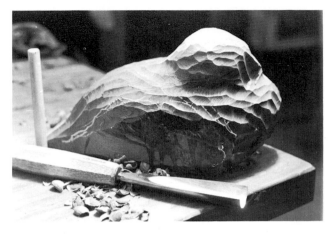

Furniture makers have recently become aware of the role of sculpturing in fine woodworking. The sculptured furniture pioneered by Wharton Esherick and recently developed by Robert C. Whitley and others uses carving as a design essential to accent light and shadow, and to form such functional elements as handles and pulls. Some craftsmen have branched out into wood sculpture as art. They start with a background and feeling for wood that trained artists often lack. But for whatever reason, a craftsman who develops an interest in carving is faced with the problem of acquiring suitable tools.

Too frequently, the craftsman new to wood sculpture buys a set of carving tools that does not meet his needs. He should be guided by the principle he followed in equipping his shop: buy a rudimentary set and add to it as experience and knowledge increase. Since most suppliers of woodcarving tools carry at least 100 shapes and sizes, it is impossible to make specific recommendations without knowing the type, style and scale of carving he plans to do.

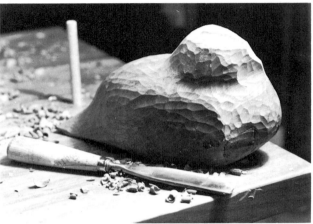

But without some guidance, the novice may not know where to begin. I feel that sculpture of moderate size provides a realistic starting point for beginners, especially for craftsmen who intend to sculpture furniture. I have arrived at this opinion through some early false starts and later during five years of teaching woodcarving and sculpture in local adult education courses. Small, intricate carvings do not provide the experience in line, movement and form that can be transferred to sculptured furniture.

For moderate-sized sculpture, I recommend five basic tools, plus a hard Arkansas slip stone to sharpen them. They are (1) a straight gouge with a cross-section curvature of #9, #10, or #11 and 25 to 30 mm. wide, (2) a smaller straight gouge, #5, #6, or #7 and 20 to 25 mm. wide, (3) a cylindrical Surform tool, (4) a fine-cutting wood rasp, and (5) a mallet. The first four will total about $30 (1976 prices). The mallet can be turned from any heavy hardwood, such as maple or osage orange, or it could be cut from a branch and its handle roughed out on the band saw. The carver's mallet is preferable to the carpenter's mallet which is used to make mortises, because it carries more weight in the head and be-

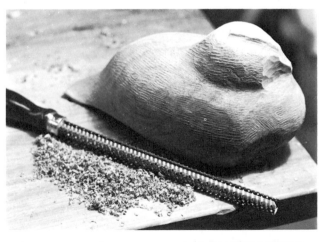

Photos show what can be accomplished with four tools. Rough bosting out was done with a #11 30-mm straight gouge (top), followed by #5 25-mm straight gouge, which produced a smoother form (and smaller chips). Cylindrical Surform goes even further, while a fine, half-round wood rasp just about completes it (bottom). Area around the bird's beak will be finished with sandpaper of 80 garnet prior to the usual series of sandings and finishing as desired.

cause its cylindrical form gives the hand only a glancing blow when it misses the handle of the carving tool. There is much less damage to the knuckles.

The photos show what these tools can do. I began with a #11 gouge for bosting out the rough form of an abstract bird, after band-sawing a top and bottom view. This gouge makes deep cuts and removes excess wood rapidly. At this stage, the form has many valleys and humps. Next, I reduced the extremes of these humps and valleys with a gouge of flatter curvature, the #5. I then smoothed the piece with the Surform tool, which eliminated ridges and valleys left by the gouges and enabled me to make slight changes in the overall form. Before sandpapering, I used a fine rasp lightly so as not to pull any of the wood fibers. Sculptures may be left unsanded, with the texture and finish of the gouge, or rasped and sanded with garnet paper in the grit series 80, 120, 200 and polished with 400 or 500-weight wet-dry paper.

By now, it should be evident that sculpturing of moderate-sized pieces can be done well with this set of tools. I am sure that in my own carving, 95% of my time is spent with these five basic tools.

A craftsman who has mastered these tools may discover that he is more interested in smaller carvings. He can then buy tools of smaller sizes and different curvatures, and various types of hand-held knives and rifflers. With these, he can do small animal carvings, caricatures of cowboys and goldminers, or small religious items such as creches.

On the other hand, one may wish to carve much larger objects for the yard, foyer or a large room. Such carving is done with larger gouges and hand adzes. These tools, along with the basic five-piece set, can be used for carvings as large as totem poles or full-scale sculptures of human form. Some carvers are adept at using the chain saw for oversize and bold pieces.

As in all tool buying and usage, the limit is set only by the person and the work he contemplates. Other available tools include bent gouges, fluters, veiners, short-bent gouges, back-bent gouges and parting tools. The bent gouge is used extensively in free-form bowl carving. Fluters are semicircular in cross section. Veiners have u-shaped cross sections and make deep, continuous-cut lines. Spoons, front or short-bent gouges—they go by various names—are used for ''spooning'' wood, making deep, abrupt incisions. The back-bent gouge is the reverse of the short-bent, with the sharpened surface on the opposite edge. It is used to carve intricate flowers, leaves, etc. Parting tools make a v-shaped cut of various depths and angles.

Musical instrument makers use other specialized tools. The macaroni, fluteroni and backeroni gouges are designed for carving violin, viola and cello necks, backs and bellies. Like all carving tools, these may be short-bent, bent, etc. Some experienced woodcarvers even forge, grind and temper their own tools.

As in all craftsmanship, the ultimate is never achieved. A serious craftsman continues to improve his work and extend his horizons as he creates. Start with the simple set of tools and add to it as you find need and outgrow the limits of those you have already purchased. □

Author's basic carving set (right) includes wooden mallet, hard Arkansas slip stone, #11 30-mm gouge, #5 25-mm gouge, fine rasp and cylindrical Surform. For smaller, more intricate work (below), add gouges, knives, chip carving tools and rifflers. For bigger work (far below), there are from bottom to top a #7 35-mm bent or long bent gouge, a #7 50-mm straight gouge, a #7 50-mm fishtail gouge, and an adze with two cutting faces—a gouge and a small ax. Carving tools other than straight gouges include (below right) a long bent gouge for deep carving, a front bent for deep incisive cutting, a back bent for carving leaves or petals, and a parting tool for deep angled and continuous cuts. Round lens cap shows relative size.

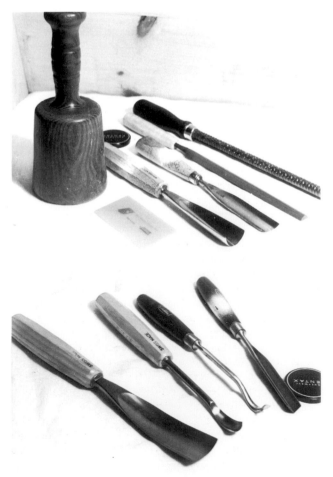

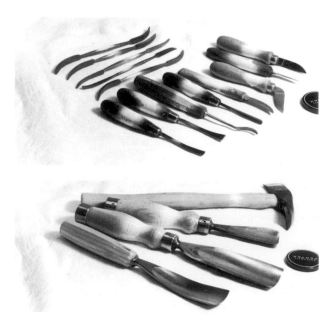

Chip Carving
Simple cuts form complex patterns

by Rick Bütz

Chip carving is one of the oldest forms of decorative wood-carving and also one of the simplest. A straight-edged knife sharpened to a fine point is all you really need, though a skew-ground knife and a knife with an offset blade are useful. Complicated geometric patterns are formed by arranging dozens of small triangular incisions.

The simplicity of technique and the personal satisfaction chip carving offers caused it to flourish well over 1,000 years ago. It seems to have developed simultaneously among peasant communities in many lands, including Scandinavia, Germany, Switzerland and Russia. As the centuries passed, many of the patterns and designs were freely exchanged, and in time it became impossible to identify which motif was developed by which nationality.

In its heyday, chip carving was used primarily to decorate household items. Many elaborately decorated objects were carved during the long winter and later given away as gifts. However, as the slow pace of country life was hastened by the pressures of industrialization, fewer evening hours were spent carving at the hearth. Eventually, chip carving faded into obscurity and was continued only in remote parts of Switzerland and northern Europe. In America, the tradition was carried on by the Pennsylvania Dutch.

Traditional chip carving was also used as a training device for woodworking apprentices—it remains a good test of self-discipline and sharp tools. Mistakes and overcuts, once committed, are not easily corrected or concealed.

To start chip carving, first make sure your tools are razor-sharp, because the final appearance of the work is judged by neat cuts and crisp, clean lines. In addition, a sharp knife will be less likely to slip while you are carving, minimizing injuries and the unnecessary frustration of spoiled work.

Test the sharpness of your knife by lightly, carefully scraping the edge across your thumbnail. If you can feel the edge grip and hold, then the blade is razor-sharp. If the edge slides and skips, it is dull. If the edge is dull, use a medium-fine Washita or fine India stone and a leather strop for sharpening. Lubricate the stone well with a lightweight oil to prevent clogging, and hold the blade at a fairly low angle. Sharpen one side at a time, using a circular motion until a fine wire burr forms on the cutting edge, indicating that the metal has been brought to as fine an edge as that particular stone will allow. This wire edge is difficult to see, and you can best check for it by lightly dragging your fingertip across the blade away from the cutting edge. Check both sides. The burr edge will feel rough, as though it is catching on the ridges of your fingerprint. When you can feel the wire edge along the entire edge, the blade is ready for the strop.

A strop is simply a strip of stout leather securely fastened to a length of wood. You can make one by gluing or tacking a piece of old leather belt face down to a wooden base. Stroke alternate sides of the knife blade slowly and evenly along the leather in the direction away from the cutting edge. Otherwise, the knife will cut into the leather and dull the edge. Several minutes of stropping should wear off the burr, leaving a razor-sharp edge. A little metal-buffing compound rubbed into the leather speeds this process considerably. Woodcarvers often have several strops coated with different grits of rubbing compound ranging from coarse to fine, with the leather left plain for the final touches to maintain a fine edge during carving. It's a good idea to strop the blade 20 or 30 strokes on each side after every half-hour or so of carving.

After sharpening, mark out your pattern. There are several ways to transfer a pattern. One way is to trace a paper pattern onto your wood with carbon paper. Or, you could glue the pattern directly to the wood with a little rubber cement. After carving the design, rub or sand off the remaining bits of paper. Another way is to draw your pattern directly onto the wood using a small straightedge and a compass fitted with a sharp pencil lead. A little knowledge of geometry helps. Bear in mind that many of the pencil lines will remain after the carving is completed because they mark out or cross high points in the design where little or no wood will be removed. Therefore, keep marks light to make cleanup easier. Also, when sanding off guidelines, wrap the paper around a flat block of scrap wood to prevent rounding off the crisp edges of the chips—easy to do if pressure is applied only with the fingers. Too much sanding can easily ruin a chip carving, and it is best to work with a fine grade of paper as lightly and as sparingly as possible.

All traditional designs are made up of variations of two kinds of triangular chips. Both chips are quite simple, and it takes less time to carve them than to describe how. One chip is carved with three knife cuts, and the other is carved with six. Both types should be practiced until they become second nature, regardless of the direction of the wood grain. An hour in experimentation can save lots of frustration later.

The triangular chip using three cuts is called the *Dreischnitt* by Swiss and German woodcarvers, who used it for border designs. The first step is to stab out shallow stop cuts on two sides of each triangle. The easiest way to do this is with a sharp skew-bladed knife, though you can use a straight-edged knife. Firmly press the point of the knife into the apex, the deepest part of the triangle, then vertically incise each wall so that it slopes up to the surface of the wood. With a straight-edged knife, carefully slice out the wood between the two stop cuts. Be sure to watch the direction of the grain to avoid running splinters into the design. When completed, you will have a neat, simple wedge-shaped chip cut into the wood. By combining and arranging these triangles, you can create a great variety of designs and patterns.

The six-cut chip is essentially three *dreischnitt* cuts combined to form one larger triangle. Place the point of the knife into the center of the triangle and cut out to each of its ver-

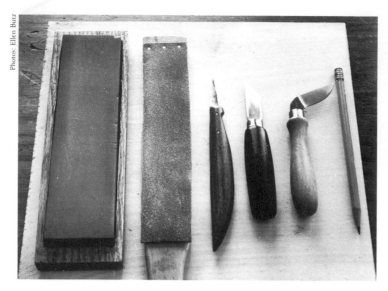

Left, chip-carving tools include a sharpening stone and leather strop for bringing knives to a razor edge, a straight-edged knife for making slice cuts, a skew-bladed knife for stab cuts, and an offset blade. The wood blank is pine, though any soft, even-grained wood will do. Top, a burr is left by sharpening on the stone; subsequent stropping leaves the edge razor-sharp, above.

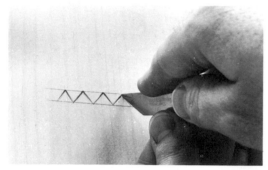

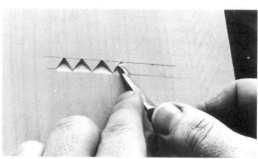

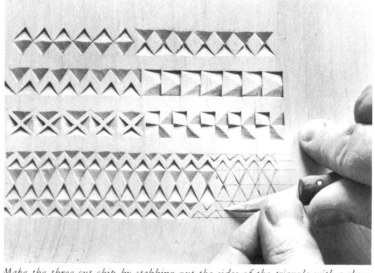

Make the three-cut chip by stabbing out the sides of the triangle with a skew-bladed knife, top left. Then carefully slice out the remaining wood with a straight-edged knife, left. Above, some traditional dreischnitt *border designs.*

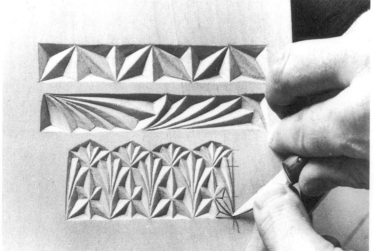

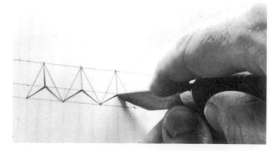

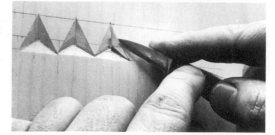

Six-cut triangles are made by stabbing into the center, top right, and then making a slice cut for each side, right. Above, traditional designs using six-cut triangles can have straight or curved sides.

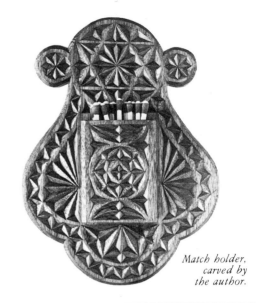

Match holder, carved by the author.

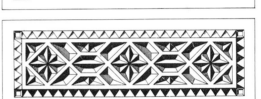

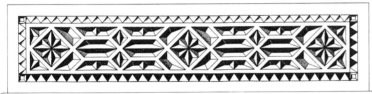

Intricate box pattern used by woodworker Otto Dunnebier while completing his apprenticeship in Germany about the turn of the century.

tices. Next, slice out three chips, leaving a triangular carving with three sloping sides meeting at the center. In the three-cut chip, the stop cuts define two walls; in this chip, the stop cuts mark the bottom angles of the triangle and will eventually form a reverse pyramid. Again, avoid slicing against the grain. This chip can be carved in a variety of shapes and proportions, with straight or curved sides.

Keep all the chips relatively shallow. The deepest portion of any triangle should not be cut more than ⅛ in. to ¼ in. below the surface of the wood. Going deeper will cause unnecessary difficulties and will detract from the appearance of the carving unless you are working on a large scale. It's also a good idea to keep both hands on the knife when cutting. You'll have greater control, but more importantly, you'll avoid the natural but dangerous tendency to hold the wood with one hand and cut toward it with the other. Brace the work against a small bench hook made from scrap lumber. This will allow you to turn the wood frequently without having to fumble around with clamps.

For carving the match holder shown above, I used a piece of ¾-in. butternut and did all the carving before cutting the block to shape. It doesn't really matter which you do first, but I find working with a larger piece easier and safer. You can use just about any moderately soft, even-grained wood, such as pine, bass, some cedar, walnut and cherry. The English even used oak, but most oak available these days doesn't hold details well.

After carving the pattern and cleaning off the pencil marks, you can give the piece a protective finish. Many old chip-carved pieces were left unfinished, but you'll find a light coat of paste wax not only helps seal and protect the wood, but also makes the facets of the carving stand out more sharply. You can use other finishes, particularly on eating utensils, but avoid high-gloss lacquer, varnish or any other material that will make your carving appear plastic.

If you would like to use a traditional finish, you might try a beeswax mixture used in Europe for many centuries. Carefully melt about three ounces of bleached or raw beeswax in a double boiler over low heat. Stir in one or two ounces of good-quality turpentine, then let the mixture cool. Within an hour the polish should set up to a butter-like consistency. If the polish is too soft, melt it again and add more wax. If it is too hard, dilute it with a little more turpentine. A small amount of melted rosin can also be added to harden and darken the wax, although I prefer the simpler mixture. Remember that this concoction is highly flammable—if the wax begins to smoke, it is too hot. Should the mixture catch fire, snuff it out with an airtight cover, which you should keep on hand for just such a purpose.

Seal the beeswax mixture, when cool, in an airtight container to preserve freshness. To use, lightly rub or brush a thin layer on your carving. Let it stand for a day so the turpentine will evaporate, then buff with a clean horsehair shoe brush. In time the polish will age with the wood and darken slightly, leaving your work with a warm mellow glow. □

Rick Bütz lives in Blue Mountain Lake, N.Y. His book, How to Carve Wood, *is available from The Taunton Press.*

Carving Lab

A basic exercise for beginners

by Robert L. Buyer

Woodcarving classes are usually unstructured meetings where a teacher advises and helps a student with a carving project. This method has the advantage of enabling a student to produce a finished carving immediately. The disadvantages are needless time spent fumbling around, often discouraging results, and at times the creation of poor work habits. This is how I learned to carve. I've often thought that some simple exercises in basic tool handling would have helped me tremendously and reduced the time it took to learn.

Therefore, in preparing to teach woodcarving last year, I developed a tool lab to introduce the basic techniques. It went rather well, and I hope it will help both novice carvers and other teachers. I am not advocating hours of tedious exercises, one after another, which must be mastered and yet produce only chips. These exercises concentrate on the gouge, parting tool and veiner, and how the various cuts are affected by the grain of the wood. Just experiment with it and observe carefully at each step.

You'll need a piece of soft wood (pine or bass) at least 6 in. wide, 10 in. long and 1/2 in. thick; two clamps for holding the wood to the bench; one or more carver's mallets, preferably of different weights and styles; a carpenter's square, soft pencil and a broad felt-tip marker; and three straight (not bent) carving tools—one gouge (such as a 5-sweep, 20 mm), one veiner (about 12 mm) and one parting tool (about 6 mm).

Please don't rush out and buy a kit of tools just for this exercise. If you have access to professional tools through a school or a friend, by all means use them. If you don't have access to tools and are sure you want to take up carving, then the three

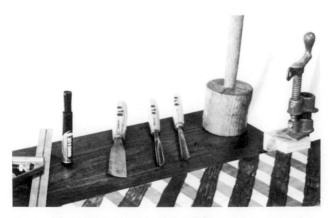

Carving lab equipment includes (left to right) gouge, veiner, parting tool and mallet. Clamps hold down board marked for cutting; lines parallel to grain are drawn on underside of board.

tools needed for this exercise constitute a beginning set and should be bought individually. You will be ahead of the game, both artistically and financially, if you buy full-size, professional-quality tools one at a time. As you gain skill, you will learn exactly which ones to buy next. A few fine tools are much better than a roll of small, clumsy ones. Swiss tools (my favorites because of their iron, shape and octagonal handles) cost between $5 and $10 each, and the three specified here can be purchased for about $20 total (1977 prices).

1. Draw a series of parallel lines on the wood, about an inch apart. Draw some lines parallel to an edge, some perpendicular to this edge and some at a 45° angle. With the marker, shade between the lines to make a band parallel to the edge of the board, another band perpendicular to the edge and a third band on the diagonal. Now clamp the wood securely to the top of the workbench, with the clamps as close as possible to the ends of the board.

2. Use the gouge and mallet to cut across the grain and remove the shaded band perpendicular to the edge of the board. Hold the gouge in your minor hand (left if you are right-handed) and the mallet in your major hand. Drive the gouge across the board from near to far, first cutting one edge of the shaded band, then the other.

3. Make a cut along the grain to remove the shaded band parallel to the edge of the board, again holding the gouge in your minor hand. Use the mallet to drive the gouge along the board from right to left, first cutting along one edge of the shaded band, then the other.

4. Now remove a diagonal band of wood, still holding the gouge in your minor hand. Use the mallet to drive the gouge across the board from near to far, cutting along one edge of the shaded band, then the other.

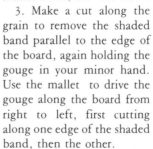

5. Observe the edges of the diagonal cut you just made, and note which edge is smooth and which feathered. Repeat the cut that made the feathered edge, but this time drive the

From *Fine Woodworking* magazine (Winter 1977): 9:64-65

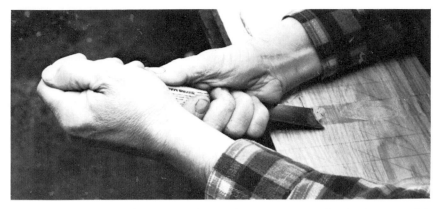

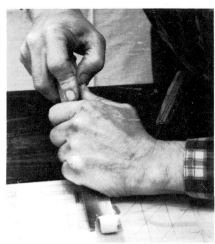

Above, gouge cut across the grain, made toward the carver. Minor hand powers cut, while major arm rests on stock for control. Right, major hand powers gouge cut across the grain, made away from the carver, with minor forearm as anchor and elbow as pivot.

gouge from far to near. Now this edge will be smooth.

6. Carve away another diagonal band, this time using the veiner to cut each edge line. Drive the veiner from far to near for one edge and from near to far for the other, so that both edges are smoothly cut. Then use the gouge and mallet to clean out the wood between the veiner cuts. Carefully compare these results with the band cut by the gouge alone. Repeat, but this time use the parting tool instead of the veiner.

7. Use the felt-tip pen to draw an arch-like design on the wood, as in the diagram. The band should be about an inch wide, and the design should begin and end at the edge of the board. Carve out the band, using the veiner or parting tool followed by the gouge, as in step 6. Change direction as necessary to get smooth edges all around the design.

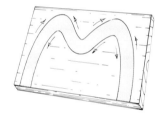

8. Now repeat all of the preceding steps, but change hands—carving tool in the major hand, mallet in the minor hand. Try the exercises again, this time without a mallet.

9. If you have more than one mallet, or access to other carving tools, try the same exercises with them and carefully compare the results using large and small tools of the same shape, or tools of different shapes, but the same size.

By now it should be very clear that a carving tool produces a smooth edge on the side that cuts with the grain, and a feathered edge on the side that cuts against the grain. The tools can cut toward you or away from you. You can hold them in either hand, and you should be able to select the proper tool for a task. You are well on your way to becoming a carver.

The following is advice about using carving tools. These points are presented not as gems of wisdom cast off by the sages, but as the condensate of the blood, sweat and tears of a dozen years of carving.

—Drive parting tools and veiners without rocking motion. Drive gouges with one rock per cut, to get a slicing action.

—Use the proper-size tool. Never "bury" the corners of a carving tool in the wood. If both corners are not visible you are cutting too deep or using the wrong size or shape of tool.

—Always keep two hands on tools: either one on the carving tool and one on the mallet, or both hands on the carving tool. Never use the palm of the hand as a mallet.

Mallet powers gouge; guiding hand holds center of tool and pivots from elbow.

—For easy identification, position the carving tools on the bench (not on the work) so the cutting edges face you.

—To rough out carvings in-the-round or remove the ground of a relief carving, cut across the grain, usually with a veiner and mallet.

—Draw lines on the carving with a parting tool.

—Finish cut with gouges, using a slicing cut and no mallet.

—In lettering: First, incise the center; second, cut from each side to the center; then cut serifs.

—In relief carving: First, remove ground; second, set in edges; third, smooth ground close to final depth with no. 3 spoon and/or carver's router; fourth, model carving.

—Use a soft pencil and dividers frequently to check dimensions on the plans and redraw on the stock.

—Whenever possible establish "points" of measure on the carving and plans. Mark these points with an X. Points are usually extremities (such as the tip of the nose, center of the head, bottom of the throat) and joints (ankle, knee, hip, shoulder, elbow, wrist).

—Begin the carving at the place containing the most excess wood. Continue by carving away layers of wood—do not work on one area until it is complete, then move on to another. Instead, work on the carving as a whole, going around and around and making smaller and smaller cuts as you approach the final dimensions. ☐

Bob Buyer is a technical writer who also taught woodcarving and ran a sawmill/lumberyard in Norton, Mass.

Tips From a London Carving Shop
A sharp pencil cuts through the problems

by Ben Bacon

Carving is one of the most difficult woodworking skills to acquire, so it's not surprising that many craftspeople find it frustrating to try to carve scrolls, foliage and other ornaments on furniture. Lack of experience is part of the problem, but the major factor is that most woodworkers go about carving in the wrong way: they start at the end, carving fine details first, instead of at the beginning of every carving job—drawing.

While there's no magic way to make carving easy, you can simplify the process by dividing it into five steps, with each step laying the foundation for the next. The most basic step is to do a good detailed drawing, as shown in figure 1. Drawing makes you think concretely about the carving and decide what it should be, then the next four steps—making a model in clay or plasticine, basic construction, rough carving, and final carving or "improving"—can reduce to manageable tasks the complexities of bringing your ideas alive in wood.

Many inexperienced carvers avoid drawing, saying "it stifles creativity" or "I'd rather do real work." Actually the reverse is true. If you skip the drawing, you'll always have the "what exactly is it that I wanted to make?" feeling, which leads to mistakes, confusion and wasted time. Remember the old axiom that carving is 75% drawing, 15% sharp tools and 10% manual dexterity—learn to draw, either by attending classes or by sketching furniture. For most people, carving without drawing is like sawing without measuring.

To illustrate this five-step approach to carving, I'll describe how I carved an ornate wall mirror in a style popular in early 18th-century England, but the process can be applied to any carving. I picked this piece because I like 18th-century carvings and had never done a mirror in this style. I don't make exact copies, however. Here in England, one-of-a-kind antiques are treasures because they are unique, and making exact copies is considered unethical. So for this project, I combined elements from several mirrors to develop a new design. You can also study a particular period until you know enough about its fashions and techniques to think like a craftsman of that period, and design a new piece in an old style. Knowledge is important here—otherwise you might design something that never would have been made in the period you've selected. I found most of the information I needed on mirror construction and style of carving in furniture books and museums. I also consulted my sketchbooks, which contain drawings I've made of some of the period pieces we've restored in the London carving and gilding shop where I work.

Once I've completed my research, I usually do a detailed line drawing. Unless I'm working in a style that's new to me, I make one drawing and modify it until it's right, rather than develop a whole series of intermediate sketches. First I study the old pieces until I understand how the original makers handled problems of design, composition and construction, then I build on these ideas when I do my drawing. I prefer full-size drawings, unless the piece is 8 ft. to 10 ft. high, in which case I reduce it to $\frac{1}{10}$ or $\frac{1}{12}$ scale, with some full-size detail drawings where necessary.

For the mirror, I drew a rectangle the size of the frame and divided it into three areas, corresponding to the carved pediment on top, the bottom plinth, and the mirror glass and pilasters in between. Then I roughly sketched the ornaments to get an idea of the feel of the piece. You often have to move the ornaments around or make them larger or smaller so they work well together. A good way to do this is to draw the ornaments on separate pieces of tracing paper. When I was satisfied with the rough sketch of the mirror, I refined it by drawing in all the fine details.

Before you go any further, step back and make sure all the components fit together well. Is the piece in proportion? Is there enough detail? Are the curves regular and flowing? Does the whole have unity? It's easier and cheaper to resolve these questions on paper now rather than in wood later.

Even when you're finished drawing, you still may be confused about how to begin carving. This is where step two, modeling in clay or plasticine, comes in. Drawings, even with full front and side elevations and a plan view, are still two-dimensional. You can't draw undercutting or all the subtleties of texture and depth that are essential to a good carving. If you can't visualize these three-dimensional characteristics exactly in your mind, you should model. Usually, you have to model only the areas that confuse you, but you can do the whole thing. Modeling is easy—just put the clay on a board and shape it with your fingers or the modeling tools available at most art supply stores. You could also make an extra copy of your drawing and work the clay right on it to establish the initial outline. If you need only a rough guide for elevations, model roughly; if you need to work out all the details, model finely. The object of drawing and modeling is to remove doubt, so do whatever is necessary to establish the shape of the carving in your mind so that you can tackle the wood with confidence. Once you've done that, it's time to work in wood.

If you're making something small such as a statue from a single piece of wood, you can begin carving right now. If you're doing a large sculpture or a piece of furniture, you'll probably have to do some construction work or cabinetmaking first. Most

Photos, except where noted: Robert Aberman

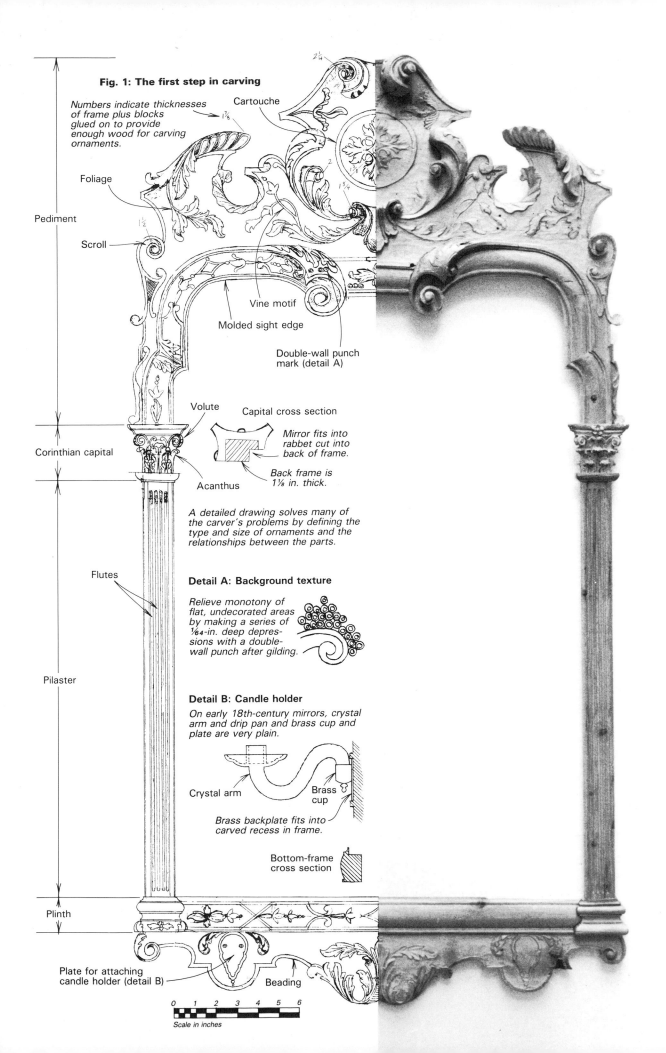

Fig. 1: The first step in carving

Numbers indicate thicknesses of frame plus blocks glued on to provide enough wood for carving ornaments.

Cartouche

Foliage

Scroll

Vine motif

Molded sight edge

Double-wall punch mark (detail A)

Pediment

Volute

Capital cross section

Mirror fits into rabbet cut into back of frame.

Corinthian capital

Acanthus

Back frame is 1⅛ in. thick.

A detailed drawing solves many of the carver's problems by defining the type and size of ornaments and the relationships between the parts.

Detail A: Background texture

Relieve monotony of flat, undecorated areas by making a series of ¹⁄₆₄-in. deep depressions with a double-wall punch after gilding.

Flutes

Pilaster

Detail B: Candle holder

On early 18th-century mirrors, crystal arm and drip pan and brass cup and plate are very plain.

Crystal arm

Brass cup

Brass backplate fits into carved recess in frame.

Bottom-frame cross section

Plinth

Plate for attaching candle holder (detail B)

Beading

0 1 2 3 4 5 6

Scale in inches

Ben Bacon

Shaped wooden blocks (above left) make the basic frame thicker in areas where ornamentation will be carved. When the frame is nearly finished, Bacon uses a small veining tool to recut the fine fluting into the gesso (above right).

traditional mirror frames are simple constructions. For a gilded or painted frame, clear pine is fine; if the frame is to be waxed or treated with some other clear finish, walnut, oak or mahogany will look better. For the mirror shown here, I first made a 1⅛-in. thick, half-lapped frame and assembled it dry. Then I transferred the outline of the drawing, bandsawed the frame to shape, and cut the rabbet for the glass before gluing up the basic frame. Since this frame is flattish with projecting ornaments, you can glue on ½-in. to 1½-in. shaped blocks where you need more wood for carving scrolls, capitals, or column tops and foliage. The frame will be gilded, so the gluelines won't show.

Now you're ready to start the rough carving. Next to making the initial drawing, this is probably the most daunting moment—there's something intimidating about taking the first cut. But forge on. And don't be discouraged at the amount of time it has taken to get to this point—your preliminary work will soon bear fruit in speed and ease of carving. As you begin, remember that there are two carving steps, rough carving and final carving. Don't ever try to combine the two and plunge right into the final details. That would be similar to dovetailing a drawer before cutting the sides to length. Beginners carving a leaf often carve the stem first, or if they're carving a head, they carve the nostrils first—only to find that they have to recarve the piece because the stem is in the wrong place or the nose is too long.

Rough carving deals with *big* shapes. I generally use #2 through #6 gouges, 20mm to 35mm wide, and form the shapes quickly. You should carve big areas, thinking exclusively about elevations, dominant forms, relationships of planes, and overall appearance and feel. Carve as if you were looking at the piece from five to ten feet away. This is somewhat difficult to explain in terms of foliage and ornaments, so you might be able to visualize the process better if you think in terms of more human shapes. If you were carving a head, for example, at this stage you'd do the general shape of the skull and hair first; you'd carve the details into these bold forms later. On the mirror, I started at the top and worked down, first knocking the corners off the bandsawn shapes and establishing all the impor-

tant heights, such as the slightly domed cartouche and other ornamentation at the center of the top, and the overall shape of the two capitals on the pilasters. Then I roughed in the molding that surrounds the glass and all the scrolls. Measuring carefully with dividers and calipers, I checked the positions of the ornaments against the drawing, and I used a depth gauge to ensure that paired ornaments were the same height.

Still thinking in terms of rough carving and big shapes, refine your forms slightly. If you were carving a head, at this stage you'd rough in the eye sockets but not the eyelids or eyebrows. You're still looking for an overall feel, not minute detail. On my mirror, this involved lowering and shaping the background behind the ornaments, more clearly defining the molding and scrolls, and giving overall shape and flow to the leaves.

Now stand back from the piece and ask yourself if you like the proportions and balance. Do the overall shapes and directions of the various parts work well individually and as a group? Remember that the immediate impact of a piece most often sells it visually and financially. This impact is not achieved through fineness and detail of carving, but by overall harmony and cohesiveness. This is the whole point of rough carving, and why traditionally it was considered the most difficult part of any job and was assigned to the most experienced workers with imagination and foresight. If you're not satisfied with the general look, carve a little more. Since you haven't carved any details yet, you'll be refining and adapting, not ruining any good work.

Don't be afraid to experiment at this stage, either. Often you can improve your drawing by exploiting the grain, color and other characteristics of the wood to give your work more direction, liveliness and flair. If you encounter major problems, though, you've probably skimped on the initial steps.

Once you're pleased with the overall form, you're ready to start the last stage, final carving or "improving." Here carving irregularities are smoothed out and the final detail carved, at last. Concentrate on the finish of the piece: remove all tool marks, clean each surface, and make sure that the curves and lines are sweetly flowing. In a sculpture of a head, you would

From *Fine Woodworking* magazine (January 1985) 50:60-63

now carve the eyelids and eyebrows and do the final modeling of the mouth. In furniture carving, you'd give the leaves and ornaments their final shape and do the fine modeling, fluting and undercutting.

For this style of gilded mirror, this final detail-carving isn't done in the wood, but in a thick layer of gesso (a liquid made from powdered chalk and animal sizing, which is the consistency of cream when wet and like plaster when dry). The gesso is brushed on the unfinished wood before gold leaf is applied. This is what I did for the mirror, but the carving steps would be the same if you wanted to do all the carving in wood.

Most of the fine detail on the mirror involves flat foliage work, such as the carved molding around the sight edge or the foliage around the large ornaments on the top. To be effective, this shallow, ⅛-in. deep foliage must be fine and delicate. After drawing on the foliage, use a fluter or a V-tool to carve around the outside of the pencil line to a depth of about ⅛ in., thereby separating the foliage from the background. Then recess the background area about ⅛ in. so the foliage is proud. This is a tedious process, especially in this style where the background must be smooth and regular so that the foliage appears to float on top.

After the background is lowered, you can "set in" or redefine the pattern outline with a variety of shaped carving tools. Take a tool with a shape similar to the section of the outline you're shaping, and press the tool straight into the surface at about a 90° angle to create a crisp, vertical wall between the outline and the background. The trick to setting in details is to match the curves and transitions of one tool shape to the next to create a smoothly flowing, harmonious shape. If marks left by the carving tools show, each detail will seem awkward and asymmetric. Once the outline is set in, model the top surfaces by carving in the flows, swells and dips that give the leaves life and movement. This setting-in and modeling procedure is always followed in flattish foliage work, be it on frames or furniture, and is also used in low-relief work, such as the carving on drawer fronts in 18th-century American lowboys and highboys.

Tool marks spoil leaf.

Well-cut leaf flows smoothly.

When the final carving is completed, set up the work again and have another look before you do any finishing. Is the detail harmonious throughout? Do the forms and detail read well? Are there any unsightly walls or areas of excess wood, especially around the edges? This is your last chance to tidy up the piece before you or someone else has to live with it for a long time. If you're happy with it, carry on.

Most traditional work is gilded or covered with a clear finish, but finishes for carving are pretty much a matter of personal choice. A word of caution, though: Most high-gloss or thick finishes such as polyurethane, varnish and lacquer look harsh and brassy on carving. It's better to bring out carving's soft look with thin shellac, wax or oil. I used gold leaf in the traditional way on the mirror shown here, water-gilding rather than oil-gilding. After applying and burnishing a 23½-karat gold leaf, I punched the background areas with a ¼-in. double-wall punch (available from Wood Carvers Supply Co., 3056 Excelsior Blvd., Minneapolis, Minn. 55416) to visually relieve the monotony of the large, undecorated surfaces behind the carving. This background

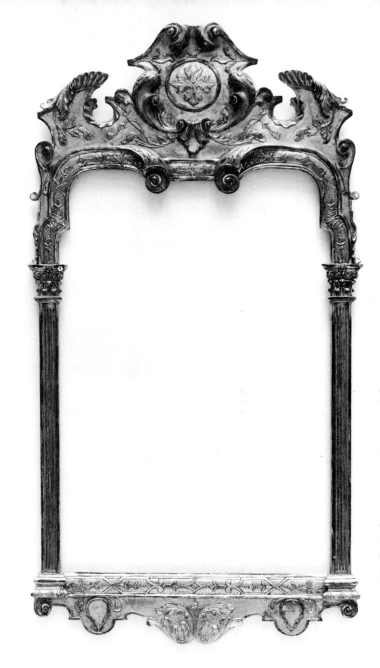

Author's gilded 18th-century-style mirror frame is a new design based on careful study of original pieces in museums and furniture anthologies.

texturing is done after gilding so the gold will be forced down into the ring impressions. I then toned the mirror (photo, above) to simulate aging, and fitted the brass and crystal swan-neck candle holders and the beveled glass.

The steps I've outlined won't solve every problem you encounter—carving is too vast and subtle a craft to be bound by a few rules. But they do work in most cases; in fact, they're still taught to apprentices in traditional carving shops, where planning and foresight are considered as important as hand skills and tools. Approaching work systematically will always reduce problems, or at least present them in such a way that they can be tackled more effectively and with a minimum of heartache. It's the difference between having a street map in an unfamiliar town and relying on strangers for directions. □

Ben Bacon is an American carver now working in London, where he completed a five-year apprenticeship in carving, gilding and framing. Drawings by the author.

Balinese Masks
Carving cross-legged on the floor

by David Sonnenschein

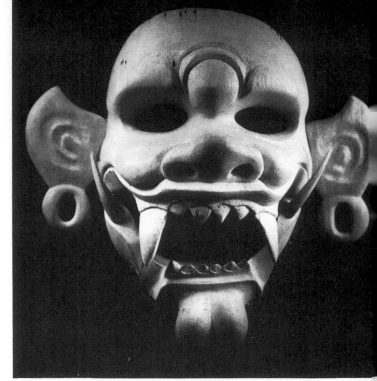

Sonnenschein's hinged-jaw mask of the evil goddess Celeluk.

Bali, the Indonesian island of enchantment, has manifested a myriad of technically and creatively advanced art forms: music, dance, painting, silversmithing, and carving in bone, ivory, stone and wood. Of all the different types of Balinese woodworking, mask carvings are best known around the world, and most meaningful on the island. At temple festivals, weddings, holidays and tourist performances, masks are used to depict stories of the Hindu Ramayana, to display the perpetual battle between good and evil, and to provide comic relief mocking the seriousness of the morality dance/dramas. Some masks cover only part of the face, an enlarged nose, for example; others are elaborate full-head pieces with hinged jaw, fangs, large ears, ascending skull and waist-length hair. Godlike, regal and demonic characters often have bulging eyes with narrow slits underneath through which the dancer can see out.

My joyful experience studying Balinese mask carving began as an academic pursuit with an American anthropologist, Elizabeth Young. We set out to videotape the mask dances and to record the artists' analyses of their theater. Then I met Ida Bagus Anom, a master carver, dancer and musician. We found a wonderful rapport, and although I had not worked wood before, I was delighted when he invited me to study the creation and use of Balinese masks.

He taught by means of the symmetric nature of the face. He would work on one half, then hand the mask to me to

Balinese-style masks made by the author for actors to wear in a film include Little Red Riding Hood in pine, the Wolf in redwood, and Grandmother in spalted pine.

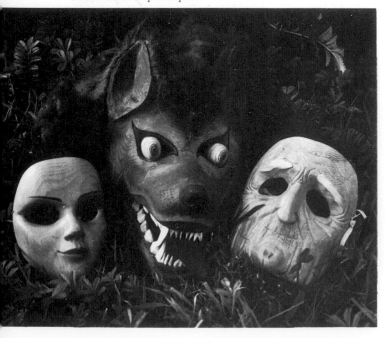

match the other side. At the beginning my work took ten times as long, with short, choppy strokes instead of the beautiful, forceful cuts of Anom. Gradually, though, I took less instruction by copying and became able to respond to the verbal mode: "A little more off the nose." As I learned to handle the tools, I was able to devote attention to the character and expression of the face. My calluses thickened and so did my endurance for sitting cross-legged five or six hours a day.

Carving is done seated on bamboo mats, the carver holding the wood with his feet, leaving both hands free for chisel and mallet. Bracing the wood against a fixed, heavy chopping block affords quick and subtle angle changes. Carving a mask begins with choosing a dried piece of *bulu* wood (similar to jelutong), light and soft but moderately strong and able to hold fine detail. A section of the trunk between 8 in. and 10 in. high is split in half upon the chopping block.

The rough dimensions of temple, forehead and jaw are pounded out with an iron hatchet, which also begins hollowing the eye sockets by forming two horizontal *V*-notches. The nose is blocked out in a rough triangle by taking wood away from the cheek and mouth areas; the first strokes are parallel to the plane of the nose, the secondary strokes perpendicular. This avoids pulling off too much wood. While one hand holds the wood at the proper angle, the other guides the hatchet straight down. These cuts come to within ½ in. to 1 in. of the final form.

It is necessary to hollow out most of the interior before finishing any facial features, because heavy pounding on the back could dent the front of the mask. The gouges bring the thickness down to ¾ in., the carver checking continually for symmetry and avoiding irreversible thinness. Awareness of grain direction has to be maintained throughout, for a wrong move can break the mask in two. Such disasters are glued back together; the final painting hides the crack.

The carver begins to refine the facial features with a set of nine gouges and six chisels, hand-forged and without handles, driven by one of three different-sized ironwood mallets. The forehead is smoothed, the temples narrowed, the eye

Photos: Katherine Higgins

sockets deepened, the cheeks planed, the nose and mouth curves started and the jaw-line defined. The carver constantly changes tools to suit the curves. Because the metal is soft, the tools can easily acquire a very sharp edge, but they need frequent regrinding on curved stones.

Learning the nature of the cylindrical wood grain is the key to clean cuts with the hatchet, chisel and knives. The general rule is, always to move toward the center rings, using the inner layers to support the wood being cut. Changes in cutting direction usually occur around the nostrils and cheeks, where a line or curve flows toward the center and then away.

The knives used for detailing are of two basic shapes: the *pissau*, with flat sides and sharpened along a 1½-in. curved edge, and the *pungut*, a symmetrical, upward-curving blade coming to a point and sharpened on both edges. The *pissau* smooths and defines convexities—forehead, cheeks, nose—and produces sharp, incised lines by making parallel strokes at various angles to the face—nostrils, lips, wrinkles. The *pungut* creates and smooths concavities and recesses—eye sockets, under the lower lip, inside the mask. Both types and all sizes of knives are positioned with both hands. One hand grabs the wooden handle and iron stem, with thumb pointing toward the tip, while the other grips the mask in such a way that its thumb can press against the knife as a pivot. Thick calluses develop on both thumbs. The carver sits cross-legged and cradles the mask against his thighs. The knives are both pulled toward the body and pushed away—both strokes are necessary to cut toward the inner rings. Anom, my teacher, would peel off wood curls like skin from an apple.

The finished carving is then rough-sanded for the long process of traditional painting. Paint-making starts with fire-dried and pulverized pig bones, ground in water to a smooth paste. An imported Chinese glue, in the form of brittle, translucent rectangles, is blended in, along with pigment from a rock, lamp soot or commercial acrylic. When it is the right color, water is added and the heavier particles allowed to settle in the grinding plate. This pasty sediment is used to fill any holes or cracks. The thin paint is then applied and the mask set in the sun to dry. Between 20 and 40 coats are brushed on before the details of eyes, nose and mouth can be added. Finally, five coats of clear glue give a lacquered appearance and a protective finish.

The mask may be further embellished by the addition of goat hair for eyebrows and mustache, the hide held in place by small wood spikes. An elastic band through holes at eye level holds the mask on. Now it's ready for its ceremonial debut in the village festival, or for sale to a tourist.

Since studying with Anom, I have continued carving masks in Oregon, using seasoned driftwoods (pine, cedar and redwood). I am also a dancer, filmmaker and musician, and have created a Balinese-Oregon film version of Little Red Riding Hood. The characters' masks are carved in time-lapse photography. Actors don the masks and mime the story in the Oregon forest, each accompanied by a different woodwind instrument. □

Photo, top right: an array of Balinese woodcarving tools—nine gouges, three pungut *knives, two* pissau *knives and five straight chisels. The next photos show these tools as traditionally used. Mallet-driven flat chisel shapes forehead of Grandmother mask-to-be, while feet hold wood against chopping block. Fine features emerge as* pungut *hollows eye socket, and* pissau *incises wrinkles in forehead.*

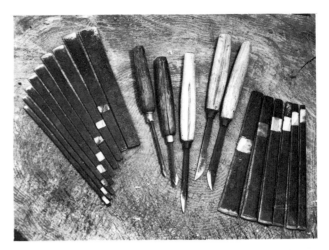
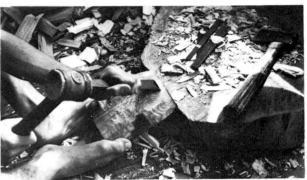
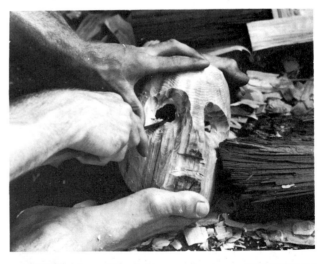
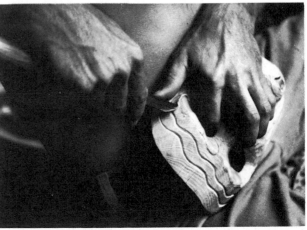

From *Fine Woodworking* magazine (July 1979): 22:46-47

Carving Running Patterns
How to chop out picture-frame moldings by the yard

by Miles Karpilow

This complex Spanish design derives from a series of straightforward cuts.

The great picture frames, such as the richly carved portrait frames of the Louis XIV and Louis XV periods in France and those of 17th-century Spain, are carved with the whole frame in mind, so that the pattern is symmetrical, running from the center of each side to the corners. To make one of these, you have to know the size of the frame before you can begin to carve. But there is another way to make frames—you can carve a running pattern on a length of molding, and then cut it to whatever size is needed. By its nature, this is production work, and it goes quickly. Each cut may not look like much, but it sets the stage for the next, with no wasted motion and with far less fuss than one would imagine. There are fine examples of such continuous carved frames from virtually every historical period, from the Italian Renaissance through the end of the 18th century, when handcarving generally gave way to machine-made moldings with embossed patterns or cast ornamentation.

Like their more aristocratic cousins, running-pattern frames were usually finished with several layers of gesso followed by gold leaf. The patterns are similar to those found in furniture, but because the heavy gesso obscures the detail, the carving tends to be cruder. For a crisper look, some designs were reworked by carving the gesso. The scope of these carvings runs from simple beads, popular in the Renaissance and again in the Neoclassic period of Louis XVI, to the wide, flamboyant carvings of the Spanish and Italian Baroque. The origins of several patterns can be found in medieval manuscript decoration. One motif, peculiar to Spain, consists of spoon shapes and elephant ears. There are many versions of this, one of which I've described on pp. 20-21.

The word "bead" originally meant to pray—hence rosary beads, and eventually anything that looked like them, such as the beads on a necklace. Carved beads are actually a series of half-beads in high relief, as if a necklace were emerging from the wood. The molding is first planed into a sort of half-dowel shape running its length. The plane used is called a beading plane because it produces the shape that can be carved into beads. The shape on the molding is also called a bead, whether it is carved or not.

During my eight years as a carver and gilder, I developed a great respect for historical models. Robert Kulicke, the man I worked for and learned from, was very wary of what he called "inventing in the past tense." Chances are that our understanding of any period has been too much modified by our own, and that our attempts to work out new designs for a period will look inadequate and distorted to the next generation. But sometimes a carver has to take that risk. On one occasion I had to come up with something for an important 17th-century drawing, and nothing we had available would do. I decided to scale down and modify an existing model, and a short time later found an original frame virtually identical to my invention. Nearly every period frame we made,

however, was copied from a specific model, and in most cases we owned the original, to which we continually referred in order to keep from straying. When possible, we'd scrub a section down to the bare wood to analyze the cuts. If you have a carved molding that you wish to duplicate, this is the route to take whenever possible. Examine the carving to figure out the minimum number of cuts and the most efficient order.

The carving technique is basically punch and shape. Each carving is a fixed number of strokes. When the chips fall away, you need to do very little secondary shaping. The interaction of the molding profile with the surface indentation creates an enormously rich texture, even though the execution is deceptively simple and satisfyingly quick. One traditional carver of my acquaintance, trained in Europe before World War II, was used to spending days on one delicate Louis XV panel and months on whole rooms of boiserie. He refused to believe me when I told him how quickly a particular frame could be carved, until I brought him into the shop to watch. He was convinced, but he walked away muttering "chip-chop," which, of course, is just what it is.

Any running pattern consists of a series of similar units strung together. The trick is to do the same cut of each unit all the way down the line, then turn around and do the next cut, and so on. I generally start out with pencil marks for the center of each unit and then do the rest by eye. If it's a carving I haven't done in a while, I'll carve one complete unit and use that as my guide. Sometimes it is necessary to do a few units before you get it just right, but one awkward unit—if it isn't *too* far off—will blend into the complete frame.

For this kind of carving, the molding profile is critical. If it isn't just right, the carving won't look right either. A bead on a molding has to be round, without a peak, and only slightly higher than its width. If hollows are too deep, they will interfere with your punch cuts. Steps have to be wide enough so that they don't break off, and rabbets have to have enough meat on top for the same reason. Once, when I was carving a Louis XVI molding, I found myself having to glue most of the beads back on, a tedious and costly process. I did a little research and discovered that the bead should not sit on top but go in at an angle, as shown in figure 1, so that you're carving toward the solid part of the frame instead of directly down on the rabbet. As a further precaution, you can place

From *Fine Woodworking* magazine (September 1983) 42:46-49

a strip of wood in the rabbet to support the lip.

Most professional framemakers have moldings made to their specifications by a mill, but the part-time framer cannot have a stock of hundreds of feet of moldings in all the profiles he may want. There are many ways to deal with this. Shapers, routers, and even a tablesaw, with the aid of an adjustable-angle fence, can make moldings. I use block planes, molding planes and gouges. Back-bent gouges are particularly helpful. One caution, however: If you are going to carve the molding, remember not to sand the milled stock. Fine abrasive particles lodge in the wood and will quickly dull your tools.

My favorite wood for frames has always been basswood. It is the blandest wood I know of. It hardly ever asserts itself—just sits there and lets itself be carved. Jelutong, a southeastern Asian wood, is very similar in character. Neither of these woods looks particularly good with a natural finish, so they are best used when the frame will be gessoed and gold-leafed. Wormy chestnut finishes nicely, and is pre-antiqued in the bargain, but it isn't much fun to shape and can also be stubborn to carve. Honduras mahogany is an excellent choice for a natural finish. French frames were generally carved in oak, but the European variety of oak is finer and softer than our white oak. The Spanish carvers used a species of pine that is a little harder than those generally available in this country.

Bench—A carvers' "bench" is a work surface that can be set on top of a sturdy table or supported by a framework of 2x4s. My favorite is a 2x12 with a 2x6 fastened along the top to form a step. The molding will be nailed to this, so you'll want lumber with few knots, but good kiln-dried construction lumber is adequate. An 8-ft. bench is portable, and can be clamped on top of a regular woodworking bench. But if you're planning a production operation, 12 ft. or 16 ft. is better. The height should fit the individual. I like about 40 in., so I can rest my forearm on the work. The bracing should be about 2 ft. deep for stability, which leaves room for a 1x12 along the back, on which you can lay your tools.

Nail the molding to the bench with 4d or 6d finish nails and set them, even if they don't go through an area to be carved. This not only holds the work more firmly, but protects the tool edge from an accidental brush with them. As an added precaution, when you know that a cut will be made directly over a nail, interrupt yourself and give the nailset an extra punch. Better time spent setting nails than regrinding chisels. When the work is finished, pry the molding from the bench. Remove any nails left in the bench with a claw hammer and pull the ones left in the molding out from the back with a pair of nippers. Never pull nails out from the front.

Tools—Because most cuts are made with one punch, the shape of the tool determines the shape of the carving, and you will eventually need a fair number of tools. When I was carving full-time, I got up to about 30, which served me for 12 or 15 different designs ranging from delicate to heavy moldings. The tools range in width from $\frac{1}{16}$ in. to 1 in. Most frame carvers call all their tools chisels, including the gouges. This is less confusing than it might seem, because each tool is numbered according to its width and the shape of its curve. A $\frac{1}{2}$-in. #8 and a 1-in. #8, for instance, have different widths but the same curve proportionally. A #7 has a slightly broader curve, and a #1 is a straight chisel. With a couple of exceptions, tools are ground straight across, with the bevel on the outside of the tool, opposite the cannel. For the carvings I'll discuss in this article you'll need the following: $\frac{5}{8}$-in. #1, $\frac{7}{8}$-in. #1 (ground to a $\frac{1}{2}$-in. radius), $\frac{1}{4}$-in. #8, $\frac{5}{8}$-in. #8, $\frac{3}{4}$-in. #8, $\frac{1}{2}$-in. #7, $\frac{1}{4}$-in. skew, and a medium-weight mallet. In addition, you should also have a soft, long-bristle wire brush for clearing away chips, a hammer, a nailset, a flat bench chisel or a prybar for removing the molding from the work surface, and a compass/divider.

Carving beads—One of the most popular styles of the late-18th-century period of Neoclassicism was a simple row of beads, often used alone as trim on a number of moldings ranging from about $\frac{7}{8}$ in. to about 2 in. wide.

Choose a chisel slightly wider than the diameter of the bead on the molding. For a molding bead of just under $\frac{1}{4}$ in., as shown in figure 2, start at the left-hand end of the piece, holding the $\frac{1}{4}$-in. #8 chisel in your left hand at a 45° angle toward you, so that it lines up with the angle of the bead, and 45° to your right, with the cannel down. There are three cuts plus cleanup. The first cut just breaks the surface. Beads have a way of splitting out, so don't strike too hard with the mallet. There are various adjustments to avoid split-out. One,

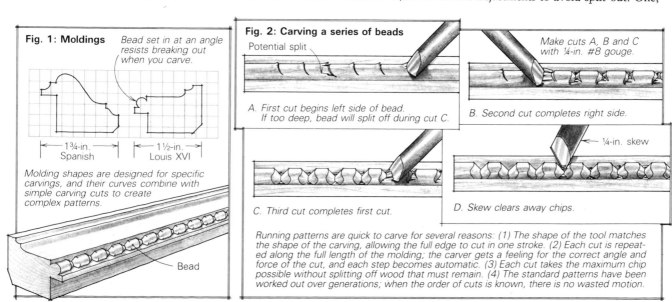

Fig. 1: Moldings
Bead set in at an angle resists breaking out when you carve.

1¾-in. Spanish ⊢ 1½-in. Louis XVI

Molding shapes are designed for specific carvings, and their curves combine with simple carving cuts to create complex patterns.

Bead

Fig. 2: Carving a series of beads
Potential split

A. First cut begins left side of bead. If too deep, bead will split off during cut C.

Make cuts A, B and C with ¼-in. #8 gouge.

B. Second cut completes right side.

C. Third cut completes first cut.

¼-in. skew

D. Skew clears away chips.

Running patterns are quick to carve for several reasons: (1) The shape of the tool matches the shape of the carving, allowing the full edge to cut in one stroke. (2) Each cut is repeated along the full length of the molding; the carver gets a feeling for the correct angle and force of the cut, and each step becomes automatic. (3) Each cut takes the maximum chip possible without splitting off wood that must remain. (4) The standard patterns have been worked out over generations; when the order of cuts is known, there is no wasted motion.

of course, is cutting lighter, but cutting down at a steeper angle can also help. The cuts should be $\frac{7}{16}$ in. apart. In the beginning you may want to use a ruler or a divider to mark the spaces, but you should learn to space evenly by placing the tool so that the previous cut is centered in the space between the one before it and the one you are about to make. You are looking one space behind as you cut. Remember, you are not a machine, and a little unevenness is desirable.

The next cut is the mirror image, only deeper. Starting at the right-hand end, hold the tool in your right hand and the mallet in your left, and go back the other way. This time go all the way down, until the corners of the gouge reach the bottom of the beading. If your first cut was deep enough, there should be no splitting out. As you place the chisel, watch the bead you are forming. There should be a neat little ellipse, nearly round. There should also be no space between the beads. The third cut finishes the first, and the outside edge of this cut should touch cut number two. The final cut is with a skew, used as a knife to slice out the chips.

When you start out, it's a good idea to make eight or ten first cuts, then finish off a few of them. If they are all right, continue to the end. If not, practice a few more. A variation, generally used with other carvings such as ribbons, is the "pencil and pearl": three beads followed by a single long one that is about the length of three beads. The long bead is simply the half-round shape with rounded ends. □

Miles Karpilow makes furniture in Emeryville, Calif.

Carving a Spanish molding

This is a very popular carving that occurs in many different widths besides the 1¾-in. shown in figure 1 and in the photos. Start by marking off 3-in. divisions with the compass. If you want, you can also mark off the centers of these too. Photo A shows the carving after a series of cuts made by punching down with the mallet. These are numbered in the order they were made, but mirror-image cuts aren't numbered separately. You can vary the order of these cuts somewhat, but it's important to maintain the overall proportions. You will need most of the tools listed on p. 19. For a wider molding, select wider tools and wider divisions.

The first cut (1) is chopped straight down on each of the 3-in. divisions with the flat chisel (or the rounded one) at the very top of the molding. Now take the ¾-in. #8. With the top edge of the tool in the first cut, chop straight down (2), almost perpendicular to the face of the molding, fairly deeply, especially along the lower portion. Cut all these along the length of the molding, then turn the gouge around and cut the mirror images. The next cut (3), still with the ¾-in. #8, begins at the bottom end of the previous cut. Be sure to hold the gouge so that a line drawn through its corners would be at 90° to the molding length. Make the mirror-image cut in the opposite direction, keeping the shape symmetrical. The next cut (4) is similar. When you are more familiar with the carving, you can make cuts 3 and 4 as part of the same run. Then using the rounded #1 chisel, make a cut (5) halfway between the original 3-in. divisions. The cut should be right on the hollow of the molding and a little deeper at the top. Using the same tool or a straight-ground flat, continue the cut over the top of the molding (6), chopping fairly deeply.

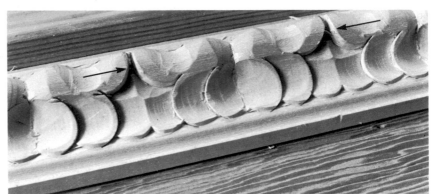

Each unit (between arrows) results from the cuts described in the following series.

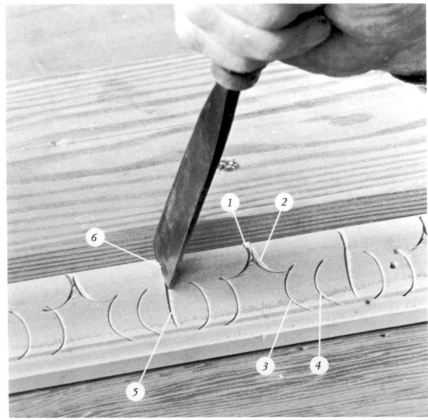

A. *The first six cuts, and their mirror images, chop out the basic proportions along the full length of the molding.*

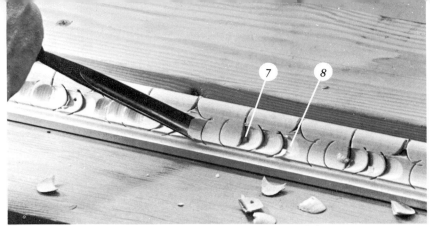

As shown in photo **B,** take the ⅝-in. #8, cannel up, and make a series of slicing cuts (*7*) starting from about ¹⁄₁₆ in. from the outside curve of the punch cuts *3* and *4,* aiming at about a 30° angle toward the base of punch cuts *4* and *5.* Cut *8* is similar, but at a shallower angle, starting from the original 3-in. divisions and aiming toward the base of cut *3.* The whole surface between the outside curves of cuts *3* will be lowered and left slightly crowned. When you get used to them, you can make cuts *7* and *8* in the same pass.

B. *Cuts 7 and 8 pare away the waste up to chop-cuts 3 and 4.*

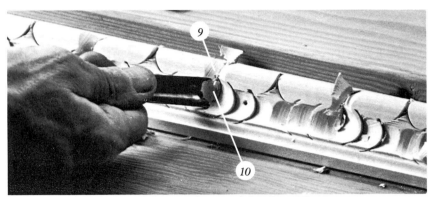

For *9* (photo **C**), turn the tool over, cannel down, and round into straight cut number *6* at the molding top. I find that two taps with the mallet, holding the tool a little higher for the second tap, gives just the right shape. Take the ½-in. #7, cannel up, and make cut number *10,* angling up toward cut *9.* This enlarges the hollow that you began with the innermost mirror-image cuts at *7.* When working soft wood, you may not need the mallet for these cuts.

C. *Cuts 9 and 10 begin to bring out the mound for the saddle.*

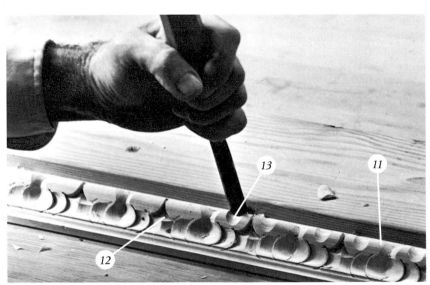

To make cut number *11,* use the same tool, cannel down, and tighten the curve begun by cut *9,* as shown in photo **D.** The "saddle" is next and is begun by cutting up (*12*) toward the base of cuts number *2.* Cut *13* comes around and over at the top of each saddle with the ⅝-in. #8, cannel up. At the top it should come in no more than ⅛ in. from the edge of the molding.

In photo **E,** cut *14* broadens cut number *13* with the same tool, but cannel down. The last cuts (*15*) are the scallop cuts along the bottom. These are chopped straight down with the ½-in. #7 and cleaned out with the skew.

D. *Cuts 11, 12 and 13 refine the saddle's edges and rough out its top.*

Mitering carved moldings—There is a technique that will ensure that at least three of the four corners of the frame will come out symmetrical. There is waste involved, but it must be weighed against the time saved by carving in the length. Start by cutting both miters on the first piece. Then trim the adjacent corner. Keep trimming until the carving on that side is a mirror image of the unit on the end of the first piece. When put together, there should be no protruding edges. Proceed this way with the next two pieces. You will then have three matching corners and you can only hope that the fourth will be close. It rarely will match, so after the frame is joined, take a small chisel and improvise. If done properly, it will take a very astute eye to see the difference. —M.K.

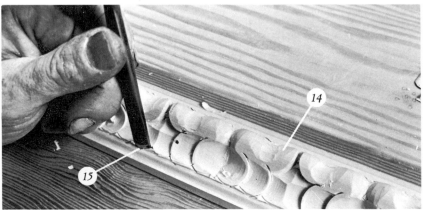

E. *Cut 14 shapes the top of the saddle. Cut 15 chops out the decoration along the edge.*

Linenfold Carving
Planes and gouges shape folds

by Rick Bütz

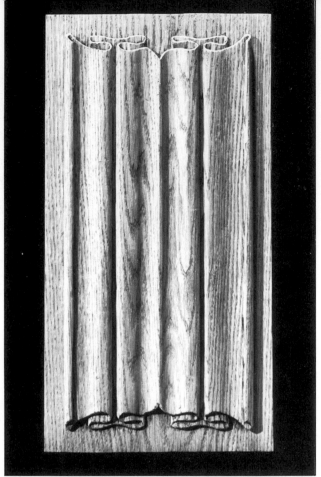

This linenfold panel, planed and carved in traditional oak, is ready to be let into a frame.

Linenfold carving creates in wood the effect of creases and undulating folds of cloth or parchment. The design seems to have originated with French and Dutch woodworkers around the year 1450, and was probably inspired by the shapes and patterns of draped altar cloths. Several surviving pieces show intricately carved borders reminiscent of the rich embroidery found on ecclesiastical appointments. During the late 15th century, linenfold was introduced into England, where it quickly caught on among the tradesman woodcarvers. The style became so popular that it is now the hallmark of Tudor-Gothic design.

Linenfold was usually carved on a rectangular panel, which was then fitted into a grooved framework. The design could easily be altered in length, and today can be seen as paneling in houses, public buildings and churches, including Westminster Abbey. Linenfold was also popular for paneled doors, chests, beds and other household furnishings of the 15th and 16th centuries. Although many of the early examples were realistic interpretations of cloth folds, the design eventually became quite stylized, and it is even found sideways at times, as if the idea of a hanging drapery had become quite forgotten. As tastes changed toward the end of the 16th century, linenfold carving was replaced by the elaborate floral themes of the early Renaissance.

There are many traditional designs to choose from. I've included drawings of a few to give you an idea of the range. The old woodcarvers varied each panel slightly, achieving a vitality that let them cover an entire room or hallway with linenfold without it seeming monotonous or repetitious. This variety sets the original Gothic woodcarvings apart from later imitations. So don't be afraid to modify the design, but keep in mind that it will be difficult to visualize the end result. Make precise drawings: a full-scale cross section and a clearly defined sketch of the end folds, as shown at right.

The carving of linenfold is basically a two-step procedure. The long folds and undulations are planed out, then the ends are shaped with various carving tools. One aspect that makes carving a linenfold panel so enjoyable and interesting is the variety of tools that are used. While you could use routers and circular saws, it's just as quick and more satisfying to do it with traditional hand tools. For cutting down the background and shaping the contours of the long folds and creases, use a rabbet plane, a plow plane, one or two round planes, and a small block plane (photo **A**, top of facing page). For carving the end folds, you will need one or two fishtail gouges of medium sweep and a back-bent gouge. If you don't own all of these tools, you can modify the design to suit the ones you have.

Rick Bütz is the author of How to Carve Wood: A book of projects and techniques, *published by The Taunton Press. Photos by Ellen Bütz, except where noted.*

Typical linenfold designs

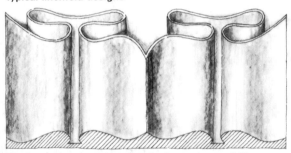

The linenfold design forms the raised part of a panel. These patterns, adapted from 15th- and 16th-century examples, provide a starting point for decorative carving in the Tudor style. Oak was a favorite wood for the panels of chests, beds, hallways, doors and window shutters.

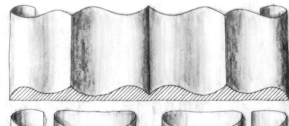

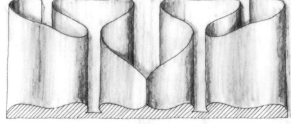

From *Fine Woodworking* magazine (September 1982) 36:98-100

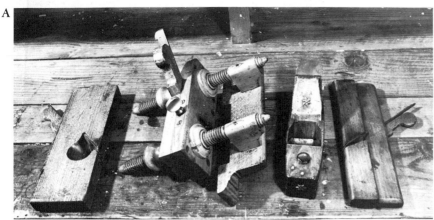

A

Four planes put back to work: The rabbet plane, at the left, lowers the background, and the plow plane grooves the guidelines; then the block plane and the round plane shape the curves.

Begin the linenfold by marking out the border with a marking gauge. Be sure to allow some extra material for a tongue, to fit the panel into a door or a furniture carcase. Next cut down the background along the edges with a rabbet plane (below). The most accurate way to set up the rabbeting is to clamp a fence, a smooth 1-in. by 2-in. board along the face of the panel, to guide the plane and keep the edges straight. As a general rule, the background should not be taken down any more than one-half the thickness of your panel. If you exaggerate the vertical scale of the drawing too much and go for a deeper relief, the end folds will become fragile, which is a real problem in oak, the traditional Gothic wood.

When the background has been cut down and smoothed, mark out the ends of the panel by tracing a cross-section template from your plan. Make sure that your markings are symmetrical and that they line up on both ends of your board. I use a plow plane with a ⅛-in. iron to cut a series of grooves that exactly match the deepest parts of the cross section. The grooves will serve as a guide for hollowing out the undulations with a round plane, keeping the edges parallel and preventing the shaping from going too deep. This is important for a clean, crisp job.

Use a ¾-in. round plane, or something similar, and carefully hollow out the concave folds. The plane iron should be absolutely sharp and the sole of the plane should be waxed with either paraffin or a hard, cross-country ski wax. Ski waxes come in different colors to indicate their relative hardness and the kinds of snow they should be used on. I find that harder waxes, such as blue or green glider, make planing easy and keep the cuts true and clean.

Next smooth off the convex surfaces of the folds with a block plane, and then use a shallow carving gouge to eliminate any remaining ridges. A #5 sweep in a 12mm to 16mm width and a small flat chisel work quite well for this job. The rest of the shaping will be done with carving gouges and the lightest of finish-sanding.

Now make another tracing and template showing the shape and outlines of the outer end folds. Transfer this to the ends of the panel (photo **B**), and begin "setting in" with a mallet and gouges.

"Setting in" means to drive the tool down vertically with a mallet (photo **C**). Then make a horizontal cut to meet the curves. The sweep of the gouges should correspond to the curves of the lines. For this panel, I used an 8mm #5 and a 4mm #7 to set in all of the lines. Don't drive gouges too deep—they can break. When you set in, stop about ¹⁄₁₆ in. short of the background depth. This is important because the outlines will eventually be undercut in order to give the final piece a feeling of depth and separation from the background. If you drive the gouge down too far at this stage, the cuts will show after you undercut, leaving the work rough.

Using a 14mm #7 gouge, ease off the edge you have just set in. This is done by carefully carving a smooth bevel that extends from the inner fold line down to the outer fold line, leaving no

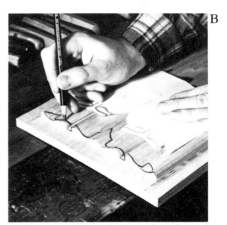

B

Make a template of the end folds and trace it on the work.

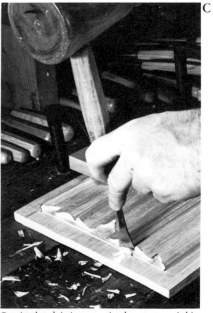

C

Set in by driving vertical cuts to within ¹⁄₁₆ in. of the background.

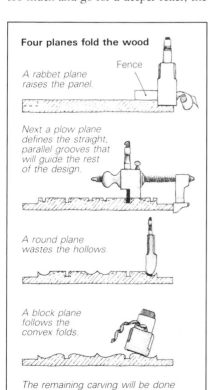

Four planes fold the wood

A rabbet plane raises the panel.

Fence

Next a plow plane defines the straight, parallel grooves that will guide the rest of the design.

A round plane wastes the hollows.

A block plane follows the convex folds.

The remaining carving will be done with chisels and gouges.

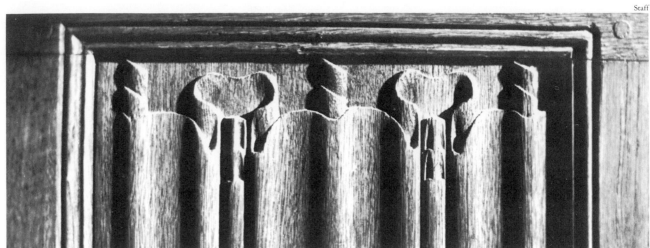

Linenfold paneling, an imitation of draped cloth in wood, evolved into one of the high points of Tudor design. This wall panel, from the Parnham House in Beaminster, England, is typical of much architectural woodwork of the 15th and 16th centuries.

D

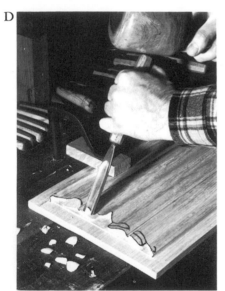

Bevel between the lines with a gouge, leaving bottom edge of 'cloth.'

E

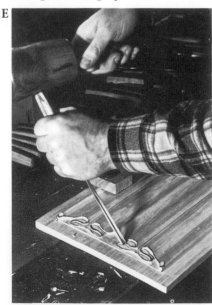

Outline the edges with a V-tool, cutting with the grain as much as possible.

less than 1/16 in. of that contoured line (photo **D**). To begin setting in the inner folds, sketch in the line of the folds, then outline these edges with a 6mm V-tool (photo **E**). To prevent splintering when working across the grain, start each cut from the outer edges of the fold and work toward the center.

Make your horizontal cuts in from the end with a 5mm #3 gouge to clear away the waste, and use an 8mm #5 back-bent gouge to even up the outline (photo **F**). Undercut them slightly. A back-bent gouge is perfect for finishing up linenfold, but it can feel awkward if you are not used to it—the action is the reverse of the more familiar spoon gouge's. A straight gouge can also be used for undercutting, but be careful— the angle of cut may split the wood.

Use the small #3 gouge to clear away any waste, and smooth out the surfaces of the end folds. Use the back-bent gouge to undercut the original set-in line, and then clear away any background material that was left earlier.

As a last step, here's one of woodcarving's fine points: Take a small carving chisel, or shallow gouge, and cut a small bevel along the entire edge of the end fold lines, to reflect light so that the edge will shine (photo **G**). If this line were left sharp, it would disappear in most light and spoil the illusion of cloth folds captured in wood. Finally, lightly touch up any rough spots with fine sandpaper. Just be careful not to smooth over or obscure any edges that should be left crisp, and try to leave the tool-mark facets prominent. Gothic woodcarvings, particularly linenfold, should be boldly simple. Those old craftsmen cut right to the line. □

F

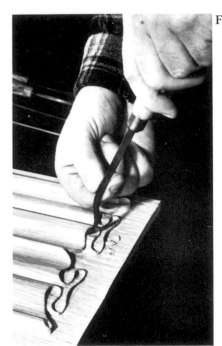

Undercut the folds slightly with a back-bent gouge.

G

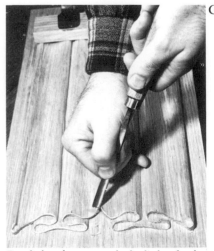

Bevel the edges to catch the light, further defining the carving.

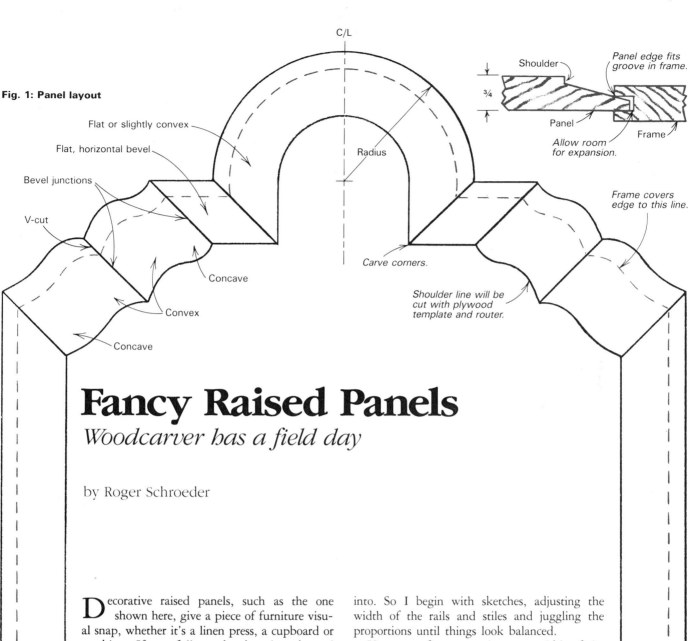

Fig. 1: Panel layout

Flat or slightly convex

Flat, horizontal bevel

Bevel junctions

V-cut

Concave

Convex

Concave

C/L

Radius

Carve corners.

Shoulder line will be cut with plywood template and router.

Shoulder

Panel edge fits groove in frame.

¾

Panel

Frame

Allow room for expansion.

Frame covers edge to this line.

Fancy Raised Panels
Woodcarver has a field day

by Roger Schroeder

Decorative raised panels, such as the one shown here, give a piece of furniture visual snap, whether it's a linen press, a cupboard or a cabinet. If gracefully rendered, a shaped panel can also lend distinction to a door or a paneled wall.

Commercial versions are cut on the shaper, which bevels the edges of the panel by following a curved template. But the shaper is restricted to gently curving, boring shapes. Old-timers working with planes and carving tools were able to shape an almost limitless variety of panels (some examples of period designs are shown in the box on p. 26). I figured that if they could do it, so could I, with a few modern time-saving procedures thrown in.

A panel's overall dimensions depend, of course, on the size of the cabinet door and the width of the rails and stiles the panel will fit into. So I begin with sketches, adjusting the width of the rails and stiles and juggling the proportions until things look balanced.

You must figure out the exact width of the panel before you can determine the size and relationships of the curves. Determining the height of the panel comes later—you want a visual balance between the width of the top rail and the curves of the panel, and this relationship is best adjusted by eye after the curves have been laid out on a full-size drawing.

The raised center of the panel, called the field, is bordered by a shoulder that's about ⅛ in. deep, and from there the panel is chamfered out to the edges. In laying out the panel drawing, I try to keep the chamfers, both curved and straight, all the same width, and I work on the curves until they flow and reverse smoothly. I find it best to begin with a compass at the

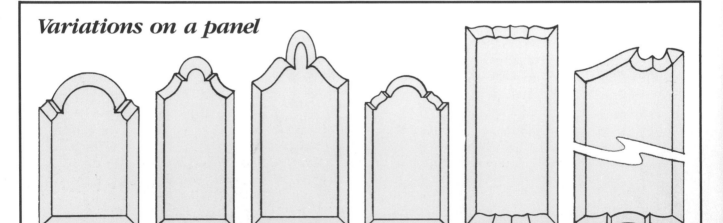

First saw away the waste at the very top of the panel (top left), then chamfer the straight sides and bottom edge. Next bandsaw the top profile, and tablesaw some additional waste (left). A piece of Formica, slid under the rip fence, keeps the panel from slipping down between the fence and the blade. A router (above) with straight bit and pilot bushing cuts the top shoulder by guiding against a template derived from the layout drawing on p. 25. Square up the straight shoulders by routing along a straight fence.

centerline, to determine the central arch, then work out from there to the sides.

The frame will cover about ⅜ in. of the panel when it's in the door, so I plot the rail line on the panel drawing at this stage—this lets me visualize what the panel will actually look like in place.

When the drawing looks right, I use machines to remove as much waste as I can, as shown in the photos above, and then rely on basic carving tools to shape the hollows and rounds. When I'm carving, I clamp the panel over a piece of plywood on my benchtop, with the plywood projecting beyond the edge of the panel to protect the bench from errant chisels. I like to keep the clamps well out of the way, which is easy on a long panel. I usually hot-glue smaller panels to a larger backing piece and then clamp the backing to the bench.

The rails and stiles of the frame are mortised and tenoned as usual, and a router—with a horizontal slotting cutter and a pilot bearing—makes the grooves for the panel. The router can cut most of the groove in the bandsawn top rail; there's just a little cleanup with a chisel necessary at the sharp inner corners.

The panel shown in this article, incidentally, wasn't just an idle exercise—by the time you read this, it will be a door to a corner cabinet in my kitchen. □

Roger Schroeder, of Amityville, N.Y., is a woodworker, author of How to Carve Wildfowl, *and co-author of* Woodcarving Illustrated. *Except where noted, photos by the author.*

Variations on a panel

Panel types are named after things they resemble. One popular basic type, for example, is known as the "tombstone" shape. Variations are called ogee, arched, half-moon, quarter-moon, serpentine, cyma, linenfold-fan, or whatever. Curiously, there doesn't seem to be a name for the entire class of raised panels with shaped edges.

The first four panels shown here are from various period pieces, most of them from Connecticut, where shaped-edge panels were particularly popular. The last two designs are my own, one for a curly-maple sideboard, the other for a pair of doors on a tall mahogany cabinet. There's virtually no limit to the ways a cabinetmaker can change the proportions of the curves and chamfers in a panel design to suit the mood and flavor of a project.

—R.S.

Drawings: Cynthia Lee Nyitray

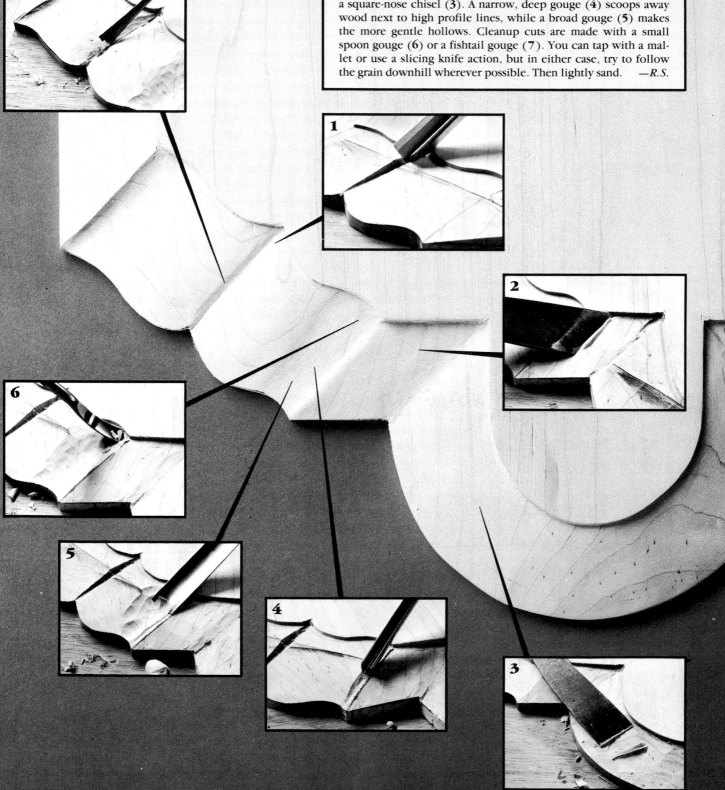

Carving the curves

This basic set of carving tools defines the shapes. First draw a gauge line on the edge of the panel to show the thickness where it will fit into the frame, then carve down to it smoothly from the shoulder line. Step **1** shows a V-parting tool, which cuts a sharp-bottomed groove that allows the other tools room to work. Broad, relatively flat or convex areas are shaped with a skew chisel (**2**) or a square-nose chisel (**3**). A narrow, deep gouge (**4**) scoops away wood next to high profile lines, while a broad gouge (**5**) makes the more gentle hollows. Cleanup cuts are made with a small spoon gouge (**6**) or a fishtail gouge (**7**). You can tap with a mallet or use a slicing knife action, but in either case, try to follow the grain downhill wherever possible. Then lightly sand. —*R.S.*

Gothic Tracery

Working with intriguing medieval designs

by Edward R. Hasbrouck

Sometime during the 12th century in Western Europe arose an architectural style which was later to be called Gothic. It developed through architects' and stonecarvers' efforts to raise their churches from squat Romanesque masses of stone to the towering, airy, light-filled cathedrals we admire today. The flowing, geometric lines and patterns that not only define but also decorate the structure were first called tracery by Sir Christopher Wren.

During the Gothic period (12th to 15th century), the Gothic style was common in most of Europe but was most fully developed in England, France and Germany. Various cultures and historical influences modified what was once an almost universal style. Ultimately the Renaissance swept over it. A brief revival in the 19th century seemed out of place and was short-lived.

The shapes used in tracery seem to derive from the sweeping structural lines of the arches and groined vaults invented by Gothic builders to open up stone walls and admit the mystical light. I get the impression that the spaces thus created were filled with lively and pleasing lines of stone or wood to support myriad tiny panes of colored glass. Craftsmen of the day were advised to study geometry, even to

Edward R. Hasbrouck, a biologist with the California Department of Agriculture, carves Gothic-style furniture as a part-time business.

depict natural forms of plants and animals. Tracery on furniture mimics this architecture, and continued after the architectural style had passed.

The serious student of Gothic tracery can differentiate the cultural and historical influences with terms such as early English decorated, perpendicular, or French flamboyant. But these terms were applied long after the fact and for my purposes are merely academic. The Gothic style was more a feeling or intuitive concept than anything clearly delineated. I don't think the old carvers had very many verbalized rules.

English publications and illustrations of English work have been the best sources of designs for me. The use of wood in English churches was primarily decorative, although timber roofs, porches and doors are exceptions. The early work, even woodwork, was done by masons and smiths. Once carpenters and woodcarvers got into the act, screens, pews, galleries, choirs, thrones, font covers, pulpits, bosses, carved beams and spandrels grew, blossomed and ultimately filled the church interiors until the stonework became almost secondary. The very nature of wood allowed this decorative elaboration and proliferation.

Broad spaces were considered great opportunities to fill with decoration. Many of the design elements had symbolic meanings. The common ellipse probably refers to the Christian fish. Circles can be foliated three or four times: the Trinity or the cross. A circle with a quatrefoil can be twisted

A 14th-century monk's stool carved from California-grown English walnut is shown at left. The pierced top and uprights were drilled and sawed before carving. Above, one panel from a headboard carved in Eastern willow and stained. Drawing shows elements of gothic tracery.

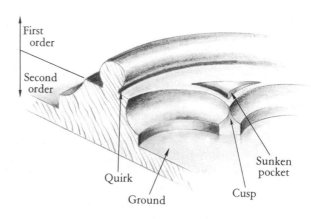

First order

Second order

Quirk

Ground

Cusp

Sunken pocket

From *Fine Woodworking* magazine (Winter 1976) 5:44-46

In photo sequence at right, a template is used to lay out one quarter of the design. The template is divided diagonally, with the first order cut in one half and the second order in the other. The entire repeat is drawn by flipping the template over. When the first-order foliations are cut, the template is used to renew the outline of the second order and the lines are cut in with curve-fitting gouges. Once the stop cuts outlining the pattern have been set in, the rest of the wood is wasted away. When the ground is established, a quick sweep is used to cut the hollows outlining the second-order foils. Most of the design was carved with the tools shown at bottom right: (from left) a flat gouge, vee parting tool, skew, and two medium-curvature gouges. A 30-degree parting tool, not shown, cleaned out the junctions between hollows and the quirk, or undercut, of the first-order bead. The finished panel is 11-1/2-in. square and one-in. thick.

off-axis to make the "whirling cross," a reference to the martyrdom of St. Catherine. I think it was all to delight the eye, enthrall the hearts of generally illiterate and superstitious people, boost the prestige of the patrons who paid for the work, and give good employment to the craftsmen. Today we view the geometry, the moldings, the twining foliage, the saints and the gargoyles as symbols of a culture and life no longer our own.

Nevertheless, I enjoy tracery. I enjoy the process of carving it. In the current parlance, it is an esthetic and nostalgic "trip." I have used it on boxes, headboards, tables and stools, and will continue to use it wherever I have the chance.

Tracery can be carved in several ways, but each begins with a satisfactory pattern, usually involving several repeats. One can draw the design onto the wood, repeat by repeat, with ruler and compass (a technique I use on large pieces). In the example illustrated here, I made a template of one of the repeats and traced out the major foliations, then added small details and corrections freehand.

The design I used is taken from Brandon's *Analysis of Gothick Tracery* (1860). The square is divided into four foliated sections. This design has two orders. In this context the term "order" refers to the organization of design elements both spatially and in complexity.

The first order consists of the thick, sweeping lines close to the surface of the carving, the main elements in the design.

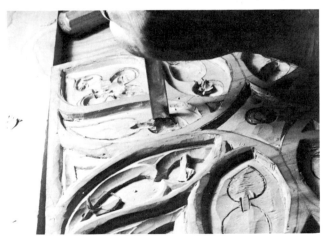

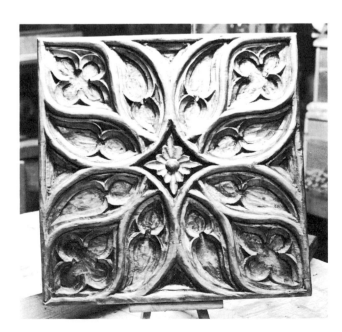

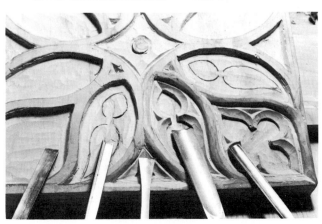

These lines trace out the four circles within the square, and divide each circle into three parts. The first-order lines are rounded and ''quirked,'' or undercut, to form a bead.

The second order comprises the sharper lines and planes within the curves of the first order, from the ground of the carving up to the flat surface at the bottom of the bead. In pierced work the ground would be cut out. The second order is cusped where the curves intersect, and has sunken pockets setting off the cusps.

In executing the design, whittling is kept to a minimum. The shapes of the design result directly from the shape of the tools. The concave portions, or hollows, take their form from a given sweep of gouge; the convex elements are formed by back-bents.

The pattern can be set in either with stop cuts inside the lines or by outlining with a parting tool. I use both techniques, depending on the material. Well-placed stop cuts are a must where the grain is short, or the space too small or deep for the parting tool. Each order is bosted out in turn until the ground, or deepest part of the pattern, has been established. If the carving is to be pierced, I drill and saw out the pierced areas first. I use a saber saw with the narrowest, smoothest cutting blade I can get.

Starting from ground, the cove or hollow of the second order is run first. The amount of curvature in the hollow is a matter of choice. The longer I work, the deeper I want the hollows and the narrower I want the lines. The junction of two intersecting hollows cleans out nicely at obtuse angles, but at acute angles, must be worked with a 30-degree parting tool. The depth of the ground from the bottom edge of the hollow is controlled by eye, as is the width of the ledge outlining the top of the hollow. A pencil line makes that control a lot easier, however. Ideally the hollows can be run with clean, curving sweeps of the chisel, with maybe a little careful paring to tidy up the lines. (True joy is also a rare experience.) Where the grain is contrary, I whittle and then pare with the intent of leaving as few tool marks as I can. Straight-shank tools were sufficient for much of the design, but the equivalent long-bent tools would have been easier.

In tracery, the first order is frequently flat-surfaced. In this case I chose to mold and undercut the pattern until it approximated a bead. The bead can be run with straight-shank gouges, but I used a couple of back-bent tools, which simplified the job of rounding the top and sides of the bead. To cut the quirk I used a 1/4-inch 30-degree parting tool, with a small skew at the corners.

Once the overall design has been cleaned up and the acute angles tapered in, the sunken pockets at each of the cusps can be cut. These pockets lighten up the design by thinning the outline on each of the orders. They can be cut in with three strokes if the grain is right. Technical difficulties arise when the grain is very short between the pocket and the hollow. Some woods tend to crumble readily, such as pine and deodar cedar, which I chose for this carving. Oak was traditionally used in England, walnut in France, and basswood in both. Cherry and maple carve cleanly but are harder to work.

The success of this kind of carving depends on the regularity of the lines and shapes. Although machinelike perfection usually looks quite dead, irregular and uneven lines are even less desirable. I avoid using sandpaper because I don't like to sand. I also take an atavistic pride in good clean chisel work, an achievement I can sometimes claim. □

Relief Carving
Traditional methods work best

by Rick Bütz

Relief carving has been around for a very long time. Exactly how long nobody is really certain, although archeologists agree that it predates written history. However, it was not until the 17th and 18th centuries that relief carving reached its peak of technical skill in the West. During this period, woodcarvers created works of such beauty and grace that few can equal today. And yet, despite this technical brilliance, it was only a few generations until the age of machine industry brought this period to an end. Looking back, we can see that the effect of changing priorities was a decline in certain types

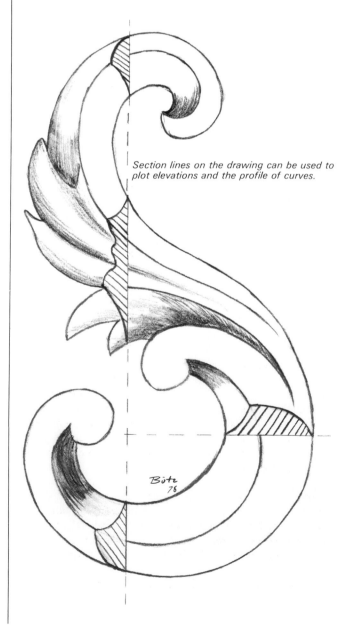

Section lines on the drawing can be used to plot elevations and the profile of curves.

Bütz
78

of knowledge. Skills and methods that were once common knowledge have become, at best, uncommon.

The result is that today many woodworkers might wish to incorporate carving into a furniture design, but they shy away on grounds that it would involve far too much time to be practical. This should not be the case. If a relief carving is approached with a sense of purpose and organization, all the work can be done by hand with surprising speed and efficiency—and considerable pleasure too. Whether the design is contemporary or traditional, a tasteful carving can add richness and depth to any woodworking project.

Loosely defined, relief carving is a method of creating a raised design that appears to stand free of the background. The distance that separates the raised portion from the background determines whether the carving is high relief or shallow relief. In either case, the basic carving steps are always the same. First, the background is carved away and smoothed. This leaves a raised design and a level background. Second, the design is shaped and smoothed. It is important to complete all background carving before doing any work on the free-standing parts of the design. This is not an arbitrary rule, but rather a method that greatly simplifies the work.

In addition, the carving must be well planned out in advance. Not only should the design be clear on paper, but each step of the carving should be carefully thought out and systematically completed before 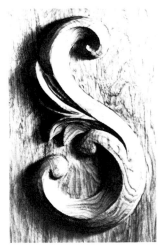 the next is begun. While this may sound overly technical and confining, the creative worker will find instead that such planning allows greater flexibility in shaping the wood. By solving basic problems first, one may concentrate more freely upon the work at hand. Relief carving, if approached in an orderly fashion, will continue to demonstrate that in many cases, handwork is still one of the most efficient ways to shape wood.

Before any carving can begin, it is essential that tools be razor sharp, able to cut cleanly and smoothly. A properly sharpened gouge will leave the wood with smooth polished facets. Correct sharpening is probably the greatest mystery of woodcarving, but it is often an unnecessary stumbling block. In addition to the variety of European and Oriental sharpening methods, we have several generations of Yankee ingenuity to contend with. For example, I know a very good carver who uses half a dozen stones to hone his tools. Another, equally good, sharpens only with sandpaper and spray lubricants. So who is to say what is best?

The reasonable solution is to follow whatever method works best for you without abusing the tools, and the best teacher is experience. One effective method uses only a flat stone of medium grit and a revolving cloth wheel. The gouge is sharpened with a rocking motion on the stone, using plenty of oil, until an even wire burr can be felt along the edge.

Rick Bütz and his wife, Ellen, are professional carvers who live and work in Blue Mountain Lake, N.Y.

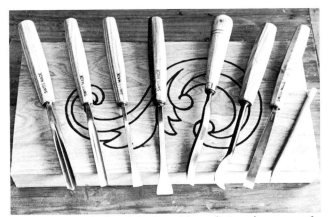

Relief carving tools (from left): V-tool for outlining, three gouges for general shaping, long bent grounder for backgrounds, spoon gouge, and flat or firmer gouge. The blank is butternut, held to the bench by a long screw from underneath.

Next, the bevel is polished on the cloth wheel until the metal burr wears off. This will leave a razor edge. A small amount of buffing compound applied to the cloth will speed the process. A razor edge can be achieved with only a little practice, and the resulting polishing of the cutting bevel to a mirror finish noticeably reduces the friction of the tool as it cuts.

While sharpening is essential, the edge is only a small part of a woodcarving gouge, and many neglect caring for the rest of the tool. A high-quality gouge that fits your hand actually does produce a better carving. I'm not sure whether this is purely a psychological reaction, or if it is because you have better control of a tool that feels comfortable.

Even the best of woodcarving gouges should be carefully checked over for anything that does not feel quite right. It is not unusual for a new tool to have sawdust and splinters embedded in the varnish of the handle. This should be sanded smooth. Also check the metal surfaces of the tool for any rough edges. I am not surprised to find wicked burrs of metal in the brass ferrule on a new handle. These should be filed and sanded smooth, or else some particularly nasty injuries may result.

Many old-timers took the finish right off the handle to prevent blisters and calluses, much on the same principle as stripping an ax handle. The exposed wood was then soaked in oil and wiped clean. The oil not only sealed the wood, but left a porous finish. It also hardened the end grain of the handle as heat was generated by the striking mallet, which helped prevent fraying and splitting.

After the wood has been selected and the design accurately marked out, work can begin. Before cutting into the wood, it is helpful to pause for a few minutes and imagine just how the completed carving will appear. With practice this visualizing will not only help solve problems well in advance, but will also create the feeling that your hands are shaping the wood almost without conscious effort. By fixing the image in your mind, your hands will be guided by subconscious mental processes. This is not a new principle, but rather a means of helping to develop a "woodcarver's instinct." This feeling develops naturally after years of experience. However, a little practice will speed the process considerably.

The design I chose for the photo series that begins on the next page is a traditional variant taken from an old family table. It offers excellent practice in all areas of carving.

1 Outlining The first step in relief carving is to cut around the design with a *V*-tool. Such outlining serves as a starting place for isolating the raised portion of the design from the background. The cut should be made ¼ in. to ⅛ in. out from the edge of the design and must not get too close to any delicate details. These can be shaped later, when there is less chance of damage.

A mallet is often helpful in making the outline cuts, although care must be taken to avoid splinters running into the design. The best way to prevent unwanted splintering is to carve according to the flow of the wood grain. If your tools are sharp and the wood still splinters and tears, try approaching the cut from a different direction.

With a gouge of medium sweep, a series of cuts is made from the waste area toward and meeting the outline cut. This widening of the outline allows enough clearance to trim up the edges of the design. Make the walls of the design vertical by taking a small flat firmer or a gouge whose sweep is similar to the curvature of the design and cutting straight down. This procedure is referred to as "setting-in."

By continually enlarging the outline cut and smoothing down the walls of the design, the background can be sunk as deeply as wanted. A mallet of comfortable weight is helpful in these steps to tap the gouge lightly. However, take care not to drive the point too deeply, or a broken tool can result, especially if the wood is dense. Remember too that up to this point, the raised portion of the design remains untouched. The object of outlining and setting-in is to cut away all wood that will not be included in the raised part of the design.

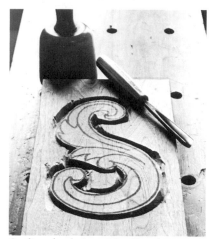
Outline the design with a V-tool.

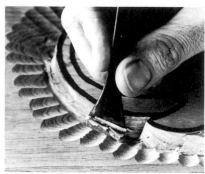
Trim the edges vertical.

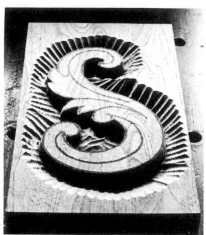
The design is outlined and set in.

2 The background Once the outline of the design has been clearly defined, work can begin on taking down the background waste areas. When this task is approached in an orderly manner, the grounding out can be efficiently completed strictly by hand. While this work can also be done with an electric router, a good professional woodcarver in times past could cut and clear a background in less time than most of us could even set up a power tool.

The best technique for cutting out a background, especially in softer woods, requires a firmer and a mallet, although a shallow #3 or #5 gouge can be used. With these tools a series of parallel cuts is made, one in back of the other. These are spaced in rows about ¼ in. apart and preferably across the grain. By lightly driving the gouge into the waste wood just behind the previous line of cuts, the waste will chip away. Roughing out should be done layer by layer if the background depth is to be very great. But take care not to drive the gouge deeper than necessary, or extra smoothing work will be required.

When the background has been completely roughed out, it is worked smooth using a gouge of fairly shallow sweep. Take care to arrange the smoothing cuts in an esthetically pleasing manner, as they form the finished background. Leveling and smoothing are sometimes easier with a bent gouge called a grounder. It is especially useful where lateral clearance is restricted, although in many cases a regular gouge will work quite well.

However, where working room is really cramped, such as inside a sharp curve, a

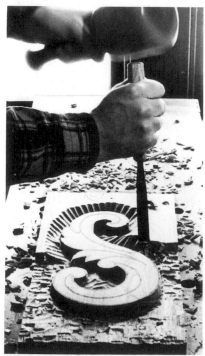
Remove background waste with closely spaced vertical cuts.

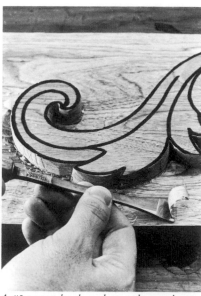
A #5 gouge levels and smooths rough cuts.

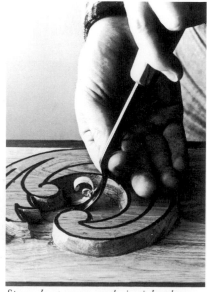
Spoon bent gouge works in tight places.

spoon bent gouge can be indispensable. These tools are available in a great assortment of sweeps and widths, yet they are probably the least used tool in many woodcarving sets. Part of the reason for this is the natural tendency of the spoon shape to be used in a scooping motion, which greatly restricts its usefulness.

Instead, the spoon bent gouge should be positioned at the angle where it just begins to cut. Then, carefully but firmly, it should be drawn across the wood without changing the angle. In effect, this produces the same cut as a long gouge. However, instead of beginning the cut at 15° to 30° to the work, the tool can be held at almost 90° to the work. This allows carving background areas inside deep recesses.

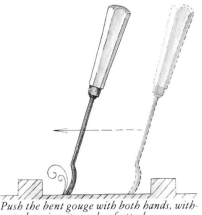

Push the bent gouge with both hands, without changing its angle of attack.

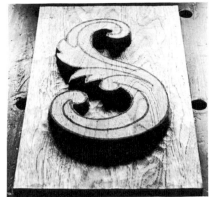

The background is now completed, and modeling can begin.

3 Modeling With the previous steps completed, the raised portion of the carving will stand free and clear from a smooth, level background. The design can now be modeled, first by roughly shaping the contours and then by smoothing the shapes with clean finishing cuts.

The roughing out is best done by carefully making cuts that round off sharp angles from the top downwards. For rough-shaping the outer portions of a curve, use a flat firmer or a gouge of slight sweep. For the inside curves, use a gouge of greater curvature or quicker sweep. This will help prevent unwanted splintering. The lines that form valleys between the leaves can be cut to depth with a V-tool and then rounded smooth.

These roughly shaped surfaces are then finished off with long smooth "sweep" cuts. These final cuts distinguished the professional works of old. This technique is used for finishing both the inside and the outside surfaces of the curves. Begin by steadying the blade of the tool with your left hand. The palm rests firmly upon the surface of the carving. By pushing the tool with the right hand and pivoting on the palm of the left, the edge of the gouge can be made to follow a very well-controlled curve. By experimenting with the point where the left hand pivots, a great variety of arcs can be achieved to follow the curves of most carvings. This requires a bit of prac-

tice, and like all carving techniques should be done with either hand. It is a very useful and satisfying technique.

For inside curves with concave surfaces, a bent or spoon-shaped gouge of considerable sweep is useful. On the other hand, a flat straight gouge can be used for convex, outer curves. Be careful to note changes in the direction of the grain so that the cuts will not be fuzzy, but smooth and polished. This will eliminate the need for smoothing with sandpaper, which should be avoided on any fine woodcarving. Sandpaper destroys the

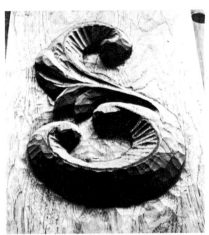

The waste is gone, and finishing cuts can now be made.

tool marks that bear witness to serious handwork, and in an age of some very good plastic imitations, this is a serious consideration. If esthetic considerations require an absolutely smooth surface, then that is a different matter. But never substitute sandpaper for good technique and discipline.

As a final note, in doing any woodcarving, try not to lose your sensitivity to the nature of the wood. If you find yourself fighting the carving, if your tools produce ragged, splintered chips instead of smooth graceful shavings, then something is wrong. Make sure your tools are absolutely sharp, the wood is correct, and that you are working in the proper direction—with the flow of the grain. □

A firmer smooths the outside curves, again with long sweeping cuts.

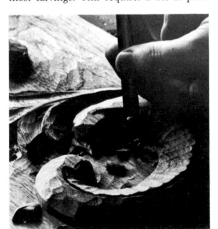

A quick gouge rough-shapes the wood on the inside curves.

Long sweep cuts leave a smooth finish. A bent gouge or spoon gouge may be best for inside curves. The right hand powers the tool, while the edge of the left hand rests firmly on the work.

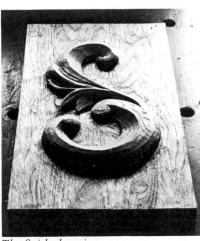

The finished carving.

Carving Fans

Reproductions gain richness, authenticity

by R. E. Bushnell

One characteristic of Queen Anne, Georgian and Chippendale furniture is the use of fans and shells as decoration. These are often found on the central drawers of highboys, lowboys and secretaries, on crests and knees of chairs, and on smaller pieces like mirrors and pipe boxes.

The addition of such carvings can make your reproductions more interesting and add richness and authenticity. Such forms are easy to carve and require only the minimum in tools and equipment.

Described here are the tools required and the procedures to be followed in making the simple convex fan and the more complicated concave-convex fan.

Convex fan

The first step is to lay out the form by drawing a base line on the item to be carved. This is generally 5/8 in. to 1 in. above the bottom of the board. Next, with proper proportion in mind, determine the overall size of the fan and mark the midpoint or center on the base line. From this point draw a half circle with the compass and erect a bisecting perpendicular center line.

Determine the approximate size of the rays desired, and with this as a starting point, use the dividers or compass to mark off the half circle into equal segments, by trial and error. Now, at the midpoint on the base line, draw a second and much smaller half circle. If you are making a drawer, the knob will be located at the center of this circle. Using a ruler, connect the equally divided marks on the outer circle with the midpoint on the base line and draw a line from each mark to the inner circle line.

To start the actual carving, clamp the board to a working surface. Use a jackknife to outline the outer circle, making several passes until the cut is about 1/8 in. deep. Be sure to make these cuts exactly on the circle line. With the parting chisel, start precisely at the inner circle line and follow each ray line to the outer circle. Put considerable downward pressure on the chisel as the outer circle is reached to avoid making nicks or chisel marks beyond that point. Do the same when using the firmer chisel later on. About three passes with the parting chisel should do. If you wander slightly on the first pass, don't worry, as this can be corrected on the succeeding cuts.

If you do not have a parting chisel, you can use the jackknife to cut exactly on the ray lines before making the successive rounding cuts. Further, 1/4-in. and 1/2-in. cabinet chisels can be used in lieu of the 6-mm and 10-mm firmers.

With all the ray lines delineated, start rounding each of the rays with the 1/4-in. or 6-mm firmer chisel. You don't have to worry about grain direction with the two nearly perpendicular rays on each side of the center line because you are carving across the grain. As the rays progress downward, however, the grain direction must be carefully watched: one side of the ray will be carved from the inner to the outer circle; the other side of the same ray will be carved from the outer to the inner circle.

It is easiest to start each cut by inserting the corner of the chisel down to the proper depth with a shearing or slicing cut. Complete the rounding by making successive passes with the

Photo, cross-section drawing show sequential steps in carving of simple convex fan.

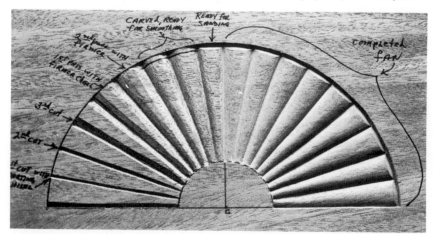

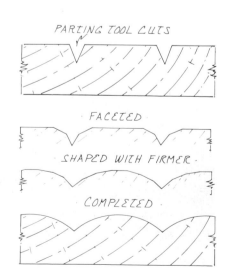

From *Fine Woodworking* magazine (Summer 1977) 7:60-61

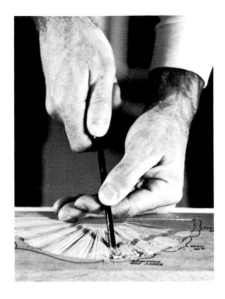

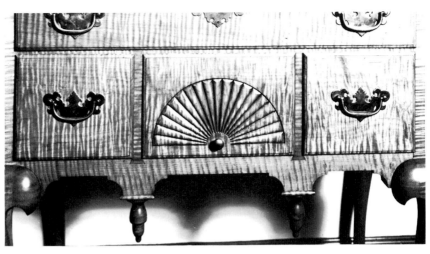

Author uses 6-mm #7 gouge to hollow concave portion of concave-convex fan. Simple convex fan enhances author's reproduction of Queen Anne lowboy, circa 1750.

chisel, each pass progressively less steep than the preceding cut until the form is as round as possible.

Each ray can now be smoothed by lightly scraping with the 1/2-in. or 10-mm chisel. If you own rifflers, these can also be used in the smoothing process.

To finish off the ends of the rays, draw a third circle about 1/8 in. inside the outer circle across the end of each ray. With the 1/2-in. or 10-mm chisel, make a sloping cut from the third to the outer circle. Sand the fan first with 100, then 150, and finally with 220 garnet paper before applying the finish.

Concave-convex fan

Slightly more complicated and time-consuming is the concave-convex fan. This is more than compensated for, however, by the added richness it conveys.

To make this fan we need three more chisels: a 2-mm firmer chisel, a 3-mm veiner and a 6-mm #7 gouge. Unlike carving the simple convex fan, it is not possible to substitute cabinet chisels.

The concave-convex fan is laid out in similar manner to the convex fan except that an odd number of rays is required to make the alternating concave-convex pattern. To accomplish this, determine the approximate size of the rays desired.

Then, by trial and error, use the dividers or compass to mark off the circle into equal segments. Start with the convex center ray, since it must be centered over the perpendicular line.

Carve this fan exactly as the convex fan but incise the outer circle only lightly with the jackknife to delineate the circumference. After the convex portion of the fan is carved, begin carving the concave portion by flattening every other ray. Use the 2-mm firmer chisel at the inner circle, followed by the 6-mm firmer as the rays widen toward the outer circle. Incise the outer circle quite heavily with the jackknife where each of the flattened rays ends.

When all alternate rays are flattened, start hollowing the flattened rays, beginning with the 3-mm veiner, followed by the 6-mm gouge. When cutting the concave portion, leave a shoulder approximately 1/32 in. wide on each side of the convex ray. You should do this by eye only, so work carefully. Be sure to work only with the grain, as the carving can easily be ruined at this point.

Judicious scraping and sanding complete the carving. ☐

Reg Bushnell, before he retired, was in charge of antique restoration at Old Sturbridge Village in Massachusetts.

Concave rays are outlined, flattened and hollowed after the convex portion has been carved.

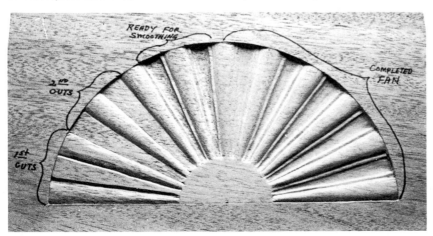

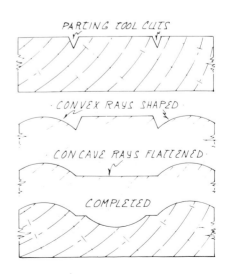

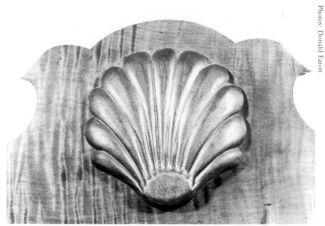

The convex Goddard shell, with alternately concave and convex rays, is found on block-front desks, secretaries and bureaus.

This shell with convex rays, the simplest example of the form, is from a large Chippendale mirror, c. 1770.

Carved Shells

Undulating motif enhances Chippendale reproductions

by R. E. Bushnell

A beginning carver is often intimidated by the apparent complexity of shell carvings on heirloom furniture. But the layout and carving are quite straightforward, and proceed easily from carving the simple fan (see the preceding article). Shells require a few more tools as well as a little more time and effort.

Whether the rays of a fan are all convex, or alternately concave and convex, the carving remains basically flat. Carved shells, on the other hand, represent natural seashells and the carving must take on depth to follow shapes and forms one might find at the shore.

The concave form represents the inner side of a shell, while the convex portrays the outer part. It follows that shells are carved on a convex or a concave surface, with the ray delineations generally following those found on the fans. Convex forms are usually carved on a separate piece of wood, which is then glued to the furniture. Concave forms, and combinations of concave and convex, are nearly always carved into the furniture itself.

You will find as you progress in carving that having a "good eye" to visualize various shapes and forms is essential. As skill and experience develop, so does that "good eye."

Carved fans are absolutely geometrical and designing them requires only a good pair of dividers and a ruler. But shells are nongeometrical, with flowing lines that require freehand drawing. It becomes necessary to visualize the form of the finished product before actual carving starts. When designing a shell form, I have found the easiest method is first to make a rough sketch. From that I make a full-sized layout, first drawing in the left-hand side, then matching on the right with dividers or a carbon-paper tracing.

A complex shell of the Philadelphia Chippendale school, although it looks ornate and difficult, is really quite simple to carve. The design is started by drawing a bulbous or elongated circle on a center line. Within this outline draw the small inner shell, which is convex and has both concave and convex rays. At the base, delineate a circle within which the drawer knob will eventually go. Surround this with several simple leaf forms. If you choose to carve vines around the entire shell, the base of the vines will also begin here.

The convex inner shell and leaf forms are raised ¼ in. above the remainder of the drawer front. This can be done by lowering the groundwork with a router or carving chisels, or by the easier method of appying this entire area to the drawer front. Since the Colonial carvers usually glued on the extra thickness, I've used this method in our example, although the crossed grain adds the risk of delamination with humidity

Chippendale shell layout: Design outline is traced onto drawer front with carbon paper; center line orients pattern.

Raised portion—inner shell, leaf and vine motifs—is jigsawn from ¼-in. stock and glued in place.

From *Fine Woodworking* magazine (March 1979) 15:76-77

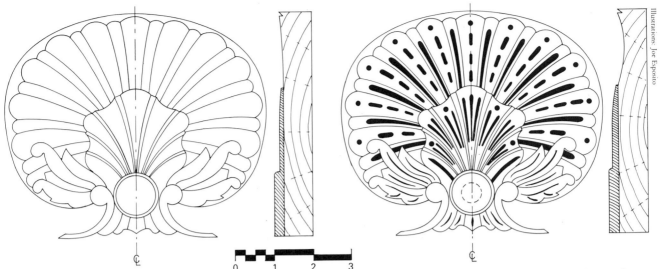

For a full-sized shell layout, draw half of shell free-hand; duplicate on the other side with dividers or carbon paper.

Side views show depth of cuts. Completed drawing locates drawer knob; dark markings indicate holes and hollows.

changes. A good finish is the answer.

With carbon paper, trace the design onto the drawer front. By the same method, trace the area of the convex shell, leaf designs and vine appendages on ¼-in. stock. Jigsaw to shape, file and sand all edges smooth. Now glue the raised portion onto the drawer front.

Start the carving at the base of the inner shell by lowering the surface approximately ¹⁄₁₆ in. with 6-mm parting and firmer chisels. The entire inner shell is then made convex using a firmer chisel, leaving the outer edges ¹⁄₁₆ in. above the surrounding surface.

Delineate the base circle and lower the inner portion about ³⁄₃₂ in. Again use the parting and firmer chisels to carve the leaf forms, which slope toward the base.

The scalloped edges are delineated by using a 26-mm #7 gouge for the large rays, and a 10-mm #7 gouge for the small rays. Hold the gouge vertical and press downward. Cut down the extreme outer portion with a 12-mm #5 gouge, taking care that you follow exactly the shell outline, which is taken down ⅛ in. at the scalloped edges.

Now, use a 20-mm #5 gouge to make the outer shell concave. The outside edge is left at its original height, the inner portion taken down ⅛ in.

Next, draw in the ray lines from the design. With a parting chisel or a jackknife, follow each line outward to delineate the convex rays. About three passes should do. Then round the rays with a small firmer chisel. Grain direction is not a problem on the nearly perpendicular rays at the center of the

shell, but it will affect the direction of the cut on the rays on either side. Smoothing is done with a ½-in. or 10-mm chisel, or with rifflers. The small rays in the outer shell are flattened with a firmer chisel and their outer ends should finish ¹⁄₁₆ in. high.

The inner shell rays are alternately concave and convex. Delineate them with the jackknife or parting chisel, round the convex rays with a small firmer, flatten the concave rays and work them hollow with a small veiner and gouges. Leave a shoulder about ¹⁄₃₂ in. wide on each side of the concave rays. The inner shell is carved so that both the convex and concave rays end up ¹⁄₁₆ in. above the outer surface. Scrape and sand all surfaces, then mark the location of the details that will complete the fan. These are the dark portions of the drawing above right.

The small holes at the extremities of the rays are made with a 3-mm veiner and located about ¼ in. from the outside edges. Hold the veiner upright and simply turn it around to release a little circle of wood. Holes on the inner shell are located on the concave rays, those on the outer shell on the convex rays.

The 3-mm veiner is also used to cut the three spaced dash-type hollows on all the convex outer rays, as well as the concave hollows in the narrow flattened rays. A 2-mm veiner is best for detailing the rays of the inner shell and the veins of the leaf forms. □

Reg Bushnell, now retired, was formerly in charge of furniture restoration at Old Sturbridge (Mass.) Village.

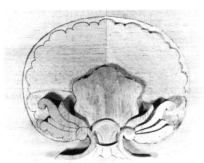

Inner shell is made convex, then base circle is lowered and leaf forms are carved. Gouge delineates scalloped shell edges.

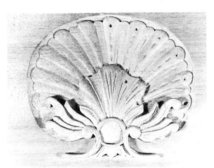

Outer shell is made concave, then rays are outlined and carved. After the piece has been scraped and sanded, a veiner cuts holes and hollows on rays.

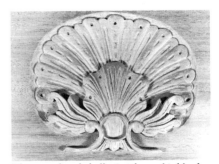

The completed shell, simple yet highly decorative, will do justice to the finest Chippendale highboy or lowboy reproduction.

Cockleshell
Giant carving gives corner cupboard class

by Franklin H. Gottshall

The beauty of a corner cupboard can be greatly enhanced by incorporating a hand-carved cockleshell in the design. Such a shell is sure to be a show stealer, and from this standpoint alone it is worth all the effort it takes to make.

It took me two weeks to build and carve the shell shown, which measures 34 in. across on the inside at the base. Some storage space is lost on the shelf where the shell is put, but the great amount of interest it imparts more than compensates for the loss.

I designed this cupboard to be as high, wide and deep as possible, in order to have maximum storage space. This permitted me to put in such a large shell. I was fortunate to find a 2-in. plank of California sugar pine 22 in. wide and 16 ft. long at the lumberyard. Others may not be able to duplicate my good fortune and will have to glue several planks together to achieve the required widths.

The layers needed to build the shell up to height can be bandsawn out of glued-up segments. Ten semicircular layers were required to build up this shell. The table gives the sizes I

Hand-carved cockleshell enhances large corner cupboard.

cut. Smaller shells would, of course, require less material. With proper planning there is very little waste.

When the layers have all been sawn to shape, they should be joined together on the outside of the arc with glue and wood screws. I used 2½-in. #14 flathead screws and countersunk the heads.

It is important to be careful when drilling holes for these screws so there is no danger of cutting into the screws when carving or smoothing up the inside of the shell. Arrow A in the diagram at the top of the next page points at the line to which waste must be trimmed. The dotted lines on layers 8 and 9 show the waste formed on the inside of the shell by stacking the layers. This waste must be removed. A cardboard template with a 17-in. radius curve may be used to help you do this smoothing properly.

Before you start to carve, glue a facing board to the front of the shell. This ensures a flat surface, while hiding the glue lines and other imperfections. Notice the direction of the grain on the facing board. A 45° angle cut on both ends of the top of the board positions the shell easily for carving.

Start smoothing the inside of the shell with wide gouges. Finish with sharp scraper blades and garnet paper. Use coarse-grit garnet paper first, and finish up with finer grit paper until the surface is completely smooth.

The broken line B shown in the top diagram is one of several you should draw to help you space the widths of grooves and fillets uniformly. The shell shown has 19 grooves. You can make more or fewer, but I advise making an odd number. First draw center lines where each groove is to go, making the first up the center of the shell. Then you can draw border lines for each groove and fillet. There is no great harm if a fillet at the bottom of the shell is a little wider or narrower than the others, but the grooves should all be the same width. A cardboard template helps lay out these lines.

Because it will be difficult to space grooves and fillets close together near the bottom, it is better to use another design here to fill this small area, as I did on my shell.

When all the carving and smoothing has been done on the inside, you are ready to cut the molding around the scalloped edge on the front of the shell. I cut mine with a router.

Put as many coats of finish on the outside of the shell as you put on the inside. This prevents unequal drying, which causes checking or splitting. This should be done before fastening the shell into the cupboard. I used several coats of spar varnish on the back of the shell. The inside was finished with pale green latex paint. I anchored this shell by screwing the outside of the bottom layer into the back of the shelf, and the top into the top of the cupboard. □

Franklin Gottshall, of Boyertown, Pa., a retired industrial arts teacher, has written numerous books on furniture making, woodcarving, design and crafts.

From *Fine Woodworking* magazine (September 1978) 12:74-75

Dimensions of each layer

No.	Inside	Outside
1	17"	20"
2	16¾"	19¾"
3	16½"	19¼"
4	15¾"	18½"
5	14¾"	17½"
6	13½"	17"
7	11⅞"	16"
8	9½"	14"
9	5¾"	12"
10	Do not bandsaw inside.	10"

Table above gives inside and outside radii for laying out ten semicircular layers, numbered from bottom of shell to top. If a board wide enough for the largest layer cannot be obtained, several planks can be glued together to get the necessary width. Several layers can be bandsawn on the same segment of board to minimize waste. In the diagram below, the first, sixth and ninth layers have been nestled on a segment made by gluing three boards together edge to edge.

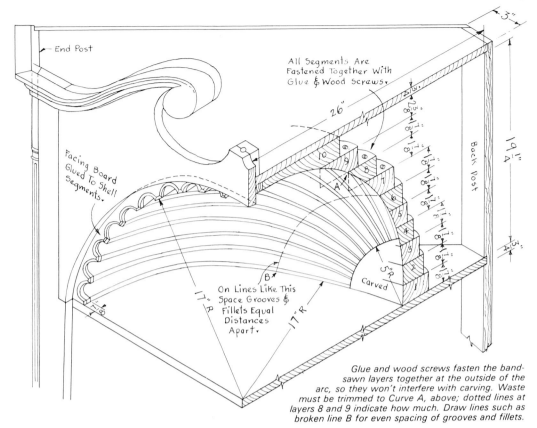

Glue and wood screws fasten the bandsawn layers together at the outside of the arc, so they won't interfere with carving. Waste must be trimmed to Curve A, above; dotted lines at layers 8 and 9 indicate how much. Draw lines such as broken line B for even spacing of grooves and fillets.

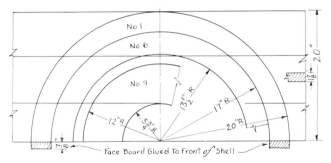

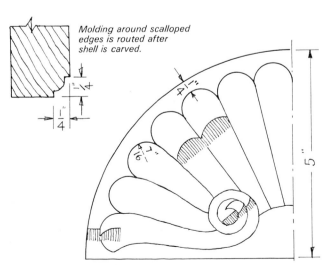

Molding around scalloped edges is routed after shell is carved.

Small shell-and-volute design, above, fills semicircle at shell bottom. Right, angle-cut faceboard steadies shell as Gottshall carves grooves.

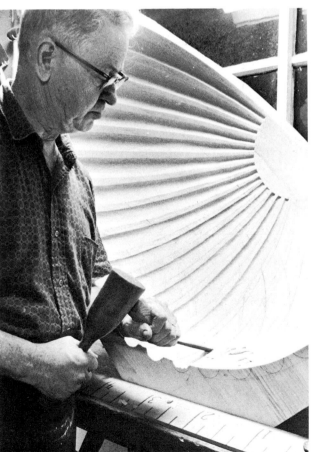

Carved Signs
Freehand lettering with the Murphy knife

by Roger Schroeder

Close to 200 of Paul McCarthy's signs adorn homes and proclaim businesses in the seaside town of Scituate, Mass. A 3-ft. wide carved clamshell hangs in front of a custom-framing shop; a jewelry store's sign features a wooden, in-the-round black pot overflowing with carved gems, and quarterboards with incised gold-leaf lettering are everywhere. Though originally mounted on a ship's transom beneath the quarterdeck, quarterboards have become popular on land, where they are most often applied directly to the side of a building, usually above a door. Apart from being a prolific carver (his shop produces about 40 hand-carved signs in a week), McCarthy is a teacher and conducts four classes a week, with 15 or 20 students in each.

McCarthy's lettering is done without templates or patterns, and also without a lot of carving tools. His primary tool, aside from a fishtail gouge, is the Murphy knife, named after the manufacturer in Ayer, Mass. This tool consists of a handle through which slides a high-carbon, chrome-vanadium steel blade. The blade itself ends not in a point, but a double-beveled skew. A setscrew allows for a variety of blade-length adjustments, and the cutting tip can be ground to different shapes. Whereas incised lettering has traditionally been carved using a variety of tools (see pages 43-45), including straight chisels, gouges and V-tools, McCarthy uses only this knife. "Most books tell you to get a tool that fits each curve," he points out. "Well, if I had to have a tool that fit each curve in an italic S with serifs, I'd have to use five different tools." Many other sign carvers use a router, which, McCarthy says, he can beat if you include the time spent setting up the templates. In a matter of minutes he will freehand the letters to be carved using only parallel lines and a homemade bevel (two 1x1s joined with a wing nut). He can carve an eight-letter quarterboard in 20 minutes or less, whether the letters are Roman or italic.

McCarthy cuts into the letter using the point, not the flat, of the knife. Practice is needed, he will tell you, to establish the angle and depth of the cut. Starting inside the outline of the letter, especially if more than one pass is needed, as with large letters, he draws his entire arm down, with the back of his hand resting on the board. He advises choking up on the

knife, avoiding excessive pressure on the back of the hand. To cut the opposite side of a curve or straight line, he turns his hand over and follows the same procedure. For a large letter, the first incisions will take out waste wood in the center. The serifs require no other tool, for the Murphy knife naturally follows the tightest curves.

The advantages of the knife are clear. Not only can it adapt to any kind of lettering style, but it also slices wood as opposed to crushing or splintering it. The problem with the V-parting tool, often used for cutting the channel in a letter, is that it has two cutting edges. While one may go with the grain, the other will go against it. Aware of this, McCarthy deals with wood grain as though it were the wind, and he follows it to get around curves.

As a boy, McCarthy loved whittling and he liked nautical art. All this led to his profession, which has now spanned over a decade. In that time McCarthy has taught some thousand students and has carved an estimated 16,000 pieces that include birds, quarterboards and elaborate signs. Aside from making what is probably the largest quarterboard in the country, for the U.S.S. Constitution Museum in Boston, he has carved an American eagle that stands 8 ft. high and has a wingspan of 13 ft. It is styled after the figurehead made by New England shipcarver John Bellamy in 1880 for the U.S.S. Lancaster. McCarthy's eagle lives in his shop.

Calls for his work come from all over the country, and a personalized sign that may have relief or in-the-round carving is his specialty. "I'm not a supreme artist," he says, "I want people to participate in the designs." So he is careful to get as much input from a customer as he can. First he might ask where the sign is to be hung. Then he will inquire about the kind of house the customer owns, its color, its landscaping. He will refuse a commission if he thinks a carved piece is inappropriate to its surroundings.

Sketching in front of a customer, McCarthy looks for what he calls a glint of satisfaction. Once found, he elaborates on the design. His interest in the customer's approval extends beyond the date of delivery, and he will repair signs that might get damaged. "It's always my sign, no matter how much a customer spends," he says. And he gets a lot of repeat business, especially from people who give his signs as gifts. Most people want quarterboards, which McCarthy believes to be "visible and in good taste, without being showy." Some

Roger Schroeder, of Amityville, N.Y., is a woodworker and author of How to Carve Wildfowl *(Stackpole Books, 1984).*

Quarterboards like this one are everywhere in Scituate.

Originally meant for ships, they now adorn buildings.

From *Fine Woodworking* magazine (September 1981) 30:64-66

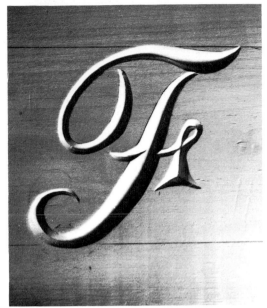

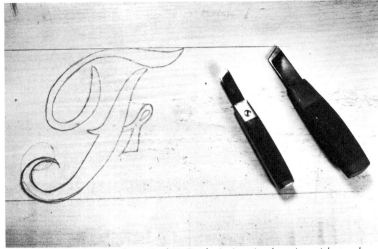

Using only these knives, above, Paul McCarthy incises sign lettering with speed and accuracy. The tips of both knives are ground to about 45° and have a bevel on both sides. The finished letter, left, shows none of the transition marks caused by using several different gouges for different parts of the curve. For results like this, the knife must be kept razor-sharp with frequent honings.

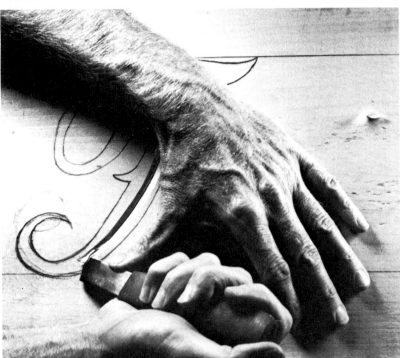

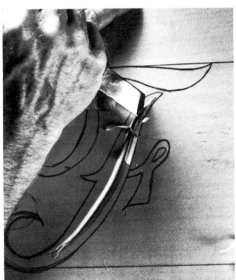

Carving begins (photo, left) by making a narrow V-trough down the stem of the letter. Back of right hand rests on work for downward strokes; thumb of left hand helps guide and power the cut. For upward strokes (photo, right), right hand is held off the work surface; thumb of left hand still provides guidance and force at the back of the blade.

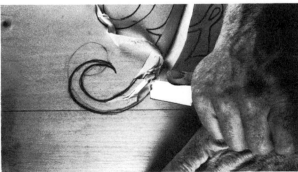

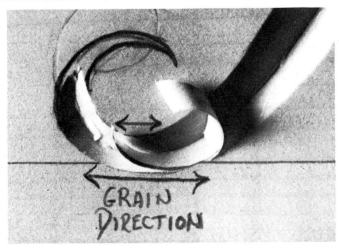

The trough is gradually enlarged with successive cuts, each taking a thin shaving, to keep the knife from digging in. Above, a final cut forms the finished wall of the mid-section of the stem. In tight curves (photo, right), direction of cut must be changed often to avoid going against the grain and tearing the wood. This is what McCarthy means by "following the grain like the wind."

GRAIN DIRECTION

Made for a Scituate restaurant, sign at right sports a carved lobster and clams in-the-round. The incised lettering and little shell at top are gold-leafed. Sign at left was made for the same restaurant.

customers like double-sided signs. One he made for a liquor store in Scituate Harbor has a wine cask with the merchant's name on either side. To save a customer's money, he suggests that one side should be elaborate, the opposite side simple, perhaps with only a monogram.

Once a design is settled on, whether a simple quarterboard or a relief of a lowboy, the wood is cut to shape and assembled with resorcinol glue. His large signs are almost always made from 8/4 Eastern white pine, while quarterboards are 4/4 pine. He doesn't use rods or dowels for the big signs, which are usually steel-banded by a local blacksmith.

McCarthy's signs get two primer coats and three coats of color. He finds lead-base paints the best. "They cover well, they are durable, they don't lose their color and they stay bright," he notes. But the most outstanding aspect of his signs is his gold-leafing. Gold leaf not only gives brilliance to lettering or carving, but it also lasts some thirty years out-of-doors. A gold-leaf sizing, which is an adhesive base, is applied after the primer and color are painted onto a smooth surface. He uses a sizing that has a slow drying time, and he will wait as long as 24 hours before applying gold leaf, depending on humidity and temperature. "If the sizing is too

wet, the gold leaf will dissolve. If it's too dry, it won't stick." So he listens for a squeaky tackiness as he rubs a finger over the sizing, and then he applies a sheet of gold leaf over the area and tamps it with a sign-writer's quill.

Some of his signs are entirely gold-leafed. The shell for the custom-framing shop is done in gold leaf, as are the scales of justice he made for a local lawyer. When asked why he doesn't use gold paint, McCarthy says that even the best will tarnish out-of-doors or turn brown. The only problem with gilded signs is that they do accumulate dirt and road pitch, especially if near a highway. McCarthy suggests cleaning dirty gold leaf with muriatic acid. He warns that varnish should not be applied over gold leaf as it will, owing to the degrading effects of sunlight, lift the gold from the sign.

When not carving, McCarthy is teaching. His youngest student is eleven years old. But regardless of age, they all start with quarterboards. Given blanks, students are taught immediately to use the Murphy knife, beginning with straight lines. McCarthy says quarterboards are easy to master and don't take up much room. After quarterboards, students have their choice of projects. At one class, students were doing signs, relief carving, gunstocks, caricatures, mantelpiece ships, animals and birds.

Some of McCarthy's students have gone off to start their own sign-carving businesses. Of competition he says, "I'm not afraid of it. It's a way of keeping woodcarving going." □

EDITOR'S NOTE: You can purchase gold leaf from well-stocked artist-supply stores or from Constantine's, 2050 Eastchester Rd., Bronx, N.Y. 10461. Murphy knives, also called general-purpose knives or mill knives, are available from most mail-order tool-supply stores.

Incised Lettering

Speed and boldness are better than puttering

by Sam Bush

Carving incised lettering is a valuable skill in the repertoire of a professional woodworker and also an instructive practice for the beginner. Its decorative effect has many applications, and its visual appeal is universal. Incised letters are the opposite of relief and are cut directly into the wood without using a router—it's actually a form of chip carving.

Those wishing to take up the work need only a small collection of chisels, a mallet, a pencil and a good piece of wood. The tools used on the sign shown here were a ½-in. and 1-in. #1 firmer chisel; a ¾-in. #3; a ¾-in. #4; a ¾-in. #5 and a ½-in. #5 fishtail; a ½-in. #6; a ⅜-in. #10; and a *V*-tool. Starting out, you'll need a *V*-tool and several sizes of flats (firmers). From there, you will want two sizes each of #3, 4, 5 and 6, say ⅜ in. or ¾ in., and one each of #7, 8, 9 and 10, in various widths. The quicker gouges are not much called for in incised lettering, yet the occasion will come along when they are just what is needed.

It is difficult to propose a truly all-purpose set. I favor buying tools individually right from the start. Quality rather than quantity is essential; nothing is worse than the poor steel and awful handles that come in cheap sets. Learning to carve with a few tools stretches the carver's imagination and ability. A great collection of chisels is usually built up gradually.

Letter design can vary widely, but almost always has to be drawn out for each job. Therefore, good models should be studied. As reference books, I particularly recommend *Writing and Illuminating and Lettering* by Edward Johnson (Pitman Publishers Ltd., 39 Parker St., London WC2 B-5Pb, England), *Italic Calligraphy and Handwriting* by Lloyd Reynolds (Pentalic Corp., 132 W. 22nd St., New York, N.Y. 10011) and *History and Technique of Lettering* by Alexander Nesbitt (Dover Publications, Inc., 180 Varick St., New York, N.Y. 10014). These authors are well-known designers and teachers; their information is helpful for relief carving as well as incised carving projects. Frequently, popular graphics can be imitated, and draftsman's transfer letters are often good.

Sharp, accurate work all the way through will ensure success in incised carving, even on the first try. Speed and boldness are actually an advantage—one sure hit produces a better surface than lots of puttering. The letters in the sign shown took me about ten minutes each to carve.

1 For this sign I used roman capitals and italics. It looks both formal and informal, the proper accent. I started with the board sized up, and sketched in with a broad pencil. This was traced for a better outline, and then in several copies on the drafting board, worked up into a well-proportioned drawing. This was a process of constant, gradual correction. In these tracings, as well as laying out on the wood, sharp, accurate lines are essential.

The wood to be carved should be as straight-grained as possible, so as to be predictable. Radial grain is excellent (this is quartersawn red oak) and can be relied upon not to warp outdoors. The board should be fully planed and scraped before carving; it should not be sanded, however, because the abrasive left in the pores of the wood will dull the tools.

Photos: James K. Taylor

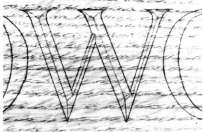

2 The side surfaces of incised letters slant down at a uniform angle to meet in the middle of the letter width. A center line drawn on the wood may give the idea.

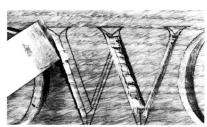

3 A sharp chisel is held on the line, on an angle, and hit with the mallet. Cut alternate sides, at a constant angle, until they meet cleanly at the center. One or two taps with the mallet will be sufficient. The cut chips should fall out; prying with the chisel destroys the top edge of the letter.

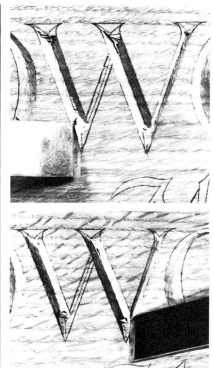

4 At the corners the chisel must be held out to avoid damaging the intersecting wall. All sides slant in. Misjudging this is a common difficulty.

From *Fine Woodworking* magazine (January 1979) 14:66-68

5 It is important to master the stop cut. The breakout from the wedging chisel must be anticipated by a cut on the other side to avoid losing something you want. The center arrow shows where the tip of the wood inside the letter has broken off. This time it was moved by the back of the chisel, because it was weaker than the ground I was lifting. The other arrows show other danger points. Glue is indeed the woodcarver's best friend.

7 An *E* is carved in the same way. The slant of the letter sides remains constant throughout the alphabet. I invariably establish this angle by eye alone, but here measured it for the reader's reference: 38° off horizontal. Using the largest chisel practical promotes straight surfaces.

10 Carving the bottom serif requires the #5, as before. I carve the serif curve against the grain, from the main shaft of the letter out. This is easier to control and generally leaves an excellent surface. I carve the other way as well in difficult grain, but it's harder to see where I'm going.

8 I find carving parallel to the grain much harder than across. The chisel quickly runs into the wood, so it is especially important to watch grain direction and pressure.

6 The serifs are dramatic, being curved, and relatively easy to carve. Here, a medium #5 tool is used upside-down, one corner on the center of the existing *V* and the other near the desired point of the letter. A similar cut is made on the other side using a #6, as dictated by the design. A cut across the end with a small flat, and most of the work is done.

9 Taking the letter down all around reveals that the narrow areas are not as deep as the wide areas. Therefore the horizontals of this *E* intersect only the upper side wall of the vertical. The center lines of the two parts do not meet. This makes for some conceptual difficulty, but is quickly learned.

11 The big flat cuts out the end wall. Take care to be out of the wood on the left while on the same angle as the existing bottom of the letter. The rest of the cleanup is done by hand. Cutting with the mallet has worked the letter almost to the bottom, so that only a few bits and shavings remain. These can be cut out without the mallet, with a smooth push on the chisel or an occasional tap with the open palm. Generally, the hand holding the chisel grasps low on the steel, in an overhand position, leaving the handle exposed. There is more control this way, because the guide is closer to the cutting edge. This holds true while malleting as well. The wrist and perhaps the forearm of the hand holding the tool should rest firmly on the wood.

Another technique that is useful in cleaning up, especially on long, straight sections, is tipping the chisel up onto one corner and pulling it toward you like a knife. In any event, take care to keep the back of the chisel lying tightly on the side of the letter already carved.

12 Curved letters are carved in the same way, using curved tools. Holding the chisel upside-down on the inside takes some getting used to, and on the outside your chisel angle has to take into account the sharpening bevel.

13 It is helpful to carve pushing with the grain, as indicated by the arrows, particularly when cleaning up the inevitable gouge ridges. The letter sides should be flat, or slightly concave.

14 The sides commonly become a series of chisel cuts, or rounded over, rather than a flat plane. This problem is avoided by keeping the back of the chisel tightly against the work and overlapping the cuts. This way, the chisel is self-jigging.

15 It takes four cuts to shape and clean the serif area. The delicate point can be accentuated, because there will be a little loss in sanding. The letters themselves should never be sanded, because sandpaper would destroy the crispness and fill the grain. Surface sanding of the finished sign sharpens up the letter outlines considerably. Sometimes a cabinet scraper can be used as well. I do not recommend planing, however, because I think it takes off too much of the wood and the letters.

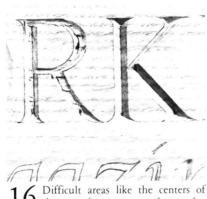

16 Difficult areas like the centers of these two letters are merely complex intersections of flat planes. Much imagination is required, but if the constant angle is maintained, everything gradually falls into place.

17 On small letters in soft woods, the *V*-tool can be used exclusively. In this job I used it just for hairlines, as in this *Z*. I don't favor its use in cleaning up big letters because it leaves a slightly rounded bottom that detracts from the crisp look. In any event, it should be kept very sharp, because one side of the tool is always cutting against the grain.

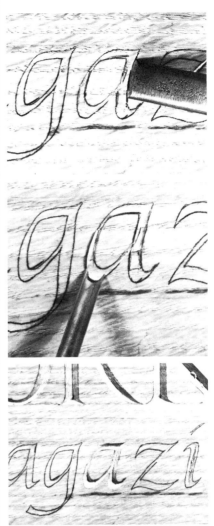

18 The chisels for the italics are selected carefully to closely match the tracing lines. The sides are worked down in the conventional way until they meet in the middle.

19 I find this #5 fishtail very handy on little letters. A brass brush with fine wires is also helpful in removing the last shavings that hang in the carving. □

Sam Bush runs a specialty woodwork business in Portland and is head of the Guild of Oregon Woodworkers.

Routed Signs
Overhead projector transfers layout to prepared wood

by Frederick Wilbur

No one can deny the need for signs, yet billboards and neon have become synonymous with a cluttered, hypermobile society. Signs routed in wood look better and also advertise effectively. They can even work well for traffic control, although this use is limited. One might argue that wooden signs weather badly and are therefore not as economical as metal or neon signs, but I beg to differ. If the correct woods are used, wooden signs become more attractive as they age. Painted signs fade, blister and become an eyesore, and neon signs get the mean jitters, then die. And there is nothing worse than a sign that is crooked, missing letters or in need of repair.

Sample routed sign displays various raised and inset lettering, carving and border designs.

Photos: Rich Wilbur

Redwood, white cedar and cypress are most commonly used for exterior signs because they weather well and resist cupping, checking and mildew staining. I prefer redwood, endangered as it is, because it routs and carves well and is readily available. All three woods are soft and will split easily, but redwood is more often denser and is clear of knots. An interior sign can be of any hardwood, provided it is treated like a piece of furniture to allow for the inherent movement of wood. Though these woods are expensive, one must overbuild exterior signs, especially those which intend to be authoritative. Three years of making ski-resort signs have taught me that such signs are abused and need to be replaced periodically. An attractive sign may even be stolen by some appreciative soul. Consequently I make nearly all my exterior signs from 2-in. stock.

The letters and logos of wooden signs can either be routed out or raised by routing out the background. The edges of the sign can be beveled, molded or enclosed in a frame. Letters or logos can also be applied to signs—they are bandsawn from marine plywood, sealed and painted, and applied to a variety of backgrounds, such as textured plywood or cedar siding. I use plastic pipe cut into ½-in. lengths for spacers.

I countersink a screw through the letter, through the spacer and into the background, and use plastic wood to hide the screws. The letters have to be repainted from time to time, and raw plywood edges, including the backing for applied siding, must be covered by a frame or (less desirable) flashing. Remember also that a large sign is subject to a lot of wind pressure. Brace it as necessary and use stout uprights.

For esthetic and practical reasons, I design my signs with wide margins. If clients want 4-in. high letters, I warn them that the sign will be bigger than they think. On the other hand, I discourage 1-in. letters because they aren't easily read and are harder to rout. When I don't use a frame, I often rout a simple border around the sign to set the letters off from the background of telephone poles or other clutter.

Sign joinery is relatively basic: edge joining, mitering and mortise and tenon framing. Design embellishments can produce complicated moldings and peculiar outlines, but more often than not, the beginner's apprehensions concern the layout and the "time-honored secrets" of calligraphy, not the woodworking. Basic skill in design and some knowledge of typefaces are necessary, but laborious hours with pen and ink are not. Architectural stick-on letters are available (Letraset, Artype and Formatt are common brands at art supply houses) in dozens of styles and sizes. Using these letters, my own designs and a few parallel lines, I mock-up my sign on a small piece of plastic film. Then I transfer my layout onto the prepared wood with an overhead projector. For economy I sometimes use letters of the same size to lay out an entire sign, even though some lines will end up smaller. I simply readjust the position of the projector for each line. With this method, one does not have to draw letters by hand on a gigantic piece of paper or manipulate small sheets of carbon paper numerous times (and what happens when four of the same sign are to be produced?). Another advantage of this technique is that the entire design can be made in miniature in minutes, easily revised and then projected to any size. Even small logos or artwork from letterheads or other printed matter can be traced directly onto the plastic film, then blown up to size. The versatility of this technique is amazing.

I move the projector backward or forward to get an idea of how big the letters can be while still leaving appropriate margins. When I have the projection about where I want it, I draw a line on the wood parallel to the top edge and touching most of the bottoms of the letters in the top line, to make sure the line of letters is straight on the board. When everything is ready, I trace the image onto the wood. If the sign is large or the wood is dark, I use tape, which is more readily seen, instead of a pencil line. Make sure the vertical members

Architectural letters, left, available in a wide variety of typefaces and sizes, are easily transferred to transparent plastic sheets, right.

From *Fine Woodworking* magazine (March 1979) 15:72-73

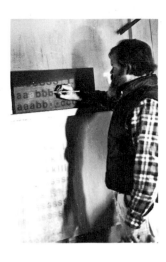

Left, Wilbur traces image cast by overhead projector directly onto the wood, then routs out sample letters, above. The heels of the hands rest firmly on the wood to guide the router through each letter. Some of his finished signs are shown at right.

are perpendicular to the baseline by using a try square. The remaining parts of letters are drawn freehand.

Up to now the process has been mechanical, but the free-hand routing that follows is the critical step because unlike the projecting, tracing and aligning, it is indelible. Patience and practice make letter-perfect signs. You may ask, why not use commercially available templates? I began on a $1,200 machine using different-sized templates and could produce a number of the same sign rapidly, but they were inferior signs. The letters were poorly spaced, stilted and, because there was little room for innovation, boring. For what I want to produce, template routing is out of the question.

One soon devises a system to rout each letter that takes into consideration the properties of the piece of wood. The most difficult letters to rout are *e* and *o*. The lower curve of the *e* has to be balanced with the rest of the letter, and making the *o* symmetrical can be tricky. The letter *s* is comparatively easy. It is best to do the verticals first, then the curves. Once a letter is begun, rout from the open space into the wood. Working the other way, breaking into the open space from the wood, will chip the points off the letter. Make several passes to get the width of the letter or to straighten a line before proceeding to the remaining parts of the letter. I usually don't outline the entire letter, except on large (4-in.) letters. I use a ⅛-in. straight bit for letters less than 3½ in. high and a ¼-in. straight bit for anything larger, because the smaller the bit the squarer the letter appears (which is desirable for a squarish typeface). I rout to a depth of ¼ in. in a single pass, which allows for sanding and ease in painting. I have found that the best router for this kind of work is the 1½-hp Black and Decker Cyclone 1 because it is compact and has an on-off switch instead of a trigger switch. Its pear-shaped handles mounted low on the cylinder allow the heels of my hands to rest on the work. I start the router, then lower it into the letter, lifting it only to go to another letter.

Sand and assemble the sign and it's ready to be stained or painted. Because redwood turns a silvery-grey, I usually use Cabot's Bleaching Oil 0241 for the entire sign, and flat black enamel for the letters. Contact Cabot's at 1 Union St., Boston, Mass. 02108 for a local distributor; the cost of the oil varies from region to region. I pay about $15 a gallon. I also use either solid or semi-transparent stains for logos and artwork. Though there are occasional instances when bright enamel colors are needed to highlight a design, I don't like to use them. I have not yet experienced flaking or peeling when

1 *Tips on routing letters: Rout the vertical members first, then the horizontals.*

2 *To rout an acute angle, do one leg completely, then rout head-on into the angle.*

3 *Outline the curved parts of the e then do the horizontal section.*

4 *First outline the inner part of the o. Then work outwards.*

I've used several coats of enamel. To preserve the grain of the wood, I've also used a thin coat of sanding sealer instead of the oil. I don't use varnish at all. For directional signs I use either black or white reflective liquid, available from 3M (3M Center, St. Paul, Minn. 55101) through local distributors at nearly $50 for a 5-lb. can (all 1979 prices).

Frames and moldings should not be put on the sign until tracing, routing and sanding of the flat part are completed. The signmaker should instruct the client to mount or install the sign with galvanized or aluminum fasteners, because regular nails and bolts bleed. If lag bolts are used, the hole through the sign should be somewhat overlarge to allow for wood movement.

The endless possibilities in calligraphy, design and also technique are most satisfying. Though the majority of the routing is two-dimensional, sculptural effects can also be achieved by routing a design in different levels, rounding with gouge and sandpaper. This is not authentic woodcarving, but for signs it is practical and legible. I enjoy doing this "public" woodworking—it is informative, pleasing and serves as an advertisement for itself. □

Fred Wilbur, a freelance writer and ex-teacher, owns Braintree Woodworks in Lovingston, Va., and specializes in wood-routed signs and woodcarving.

Courtesy Wintergreen, Inc.

Illustration: Matilde Andersen

Eagle Carvings

A carver's view of our heritage

by Allan S. Woodle

Walnut eagle by the great carver John Bellamy has wing span of 48 inches. It's on display at the Mystic Seaport in Connecticut.

This is the year to carve eagles. If you are a professional carver you can expect a much greater demand for your creations than you would in a "normal" year, as the eagle is a bicentennial symbol second only to the flag (discounting the ad-agency bicentennial trademark, the one with the interwoven lines like a doormat). On the other hand, if you are a beginner in the field of eagle carving, you are certain to find eagles illustrated everywhere, material for a rich harvest of design ideas to swell your eagle swipe file.

In any carving project that involves symbols it is interesting as well as helpful to know something of the history of those symbols and their meaning. This is particularly true of the eagle which has so rich a heritage. At the time of the American Revolution, the eagle was the symbol of royalty in many parts of Europe. Immigrants from France, Austria, Russia and Prussia must surely have brought with them the concept of the eagle as the power of government. It is perhaps for this reason that the eagle was adopted as the central figure in the great seal, and perhaps, too, because the new republic was aligning itself symbolically with the European continent against the British lion.

The adoption of the eagle did not happen automatically with the signing of the Declaration of Independence. Ten days after this act, the Congress appointed a committee consisting of Benjamin Franklin, John Adams, and Thomas Jefferson to select a seal for the new United States. How such big guns of the revolution found time to give any thought at all to this project is hard to understand, but they apparently did, and it must be stated that the country would have been better served had they devoted themselves to affairs of State. These were their suggestions:

Franklin: Moses lifting his wand and dividing the water of the Red Sea to swallow Pharaoh and his chariot.

Jefferson: The children of Israel in the wilderness with Hengist and Horsa, Saxon chiefs, on the reverse side.

Adams: Hercules being urged by Virtue (a maiden) to ascend the mountains while the figure of Sloth reclines on the ground.

Lucky for us none of these was adopted. Imagine carving one of them! A safe conclusion is that being a good statesman does not qualify one as a designer, and, of course, vice versa.

William Barton, a prominent Philadelphia citizen, is credited as the first to submit a design featuring an eagle (an imperial one—that is, a stylized, fierce one with the primary feathers widely separated) holding a flag of the United States in its left talon and a sword in its right with a laurel wreath suspended from the point. Below is a maiden representing Virtue holding a dove in her right hand and resting her left hand on a shield adorned with stars and stripes. A soldier stands beside the shield.

The Congress turned this design over to Charles Thompson of Philadelphia, a classical scholar, patriot and public servant, for its refinement, and it is to him we are indebted for the creation of the final design. He eliminated the maiden and the soldier; specified that the eagle be the American bald one; put thirteen arrows in the left talon for the thirteen colonies that won the war together, and an olive branch, the universal symbol of peace, in the other; hung a streamer from the eagle's beak with the words *E Pluribus Unum*

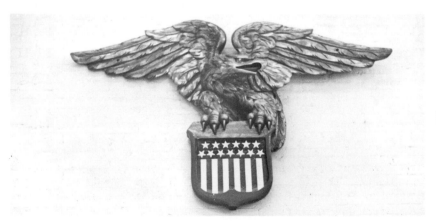

Eagle by or after Rush is in Mariners Museum, Newport News. At right, The Great Seal.

From *Fine Woodworking* magazine (Spring 1976) 2:24-27

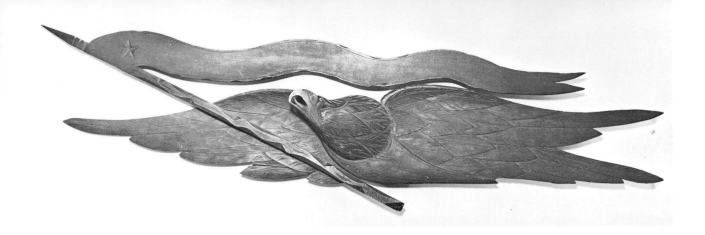

thereon; and placed a crest above the eagle with thirteen stars.

His design was adopted by Congress in 1783 and except for minor changes is the same today. It is a static, formal design as befits an official seal, but it had a tremendous influence on the proliferation of eagle designs that followed, many of them anything but formal. Important symbolic features—the olive branch, the arrows, the widespread wings—appear again and again.

A significant thing about this design is that the people of the revolution liked it. They copied it (with modifications, of course) in every conceivable way. They drew it, quilted it, cast it in metal and carved it in wood. When Washington made a triumphant tour of the states in 1789, people everywhere pasted sketches of eagles on their windows and lit them from behind with candles. A charming picture: Washington riding through darkened streets touched by the flickering yellow pictures of eagles in homes along the way. Can you conceive Pharaoh being swallowed by the Red Sea enjoying such popularity?

The bald-headed eagle was just right for the times. This suggests that perhaps it took our country's founders six years to get around to adopting what the people wanted in the first place. In fact, there is some evidence that the eagle was thought of as representing the United States some years before it was adopted; there is a wall painting in Connecticut of an eagle with the motto "Federal Union" holding arrows and an olive branch, done during the 1770's.

Thus the great seal was more than a seal used to illuminate official documents. It became a popular inspiration for designers that grew mightily during the days of sailing ships in the 19th century, faded during

the early part of the 20th century and now shows signs of a modest revival as part of the burgeoning interest in crafts.

If you are interested in continuing this tradition it is strongly recommended that you study the work of master carvers of the past. Their work is tremendously varied, some of it realistic, some stylized with a more contemporary appearance than many modern carvings.

Most museums have eagle carvings, and some have a great number of them. It is most helpful to take photographs of those that you like, or you can buy official museum photographs quite inexpensively—not through a museum gift shop, but from the curator's office. I have found the professionals and specialists employed by museums invariably eager to help anyone who is seriously interested in their exhibits. These photographs will be useful to refer to when you are working on a design. They are not a substitute for actually seeing a carving, but they help in remembering details and relationships that are easily forgotten, at least by this carver.

Master carvers of the past

There follows a brief description of a few carvers and their work that I have liked. They happen to be the outstanding carvers of their time, but that is because others liked their work too. In reading about these well-known carvers it is well to keep in mind that for every carving that is identified there are ten whose origins are unknown. And many of these unidentified creations are well worth studying. The names given here are only the tip of the iceberg.

An outstanding carver of the early years of the republic was Samuel McIntire (1757-1811). An architectural

designer and woodcarver, he produced numerous eagles and inspired others to do likewise, including Joseph True who in 1828 carved the striking eagle on the Custom House in Salem, Mass. A number of McIntire eagles, in my opinion, show the influence of the imperial style of eagle and in consequence do not deserve the criticism that they "look more like scrawny roosters caught out in a downpour than our national bird," as one writer put it. They do look rather scrawny, but so do imperial eagles. Certainly there is nothing scrawny about the striking design which used to hang over the doorway of the old Salem Custom House. I like the stance of this eagle, but the beak makes the bird look a trifle anguished rather than fierce. McIntire did not cut the inside of the beaks of his eagles to a sharp line. This may have made them stronger, but the poor birds look as if they have a mouth full of something or other.

William Rush (1756-1833) of Philadelphia was another fine carver of the Revolutionary period who did many eagle carvings, among them sternboards for sailing ships. At the time of the revolution ships were heavily decorated with carvings, but to my knowledge the eagle was not featured until the beginning of the 19th century.

Variations in eagle carvings derive mainly from the uses for which they were designed. Individual carvers varied the method of execution of their work, but they still had to fit their conceptions to the job at hand. The contrast between sternboards (aplustras if you want to be fancy) and wall decorations is an example of this. A wall decoration could be delicate because it would be viewed more closely than one mounted on the stern of a ship. To be effective, such a carving had to be bold

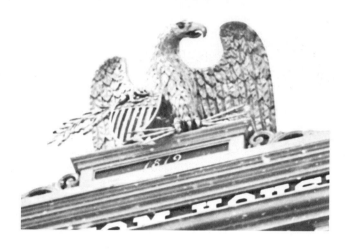
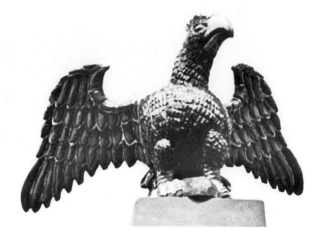

in both detail and decorative outline. A carving by or after Rush shows this. This carving is 94 inches wide so it is bold indeed. Rush had a way of carving feathers so that they looked soft and real without making them look fussy or overcarved.

Eagles were often used to adorn the flat-topped pilot houses of tugboats and sometimes of coastal passenger steamers and trawlers. Pilot house eagles are quite distinctive in appearance. They stand with beaks stretched forward, with bodies almost horizontal and with wings outstretched as if they were about to launch themselves into the wind. I know that if I had a tugboat I would want such an eagle on the roof.

Flagpole eagles are obviously smaller than pilot house eagles, but they often carry much the same pose with talons grasping the round ball at the top of the pole. Sometimes they are presented in a more vertical position but still with wings outspread. When you stop to think about it, an eagle way up on a flagpole with wings folded might be a crow or just about anything.

Eagles used as decorations in the interior of buildings and on furniture took many forms to suit the physical circumstances. The only similarity between them is that they were always small as compared to outdoor eagles.

As the 19th century progressed there was a greatly increased demand for eagle carvings. Ship captains liked them to adorn the sterns of their vessels and they also liked to hang them over the doorways of their houses.

No one carved more eagles or more beautiful ones during that time (or any other for that matter) than John Hale Bellamy (1836-1914). He lived most of his life in Kittery Point, Maine, in the house in which he was born, but for a time he had a shop in Portsmouth, New Hampshire. This gave rise to the phrase "Portsmouth eagle" in referring to his work. He is reported to have been a tremendously skilled and facile carver who turned out eagles by the dozens and gave many of them away to friends and neighbors.

Bellamy had style. He developed his own way of depicting details. He used squared-off beaks and deep eye sockets to make carvings "read" on the sterns of ships. When he turned to decorative eagles, he often made them almost abstract, playing with the form from one carving to another. Every carver of eagles can benefit from a study of the work of Bellamy and envy his life style too. He was facile with a pen as well as with his tools. He wrote poetry and articles of current interest and was a public figure of importance.

At the other end of the social spectrum from Bellamy was a carver from central Pennsylvania named Wilhelm Schimmel (1817-1890). His work is primitive but forceful and intriguing. He appeared in Cumberland County, Pennsylvania, shortly after the Civil War and remained there until his death. He seemed to have been driven to carve. This is not particularly unusual because many of us are driven to some degree, but not in the circumstances of Schimmel.

He was without a home, worked sometimes as a farm laborer, was often in jail, but he was always carving. He carried a bag of wood and his simple tools with him; these probably consisted of a jackknife and a box of paints. He never got much for his work: food and lodging perhaps, and that given in charity. (And we complain because our cellar is damp and our carving bench a bit wobbly!) Schimmel's work has vigor, and it could easily give direction to a contemporary carver who is seeking a bold style of presentation. The Shelburne Museum outside of Burlington, Vermont, has a room devoted to Schimmel carvings, and examples of his work are on display in museums all over the country.

Incidentally, the Shelburne Museum has a huge collection of eagles of all kinds. I would guess that there are over a hundred of them—the biggest collection I know. But a word of warning: if you want to take photographs you must go to the office for a permit. On my first visit I was not aware that picture-taking was not allowed, and peering into my viewfinder I was surprised to see what appeared to be an elderly symbol of Virtue with arms spread wide protecting the eagle I was aiming at. She was only slightly mollified when I came back with a permit. Such are the hazards of eagle-hunting.

Trying to carve an eagle

If you decide to turn your hand to eagle carving the easiest way to start is with a low relief suitable as a wall decoration. Work up a drawing, or if you are not handy at this, start with an outline drawing such as that in the Marine Carving Handbook by Jay S. Hanna. Such a drawing will give you basic proportions which you can modify as you wish, changing the shape of the ribbon, the sweep of the wings and so forth. When this sketch is to your satisfaction, square it off and enlarge it on paper to suit the wood you are going to use. I suggest an overall width of about two feet, which is the width of the carving illustrated. Any smaller and the details get fussy. This carving was done on 1-1/8-inch basswood; a denser wood, pine or honduras mahogany would have been better. More easily available one-inch material could be used but the thicker wood gives better modeling.

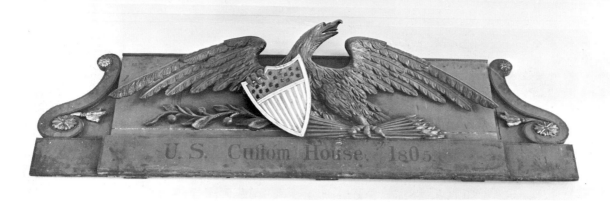

McIntire eagle (above) originally surmounted doorway of old Custom House in Salem, Mass. True eagle (far left) is over present Custom House. Schimmel eagle (near left) is at Metropolitan Museum in New York. It's approximately one foot wide.

You may find this hard to credit, but you should start two carvings at the same time. Therefore, you should enlarge your drawing on paper rather than directly on the wood. With a paper "cartoon" it is easy to transfer the drawing to the wood with carbon paper. Both carvings should then be cut in outline on the band saw. After this is done, put one aside and make your mistakes on the other. When this first carving is complete, prop it up on the back of your bench and do a better job on the second one. When it is finished you will have learned more about carving eagles than if you had tried to carve six different birds.

Even after you have gained experience you will find that carving several pieces at a time is a good practice. If you have a good drawing there is no sense in using it only once, and if the drawing isn't any good you shouldn't start at all.

Many carvers simply clamp their birds to the bench and hack away. I think it is worth the trouble to mount the bird on a board—a piece of 3/8-inch or 1/2-inch plywood is best—about three inches longer on each end than the carving. This is done by gluing them both together using white glue with a sheet of newspaper in between. This holds well enough while you are working, but when the front is finished and the carving is ready to be back cut it is an easy matter to free the bird with a flat chisel.

This backing board makes it easy to clamp the carving without either crushing or splitting it. After you have finished roughing out you will have some thin sections that can easily break when the bird is unmounted if you get the least bit enthusiastic (and enthusiasm is hard to control when the old bird begins to take shape).

The carving shown has been painted with acrylic paints in an acrylic gel medium. The latter slows the drying a bit and creates an attractive surface. These paints are easy to use. They can even serve as a gesso for filling in little errors if mixed with modeling paste. All these materials are available in art supply stores.

A carved eagle looks most dramatic if it is gilded. Applying gold leaf is not difficult and is worth trying sometime, but for the first time around paint will do and will make it look mighty handsome when you have it hung over your fireplace. □

If you want to carve an eagle, here's a pattern the author worked up for this article. Squares for the original were about 1-3/8 inches to give a 24-inch eagle, but you can make them any size you want. But start two eagles—one for practice, one to finish.

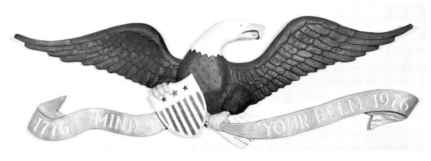

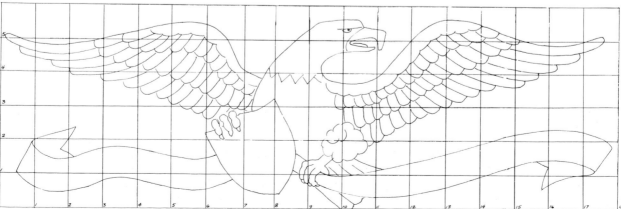

The Egg and I

by Adelaide Sproul

When my youngest child was three, she asked her grandmother to teach her to knit. When told she was too young, my determined daughter replied, "What you say I can't do I can do," so my mother meekly got out the knitting needles. I was reminded of this incident by my introduction to woodcarving at the New England Craftsmanship Center in Watertown, Mass. For years I had suppressed the urge to carve and was determined to learn but felt shy and tentative when I arrived for the first class. The assumption that greeted me was that I could do what I thought beyond my capabilities, and I was immediately launched into making my own tools. To my astonishment and delight, by the end of the second class I had made two very respectable tools, a gouge and a chisel, and learned to sharpen them (I whose kitchen knives are as dull as hoes). As soon as the chisel was sharp I was required to sharpen my new soft black pencil with it, not too difficult for one who had studied drawing in a large class with no pencil sharpener. The first carving assignment, however, was not so easy: to carve an egg. It seemed like an impossible challenge. With the expert help of my teacher, Nat Burwash, I did achieve an egg and then several other small pieces, becoming more absorbed by the possibilities with each project.

Philip McElroy

Under Nat's guidance, each student starts with two half-round files 4 in. by ½ in., and one flat file 6 in. by ¾ in. by ¹⁄₁₆ in. One half-round file is ground into a gouge that is curved on the cutting edge (a push tool). After grinding, the edge is finished on an oilstone, then buffed on crocus cloth until it is razor sharp. The chisel is made out of the flat file following the steps used for the gouge. The second half-round file is mounted on a handle, as are the other tools, and used to file shapes smooth.

Now comes the egg, which means thinking that shape into a small chunk of butternut with the help of a pencil. Most be-ginners draw on one side of the block without considering the top view, or they may draw the shape out to the edges on the largest side of the block, which results in an egg too large for the wood. These problems immediately force one to consider the concept of three dimensions and to study all sides of the block in relation to that egg shape. It is particularly helpful at this stage to study the top view, because from this vantage one can see how the sides of the egg move down and out toward the sides of the block. The next step is to decide where to plan the greatest diameter of the egg, the equator, and to mark it with a firm line.

Now carving starts; using gouge and chisel, the technique is to cut away from the equator toward each end, cutting with the grain in each direction. Since these small beginning blocks are split in the direction of the grain, it is not hard to find after a few cuts which way the grain goes and to work with it. It is good to have help within call, but one learns very quickly by trial and error. I found it most efficient to grip the handle of the tool with fingers only and use the thumb as a counter force against the thrust of carving, pushing straight ahead without prying or lifting. Turning the block keeps progress even on all sides. Forced prying can break gouge or chisel. When roughing out the first shape, direct pressure works best; fine chips and a scraping motion come later. Obviously, one must hold the wood so that hands are not in the path of the advancing chisel. It helps if extra wood is left attached to the egg as a handle until the very end.

In spite of much blundering, pushing the gouge against all the demands of nature and a surface that looks like the craters of the moon, one does achieve an egg shape. Then the next challenge is finishing. I might say parenthetically that finishing is not just making a smooth surface; it involves thinking through and refining the shape and can go on for a

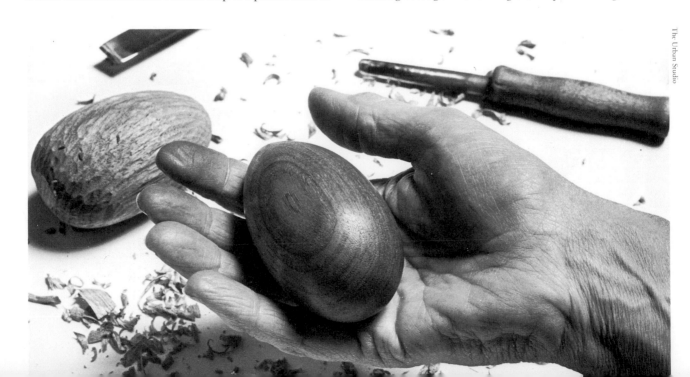

The Urban Studio

long time. When the egg is, as far as mass goes, an egg, it is ready for the final carving, really the first step in finishing. Turn the egg around in a strong light, look and feel for the high places and carefully shave them down with a newly sharpened chisel, using a sideways motion and taking off very small shavings. When you think it is really quite even, you have only just begun, for the next step is to file the surface until all the gouge and chisel marks and small humps are gone. A long, firm stroke works best; start at the equator and file to the point of the egg, then turn the egg around and work from the equator to the blunt end. Following this comes sanding with the grain, starting with coarse sandpaper, then fine, which will produce a satisfactory polish.

The final finish, when the carved, filed and sanded egg feels smooth and shows no rough places, is a liberal application of boiled linseed oil, which stands for 10 minutes and is then thoroughly wiped off. After 24 hours the process is repeated. It is important to wipe the oil off thoroughly and to proceed slowly; otherwise the surface becomes sticky and messy. With patience, after three to five such applications, the surface builds to a beautiful patina. I like to sit quietly with a newly oiled piece and buff it with a soft cloth until it glows; then I know the work is finished.

Today one can purchase anything from wood to apples neatly encased in a plastic skin. There is no hint of the sprawling roughness of trees; it is easy to forget where the materials originate. One of the satisfactions of the craftsman is to go to the source—to dig the clay, cut the tree, spin and dye the wool, grind the pigments—to become acquainted with the patient beginnings that are the foundation of expressive life. In this day of prefabricated everything, we must find our way

back to raw materials—sand, clay, wood—the roots of our imaginative existence and the building blocks of our future, the stuff of the earth. To return to my daughter's words, we need to know that what we think we can't do, we can do. I found this out one day when my teacher, ever alert to new challenges for his students, showed me a nice piece of butternut and suggested it was time for me to start a larger project. The "nice piece" was a 4-ft. log, of which I wanted half. But I had never split a log (the small chunks for our beginning eggs were split for us). Who would do that for me? Silence, inaction as I fretted to get to my new work. Finally I was given two wooden wedges and a mallet along with some hints on how to get started, the main requirement being to hammer hard. As the wedges parted the fibers of the wood and a clean split traveled to the bottom of the log, I was elated out of all proportion to my accomplishment.

An egg shape, the beginning of it all, is just a start. Having finished the egg it doesn't seem preposterous to attempt an animal, a person, an abstraction. The same tools will suffice, unless, like me, you try a larger piece and wish to add a larger gouge and chisel and a spokeshave. But still a great deal of the process happens in one's lap, slowly and contemplatively. Perhaps this is why it means so much; carving wood that took a long time to grow is undertaken only in "good sadness," with time for thought and a ripening of perception.

Adelaide Sproul, of Cambridge Mass., is an artist and an author of books on printmaking, drawing and resources for art teachers. Carving the egg she describes here launched a whole new career for her, leading to selling and exhibiting of her wood carvings.

Q & A

Could you give me some information on a "chops," the traditional English carver's vise?
—*Robert L. Woodward, Mascoutah, Ill.*
ROGER E. SCHROEDER REPLIES: Below are drawings of the chops that I mentioned in my article on carousel horses (see

"The Carousel Horse," pages 79-81). Note the dovetail joinery. This particular vise was made for Gerry Holzman by an English joiner, although some woodworking supply shops in England do sell them. Holzman shaped the sides of the jaws at the suggestion of his British teacher.

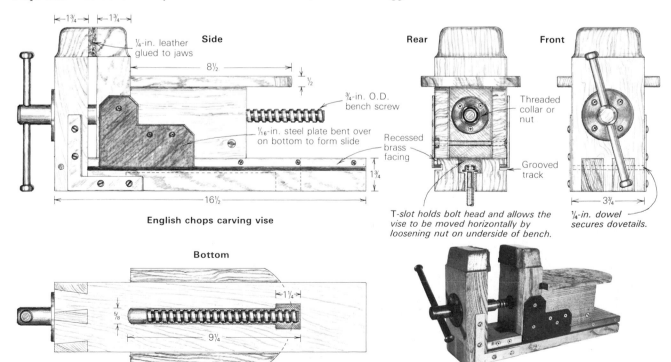

English chops carving vise

Bottom

¼-in. leather glued to jaws Side 8½ ½ ¾-in. O.D. bench screw 1/16-in. steel plate bent over on bottom to form slide 1¾ 16½

Rear Front Threaded collar or nut Recessed brass facing Grooved track T-slot holds bolt head and allows the vise to be moved horizontally by loosening nut on underside of bench. 3¾ ¼-in. dowel secures dovetails.

Alpine Peasant Furniture
Carved designs embellish sturdy construction

by Christoph Buchler

From the late Middle Ages to the 19th century, peasants in the remote Alpine regions of Europe fashioned themselves whatever furniture they needed—a simple table, a bench, one or two trunks for storage. Most villages, however, had carpenters, and there was no need for the peasants living there to build their own furniture. Peasants in the fertile plains were wealthier than those in the mountains and could afford to pay a carpenter. The term "peasant furniture" has come to mean furniture made both by peasants and for peasants. It generally refers to trunks, beds, wardrobes, tables, benches and chairs. Basic patterns recur, but their construction and style vary widely with regional fashions and tastes.

Ornamental designs — The most prominent characteristic of European peasant furniture is abundant and intricate dec-oration. Painted or carved geometric, floral, animal, religious and representational motifs abound. The most primitive form of carving was scratching the surface of the wood with some sort of pointed tool, such as a nail. It seems that this technique was also used to lay out the design and that, in some cases, the laid-out design was never carved.

Chip-carving (see pages 7-9) is a more sophisticated tech-nique, widely used for the early geometric designs, which originated in old Germanic pagan beliefs. The most common symbol was the sixstar. Its construction was simple, and all one needed was a compass, which could be a piece of string with a nail on either end. The sixstar was thought to be a sym-bol of life. It was originally a letter in the Runic alphabet, known as the hagalrune, and expressed the beginning of life. This symbol could also be elaborated into the sevenstar—a

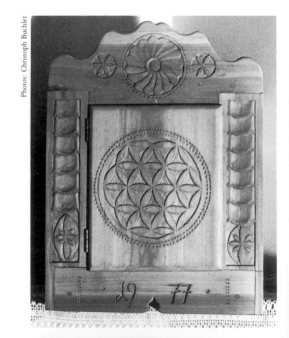

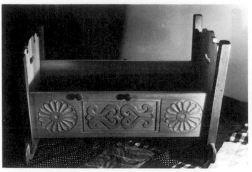

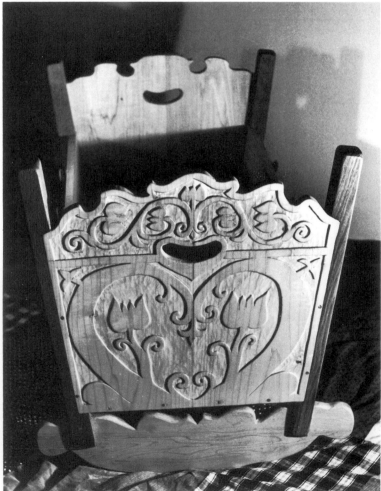

Carvings on wall cabinet, top left, include sevenstar on door and floral and Gothic-style hanging-curtain patterns on face frame. Peasant-style cradle made by Buchler, right and bottom left, sports free-flowing floral designs on ends and more abstract daisy and rose patterns on sides.

Photos: Christoph Buchler

From *Fine Woodworking* magazine (May 1980) 22:48-50

beautiful arrangement of seven sixstars.

A related symbol is the sunwheel, left, another simple compass construction. The sun played an important part in the peasants' life, and was thought of as a source of life. The signs used to represent the sun were all variations of the sunwheel.

Sunwheels and sixstars were thought to bring good luck. Other signs were thought to ban the entry of evil spirits. Many of these were in the shape of an endless knot, and the best known is probably the pentangle, a five-pointed star. Geometric signs and symbols were either arranged to form one big design or strewn over the surface of a piece of furniture. Often the peasants themselves carved the symbols, and they added on whenever they felt the need.

Reproducing floral patterns required a different technique—flat relief. To heighten the effect, the low areas were commonly blackened with a soot mixture. In the heyday of peasant furniture, in the late 18th to early 19th century, full relief carving embellished special representative pieces.

It appears that the discovery of floral design took the lid off the creators' imaginations—the restrictions and limitations of geometric designs were supplanted by the virtually endless flow of stems, leaves and blossoms. Craftsmen did not try to copy the natural model in all its delicate details. It was the symmetry and richness in nature's formations they were after. Grape and pumpkin vines were a favorite for decorating furniture frames.

Carving panels was different. The ornament had to be centered, and the center had to be low because otherwise the ornament looked top-heavy. Balance could be achieved simply by putting the plants into a flowerpot or vase. From this solid base a network of blossoms, leaves and stems could spread over the surface of the panel without seeming uncontrolled. Especially in these flower-pot arrangements, one can see how little attention these carvers paid to the logic and laws of nature. Out of the same stem they let three or more different flowers bloom. Sometimes one blossom "grows" out of the center of another blossom.

Along with floral designs we find animals. All the animals connected with the life of the peasants were represented. Without doubt, however, images of birds were most common, and the most commonly pictured bird was the eagle. On peasant furniture one finds both one-headed and two-headed eagles. Many abstract patterns can be traced back to the eagle image.

A fourth category of ornamentation encompasses themes connected with the life of Jesus Christ. Especially in regions that were strictly Catholic, such as Bavaria and Austria, the letters of the words Jesus and Maria were turned into symbolic images that resemble the early geometric signs. There one can see how the old pagan attitudes find

Jesus and Maria symbols resemble pagan geometric signs.

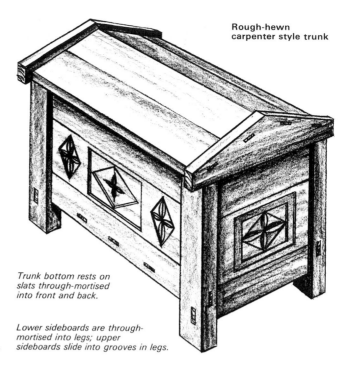

Rough-hewn carpenter style trunk

Trunk bottom rests on slats through-mortised into front and back.

Lower sideboards are through-mortised into legs; upper sideboards slide into grooves in legs.

expression even through the mantle of the Christian creed.

Another motif was the representation of the human figure. Here again peasant life is reflected in the subjects. One finds scenes of a plow team and the harvest—or tradesmen like the cobbler or the joiner. These themes required great carving skill and therefore were not as common as geometric, floral and animal designs.

Construction — A carpenter built furniture differently from a joiner, whose trade evolved later. The carpenter's techniques of construction were similar to those used in framing a house or paneling a room. This is evident in the most common piece of peasant furniture: the trunk. The carpenter started out with four pieces that formed the legs. About 8 in. off the ground he fitted the bottom sideboards into the legs with mortise and tenon joints. The rest of the side boards were then inserted in grooves in the legs. The bottom sat on a pair of slats mortised into the front and back. The lids were shaped like the roof of a house. Because these boards were split from the trunk of a tree and then hewn flat, the furniture was heavy and looked rather coarse.

Sawmills began to flourish around 1400 and so did the carpenter who specialized in furniture. The joiner's trade was established. Sawn boards brought advantages: They enabled the joiner to build much lighter furniture and opened new construction possibilities. The trunk, for example, evolved from the model described above to the *Seitenstollentruhe* (sideboard trunk). Here the sides extended to the ground and served as legs. Front and back were butt-joined and pinned onto the sides. The bottom was mortised into the sides and butt-joined to the front and the back. The wooden pins that reinforced all the joints were inserted at opposing angles, keeping the joints from coming apart.

A further development was frame-and-panel construction, which became the most common. The joiners could now build sturdy, durable and relatively lightweight furniture, which also gave the most opportunities for decoration.

Because trunks were used for a wide range of purposes,

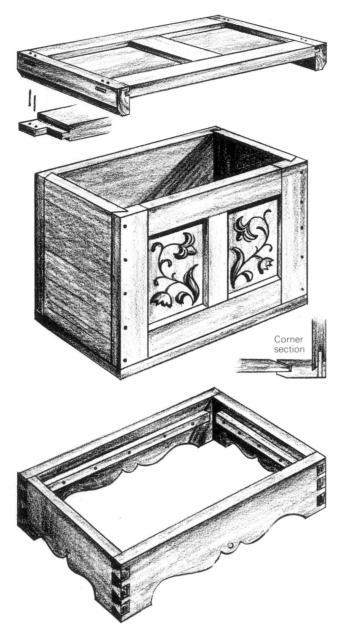

Corner
section

Three-part frame-and-panel trunk construction

sides can be made the same way, but the back is generally made from solid wood. The sides are often made from solid wood, too. In that case, the grain of the wood runs horizontally to give the carcase strength. The bottom of the trunk is butt-joined to the carcase sides with glue and wooden pins. Cracked bottoms are common.

The construction of the lid is similar to that of the front. The lid usually consists of two panels (if the trunk is small, one panel is enough). Usually the frame support between the two panels is rather wide (about a quarter the width of a panel) to add strength. The side members of the frame extend down over the sides of the case. The thickness of these pieces prevents the lid from warping.

The purpose of the base is to keep the body off the floor and to prevent moisture from seeping in, which would start rot in the bottom and, even worse, would destroy the goods stored inside. The base consists of four boards joined with dovetails. The middle parts of the sides are cut out to permit air to circulate under the chest. A strip of wood about 2 in. wide is glued and pinned into the base about 2 in. below the top on the inside. The case rests on this ledge.

Another kind of construction typical in trunks made after 1600 is the common six-board, dovetailed chest, but with framing arches applied to the sides to create the effect of frame-and-panel construction. Carving, painting and applied pictures decorate the areas between the arches; the arches themselves were molded with architectural motifs.

If the trunk is to be decorated with carving on the panels and the framework, the carving has to be done before assembly. Although I work out the ornaments while I carve them (I do start out with a rough draft), it would be helpful for people who aren't familiar with this kind of ornamentation to work out the complete arrangement beforehand.

I work with hand tools. I feel that a sincerity towards the trade as well as towards the wood is necessary to build furniture true to the spirit of the material it is made of. This sincerity is rewarded in the end by a feeling of pride in one's work. To construct a trunk I use a bowsaw, a panel saw set for ripping and a backsaw. I also have a number of planes (plow, rabbet, smoothing) and a few chisels. Carving the traditional ornaments requires gouges, veiners, carving chisels and various molding planes.

The last step is finishing. I use only raw linseed oil and beeswax, except on pieces that come into contact with food. There I use mineral oil. The workers I draw my knowledge from and those who worked a hundred or more years ago used only linseed oil, and their furniture is still around and sometimes even still in use.

The growth of furniture factories in the 19th century halted the development of peasant furniture. The imagination of a single person no longer gave the ornaments individuality and liveliness. In the factories, pieces were designed by a person trained to do only that. Because most factories were located in large towns, the furniture they produced was designed for the tastes of the townspeople. With the rise of the bourgeoisie, peasant furniture was soon looked down upon. In the beginning of this century, and today, it is admired as the artistic expression of a bygone way of life. □

Christoph Buchler, of Talent, Ore., learned about hand tools and peasant furniture while living in the German-Austrian Alps nine years ago.

their size varies greatly. I have seen examples that measure from 8 in. high by 16 in. wide by 7½ in. deep to 40 in. high by 70 in. wide by 28 in. deep. All kinds of household items were kept in the smaller ones, and folded clothing was stored in the larger ones. The broad surfaces of such a trunk offered ample opportunity for richly carved decoration.

A typical frame-and-panel trunk is built in three parts. The largest part is the carcase, and the other two are the lid and the base. The carcase consists of four sides, joined with what may be called a half dovetail, as shown in the drawing above. Its effect is similar to a tongue in a groove. Wooden pins inserted at opposing angles secure the front and the back to the sides. The front is made of frames and panels—the number of panels depends on the size of the trunk. The rails and stiles are grooved on the inside to receive the panels, with room for the panel to expand and contract across the grain, which runs vertically. The panels are rabbeted on the face side and planed on the back to taper to a snug fit in the groove. The

Grainger McKoy's Carved Birds

A wooden covey on springs of steel

by Roger Schroeder

Though they are wooden feathers that spread out in flight, metal feet that cling to brass foliage, and basswood bodies that seem to defy gravity, the birds carved by Grainger McKoy look alive. One of the finest wildlife artists in America, McKoy has spent ten years perfecting his art. He has a degree in wildlife biology and training in architecture from Clemson University, but he learned nearly all his techniques from his mentor, Gilbert Maggione, South Carolina painter and bird sculptor. Maggione showed McKoy how to create dynamic postures and how to avoid the static forms common to decoy carving. He taught McKoy how to insert individual feathers and how to give unerring attention to anatomical proportions and detail. McKoy now knows so much about his birds that, pointing to a bobwhite quail he carved, he can tell you how old the bird it represents would be, and why.

Since his two-year association with Maggione, McKoy has made more than 75 bird sculptures, some consisting of a number of birds. His and Maggione's works have been exhibited at the Museum of Natural History in New York, as well as in shows throughout the East and South.

McKoy's workplace on Wadmalaw Island, 20 miles outside of Charleston, S.C., is a tin-roofed country store converted to a workshop and an upstairs studio. Near a window is an old graffiti-covered student desk where he does much of his carving. He has few traditional carving tools, and his only standing power tool is a bandsaw. About his desk are large piles of Styrofoam blocks, which he uses to make models of his birds. When I visited him in the summer of 1980, he was working on a commissioned sculpture of a covey of quail: 15 bobwhites exploding into flight (cover). The uppermost quail soars four feet above the base. His most ambitious project thus far, it wasn't completed until the spring of 1981.

Though McKoy did make preliminary sketches of the covey, the drawings confined themselves to basic joinery and to the relative positions of the birds. He didn't do exacting sketches of his sculpture, claiming that too much planned detail would have bound him to a preconceived image. Rather, he let first the Styrofoam models and then the wood tell him how the sculpture would look. Each of the 15 birds began as a Styrofoam model. "They're easy to throw away," McKoy says, "just something you can play with." Cardboard wings can be variously positioned, and heads can be cut off, rotated and reattached with pins to test different postures.

Before McKoy could begin carving the individual quail, he had to see how they would be positioned in flight. On a turntable work surface that economized his own motions, he used thin, vertical steel rods that held chemistry-lab clamps, which in turn held pieces of brass tubing at right angles. A wood screw through the flattened end of this tubing could temporarily hold a bird, either Styrofoam or wood, in the air. These supports allowed McKoy to position the quail wherever he wanted until he was satisfied with the places they all held.

One of McKoy's preliminary sketches of his covey sculpture, showing the steel-ribbon understructure that supports each bird.

McKoy's solution to keeping the birds airborne, without hanging them like mobiles, is ingenious yet simple. The quail are joined together from the lowest to the highest, even if only by the tip of a feather. Yet how could solid wooden-feathered birds support each other when the uppermost life-sized bird is four feet off the ground? One answer is that the quail are not solid wood. McKoy bandsaws the bodies in half and hollows them with a #5 gouge before rejoining the halves. This reduces the weight by a third or more. The other answer is that the birds are joined from top to bottom by lengths of ⅛-in. thick by 1-in. wide steel, an annealed high-carbon knife-blade steel that can be bent, ground, welded and then hardened by heat-treating in a furnace. The hollowed bodies have another advantage, for a steel ribbon runs into the bird's body cavity where wood screws hold the metal to the wood. Another length of steel can then emerge from beneath a wing and end as a detailed feather, complete with

From *Fine Woodworking* magazine (January 1982) 32:77-80

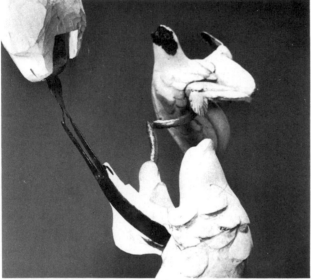

To make the bodies of the birds in his sculpture as light and structurally stable as possible, McKoy bandsaws them in two and hollows out the insides with a gouge (photo, top). Note the high-carbon steel ribbon that has been let into the wing and screwed in place. This is part of the understructure of the covey that supports the birds impreceptibly, presenting the illusion of flight. McKoy devised a tenon-and-socket joint (above) which allows the pieces to be disconnected when necessary. The basic joinery was worked out in sketches as at right.

rachis (quill) and barbs, those parallel fibers that stand out like the teeth of a comb. To this steel feather is welded the steel counterpart of yet another bird. The rest of the feathers are individually carved of wood. Using the branching steel ribbon, McKoy can have one bird giving support to two others above or beside it, one at each wing. Where bodies and not wing feathers touch, steel supports are concealed elsewhere in the anatomy.

The problem of disassembling so many birds for carving and detailing was solved with a socket-and-tenon joint. By making the steel ribbon in sections and brazing two flat pieces of brass and spacers to the end of one, McKoy was able to create a slot to accept the tenoned end of another section as shown in his drawing above. So even where the tip of a steel feather is permanently welded to the feather of another bird, its other end can slip into a slot carefully hidden among wooden feathers. As a result, McKoy can simply lift birds off one another, enabling him to work on them individually, then replace them.

After each bird was mocked up in Styrofoam, its wooden counterpart was shaped on the bandsaw, though McKoy had to rough out each one at least twice before he got what he wanted. He used basswood because of its stability and resistance to checking and cracking. It contains little resin and so it is easy to paint. He has in the past used poplar for feathers

because this wood can be cut extremely thin and still retain its strength. But poplar, McKoy points out, is fibrous, and thus is more time-consuming to work than basswood.

While the bone-and-sinew part of the wings was roughed out from thick stock and attached with screws to the quail bodies, the individual feathers began as ⅛-in. thick basswood blanks. After drawing an outline on the blank, McKoy carved with a 2½-in. pocket knife each of the bird's primary, secondary and tertiary feathers. These were then reduced in thickness with a hand-held, motor-driven, ½-in. by ½-in. sanding drum. The larger feathers could be held by hand, but for the smaller ones tweezers had to be used. For feathers that had to be bent, McKoy first heated the blanks on a bending iron and then bent or twisted them to shape.

Once shaped, the feathers needed barb details. For this McKoy used a burning tool that has a skewed tip—the Detailer, manufactured by Colwood Electronics (715 Westwood Ave., Long Branch, N. J. 07740). It is held like a pen and drawn forward, the slanted end of the heating element burning a straight line into the wood. He also used the Detailer for burning in feather detail on the birds' bodies.

McKoy's attention to anatomical detail is evident when one sees a wing disassembled into as many as 22 individual feathers. Yet he claims that if he reproduced them exactly as they are found on a bird, each feather would have taken him

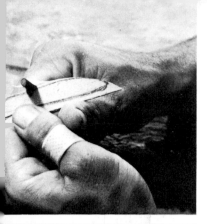

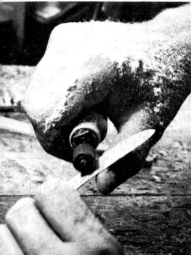

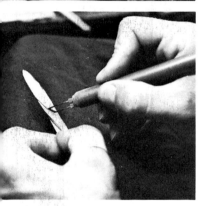

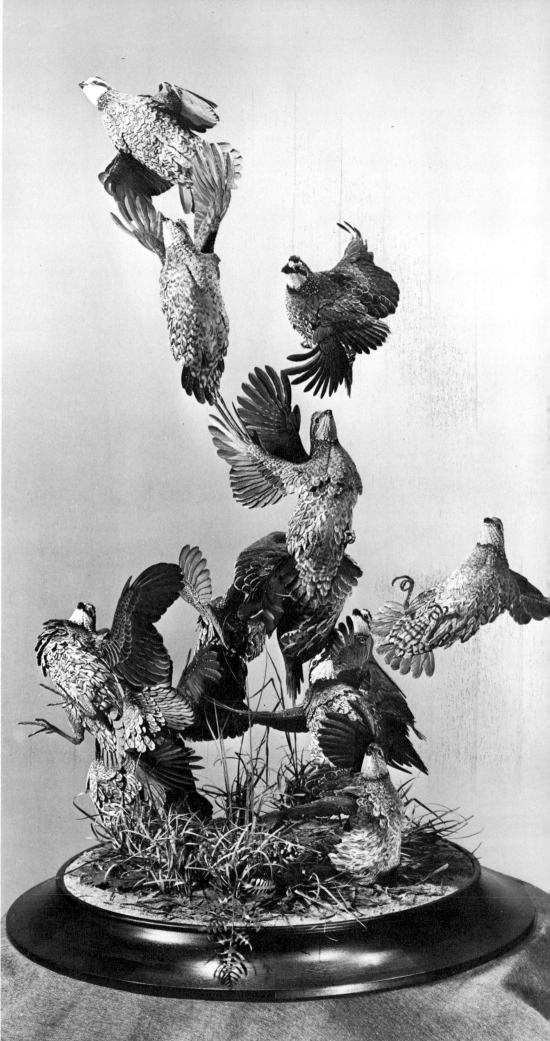

Top, McKoy shapes a feather in poplar using a sharp pocket knife. Next, he thicknesses the feather with a sanding drum in a Foredom rotary tool. Details (barbs and rachises) are then burned in with an electric hot knife. A wing may be made up of as many as 22 individual feathers (bottom photo). At right, the finished sculpture reveals an unexpected flurry of flight. Photo: Ted Borg.

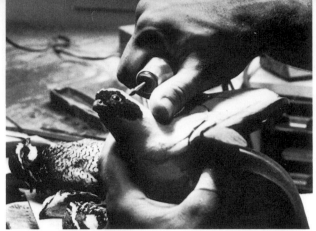

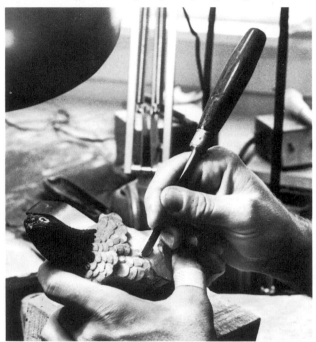

For rough carving and shaping, McKoy uses a rotary stone in his Fore-dom power tool. The stone leaves behind a textured surface which enhances the expressiveness of the piece by deepening shadows.

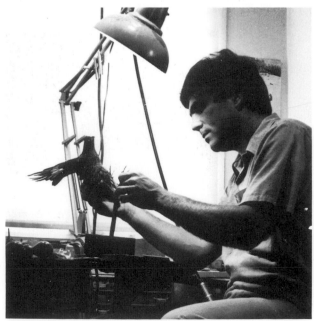

For fine carving—defining and undercutting the feathers and other features—he uses a skew chisel and holds it much as you would a pen-cil. This grip affords little power but maximum control.

a day to complete, requiring, then, two years to do nothing more than the wing feathers of 15 quail.

McKoy's major tool for carving and shaping is the Foredom Series R rotary tool. Not only can the Dremel bits he uses work both Styrofoam and wood, but they can also add the details to a steel wing. For fine carving he uses a skew chisel which will undercut and define the feathers of a bird's body. But McKoy uses a rotary stone in his Foredom for coarse shaping. This setup will not produce sharp details. Instead, the stone will create a shadow effect that gives "expression, not duplication." This was of particular concern in the covey sculpture because the quail are meant to be viewed from a distance. Too much detail would look busy and detract from the overall effect.

The eyes of his birds are taxidermy glass, and the feet are brass, the metal being soft and easily worked. The toes of the quail, he solders on individually, and the completed feet are held in sockets in the birds' underbodies. The Foredom rotary tool again comes into play, with a carbide cutter used to form the scales on the birds' legs and toes. The feet of the still-grounded quail are brazed to lead plates in the base, which give the entire sculpture stability.

All of the quail were painted with oil-base paints, with the exception of the white areas, which were lacquered. He used lacquer because it could effectively cover the dark umber base produced by the burned-in details, which entirely cover the birds. Wings and feathers were removed, and painted with an airbrush to fill the smallest crevices. The final colors, how-ever, were hand-painted. The process took an entire day for each bird. After the painting was completed, the feathers were glued into the wings.

About his sculpture, McKoy says, "This is the way a covey of quail might appear if frozen in flight by a stop-action photograph. But I didn't have any such photograph, and so I had to follow my instincts and intuitions in deciding how these birds look at the very moment they break from cover."

Remarkably portrayed are the instincts of flight and escape at the bottom, giving way to the natural grace of birds over-coming gravity at the top. It is a study in conflict that McKoy seeks to represent in many of his compositions. McKoy is a birdhunter and knows the habits of quail and other game birds. He is also licensed to collect game birds, and large drawers in his studio hold dozens of preserved birds, wings, and feet, all of which aid in his work. Yet, he does not want his works to look like taxidermy. His are wood sculptures in which anatomical accuracy must serve an expressive end. One recent piece, three weeks in the making, is what he describes as a pen-and-ink in wood. Out of a roughly carved basswood background emerges the body of an unpainted semipalmated plover—emphatically a composition in wood.

To McKoy the design of flight and escape are more impor-tant than carving technique or background. Over the years he has been de-emphasizing the habitats in his compositions, claiming that the background was dictating the piece and that they looked too much like museum dioramas. Always improving and simplifying his work, McKoy strives to avoid inert forms and excessive detail. Future works will probably include more examples like his pen-and-ink plover, where the concept of a bird as wood is clearly defined. □

McKoy applies metal feet to a completed bird.

Roger Schroeder, of Amityville, N.Y., is a woodcarver and freelance writer. Photos by the author, except where noted.

Burning-In Bird Feathers

by Eldridge Arnold

Man has had a long and varied experience with birds. He has envied them, worshipped them, painted and sculpted them and eaten them for dinner. Birds as symbols and motifs are everywhere, from King Tut's tomb to silver dollars, from pueblo petroglyphs to automobile ads. But the thousands of contemporary bird carvers in America trace the origins of their craft to the dinner table, and not to the making of feathered icons for hungry spirits.

Learning from the Indians how to make duck decoys with mud and rushes, American colonials soon began to carve decoys from wood and to color them with paint to achieve a lifelike quality. Anchored close to the hunter's blind, in shallow water, these wooden ducks attracted real ones, which made for good sport and tasty meals. These early decoys (those that have survived) are now collector's items and museum pieces. Decoys are still being made for hunting purposes, but most all of them are carved by machine or injection-molded from Styrofoam. And yet even with this great outpouring of machine-made models, the art of decoy carving is more widely practiced now than it ever has been before.

One branch of the craft, however, has evolved beyond just making decoys, and its practitioners find a special challenge in trying to reach absolute realism in their work. Not only do they pay closer attention to form and posture, but they strive to replicate the tiniest of anatomical details, down to the very barbs of the feathers. Texture is the subtlest and most difficult quality to get, created by a combination of carving, burning and painting.

Once the body of the bird is shaped and smoothed, and the parts for the feathers have been cut, you can pencil in the outlines of the individual feathers (photo, below left). Instead of carving around the feathers on the body, which gives them a shingled, layered look, I prefer to burn-in the edges, as well as the barbs. There can be as many as 300 barbs on a small ¾-in. long feather; so a good deal of practice with the burning tool is needed to get the required degree of control.

I use a couple of different burning tools—the Hot Tool, available from Hot Tools, Inc., 7 Hawks St., Marblehead, Mass. 01945, and the Detailer, made by Colwood Electronics, 715 Westwood Ave., Long Branch, N.J. 07740. The latter has a rheostat control, allowing you to regulate the heat; the Hot Tool also can be equipped with an accessory heat-control unit. The skewed tip of the tool must be kept sharp, and its beveled faces cleaned often during use. I use 320-grit wet/dry sandpaper tacked to a block of wood to hone and clean the tip.

The burning pen is gripped somewhat like a pencil, but is usually moved away from you in sweeping strokes. Pausing too long will make the line dark and deep, and stopping at the end of a stroke will create a dark blob where you want the line to be finest. To avoid this, follow through with each stroke and lift the tool, while it is still in motion, from the wood. With practice you can develop a rhythm that will make the work proceed efficiently, but even then it takes several hours to burn-in the barbs on ten or twelve feathers. Because the barb lines are so close together and because you can't interrupt the motion of the tool, intense concentration is required, and it's best to take frequent breaks to keep from ruining your work. Most lines on feathers are slightly curved. To get the curve, you have to rotate the tool minutely as you move along the line. Use only the point of the tip, not its whole edge, and avoid making absolutely straight lines. Every carver has his own style, and with practice you'll find your own.

Burning-in these details imparts a warm, vibrant texture to the wood, and gives it a lifelike quality you wouldn't get from carving or scratching. I like the brownish color of burned lines to show through the paint. It adds a subtle touch of realism to the finished sculpture, and it shows the craftsman's hand. □

Eldridge Arnold, a retired graphic designer, is now a sculptor in Greenwich, Conn. For further reading on this topic, see Pyrography, The Art of Woodburning, *by Bernard Havez and Jean-Claude Varlet, Van Nostrand Reinhold, 135 West 50th St., New York, N.Y. 10020.*

Using real birds and photos for models, Arnold pencils in the outlines for the body feathers on a mourning dove, above. Several feathers on the bird's flank have been undercut to give them a shingled look, something the author does judiciously. Working in his lap, right, Arnold burns in the barbs of the feathers he has just drawn. The burning pen is drawn away from the body in sweeping strokes, and the thickness and depth of each line is controlled by pressure and duration of stroke.

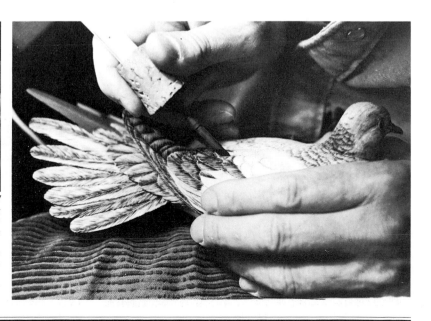

Natural Patterns
A patternmaker carves wildlife

by Jim Cummins

*Ripples from
a watersnake.*

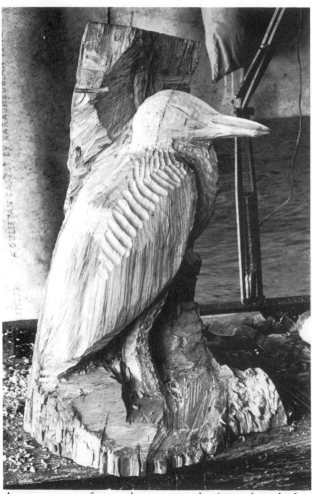

Sharp rubs a coat of linseed oil over the back of a nesting tern, who seems to be warning him to keep his distance.

An egret emerges from a cherry stump, showing tool marks from chainsaw, ax and gouge. Beak and head have been spokeshaved.

When John T. Sharp worked as a full-time patternmaker, he had to turn engineering drawings into three-dimensional wooden models, exact prototypes from which thousands of precisely mechanical copies could be cast. In a way, as a woodcarver now, he's working in reverse. In any flock of canvasback ducks, individual birds can differ, but each has the essential quality of its kind, a form and essence that distinguish a canvasback from any other bird. Sharp's carvings capture, and concentrate, this vital identity through abstraction and simplicity rather than by exactly imitating the lines of every feather.

Although his wildlife carvings are not the patternshop's literal copies, it was patternmaking that developed Sharp's ability to visualize three-dimensional shapes in wood. He says it was a necessary part of the job. Once, while working on a Pontiac grille, he spent a week studying the drawings before picking up a tool. But by the time he began to cut, he could see in his mind what he was aiming for.

Patternmaking is absorbing work, but Sharp says it never gave him much satisfaction, even though he could see the mass-produced results of his work all around him. So in his spare time he began carving log sections and tree stumps into birds, fish and water, combining the skills of his trade with his love for the outdoors. Every hunting or fishing trip through the country around his farm on the outskirts of Kent, Ohio, provided more data for his work. And most of the stumps were free for the asking—there's so much walnut and cherry in the neighborhood that Sharp burns it for heat.

When carving a bird, Sharp determines where it will be in the wood, usually leaving the pith to run through the bird's backbone. He roughs out the top view with one of his four chainsaws, and then he comes in from a side. He doesn't make many drawings, doesn't really even think in two dimensions, just cuts down toward the three-dimensional bird. After roughing out, he cuts as close as he can with a lightweight Stihl chainsaw, then finishes up with homemade knives, gouges and wooden spokeshaves, filling any objectionable radial checks with slivers of wood. He rubs in linseed oil, and patiently waits for the block to check some more. One green piece, on display last March in the dry air of the Cleveland Museum of Natural History, opened up a 1-in. crack clear through the water into the bird. Sharp, unperturbed, said he liked it that way.

Sharp balks at being called a wildlife artist, though his carvings exemplify why wildlife art has become so popular—

From *Fine Woodworking* magazine (September 1983) 42:40-41

Canvasback ducks at sea, carved lifesize from a walnut stump.

animals and birds with every line and movement spare, efficient, and honed by the tough business of staying alive. But to Sharp, "wildlife art" includes sentimentality and caricature, not at all what he's aiming for.

He likes to figure on charging $100 a day for carving, and his sculptures range in price from $500 to $5,000 (1983). So a small one takes about a week, and—because he figures that $5,000 is about the top of the market—he can't afford to spend more than a month or two on a large one.

When somebody commissions a particular subject, Sharp has to be able to tell at a glance how long the work will take, in order to give an estimate. He's gotten good at this, partly because patternmaking estimates are made the same way. I asked him whether there is much other carryover from the patternmaking trade, whether he uses the same tools, for instance, and he said that mostly he does—more planes in patternmaking, because there are more flat surfaces, but spokeshaves too. He likes to cut, not grind away. He uses quite a few Oriental tools in both kinds of work—there was a Korean worker, Rak Suh Kim, in the patternmaking shop when Sharp was learning the trade, and the tools stuck.

Sharp doesn't do much patternmaking these days, but returns to it once in a while. He thinks the discipline is good for him. Patternmaking is exact, both in the amount of time a job can be allowed and in the work itself. The birds? Sharp says the birds aren't disciplined, the birds are free. ☐

Jim Cummins is an assistant editor at Fine Woodworking.

Arnold Mikelson

by John Kelsey

Arnold Mikelson describes his carvings as "refined and diligent art." His house, surrounded by gardens, sits back from the road atop the bluff above the ocean in White Rock, B.C., Canada. Behind the house squat two A-frame buildings, the front one Mikelson's gallery, the rear his shop. Every day around dawn, there goes Mikelson, working steadily until late in the evening, 100 or more hours every week. For every hour carving, he guesses two are spent on overhead—sweeping, gardening, relieving his wife from minding the gallery. Even so, he makes 250 or more sculptures in a year, some duplicates of earlier work, but most of them new, always discovery. Often, he's actively working on one large piece and a dozen or more small ones, out of the several dozens that stand in various stages of completion around the shop. Says he, "If I do a large piece it's like a love affair with a beautiful woman, you can't find anyone to replace her. When I do a big piece I can't handle more than one, so I always have many little ones started also."

Mikelson figures he nets about $2 an hour for his labors (1980), but still he is diligent enough to support his wife and four children by carving alone. "This is not for a young person," he says. "John Matthews, the English writer on carving, once said I was the best in the world, and I agree that I am probably among the best. If I make only $2 an hour, what can a young guy do? I could double my prices and probably still would sell them all, but I don't have the nerve to try it."

As for refinement, you will have to judge for yourself from the photos. As for art, ask Mikelson whether this is woodcarving, or craft, or sculpture. Be

ready for an anecdotal excursion through art history: "This is not woodcarving. In the old country, woodcarving is like die-punching metal. My tools are the same, but if an old-time woodcarver makes a curved line, he uses a curved blade, and there's the curve, finished on the spot. My tools also have the curved blade, but none are used to determine the final shape; I do that, not the tools. In England I stopped in the studio at a cathedral, where a woodcarver was doing beading in a grape-and-vine motif. I say, 'Don't you ever get fed up with carving this same motif?' 'No,' he says, 'I've carved this pattern for the last 30 years.' The difference is design, and 90% of carvers don't design, they take someone else's design and copy it. Now, most people have the ability to learn to design, but the ability has to be developed from an early age."

He is just warming up: "Art form develops by line flow, you can spot where a thing came from by the line. The renaissance line is the most powerful, signified by a fluid, shallow S-curve, which is what I use....I have no argument against modern art, most of it is pre-caveman anyway. My request is if a person looking at fine art does not understand what it means, the artist should be able to explain. Art is creation by a man, as opposed to discovery, nature's art, such as driftwood or the shapes made by waves and wind. That's not creation, but accidental discovery. If the artist can't explain it, it's a discovery—the artist has to know."

Mikelson was born in Latvia in 1922, the son of a cabinetmaker, fortunate in those days to be able to study painting and drawing, the essence of design. After the war, in England, he designed porcelain figurines for production, many of them birds. "Birds are a part of my life, so I don't have to stop to reason out their forms. The human female, horses, have to be done a tiny chip at a time; take too much off, you fail. I understand birds, and with my fantasy figures, you can take a 7-in. wrong cut and nobody knows the difference." Nonetheless, Mikelson also makes women, and fish, and a menagerie of animals. But always he returns to birds, both real and fanciful.

Mikelson's figures are all laminated from solid stock, so the lines of each ele-

ment of the carving can work with the figure of the wood. His principal machines are the band saw, for roughing out the shapes, the belt sander, for making flat surfaces to glue together, and a small flexible shaft grinder carrying a 220 or 320-grit abrasive disc. "My secret," he grins. "I sharpen with it, first the belt sander to shape the edge, then the little grinder, then strop on leather and it's razor-sharp."

Hundreds upon hundreds of cardboard patterns festoon the rafters of the A-frame. "I draw the form, make the pattern, put it on the wood and arrange it so the grain can follow the lines of the carving. The patterns help me visualize, to develop full utilization of the lumber. Some of these have never been used, some I use over and over."

Once he roughs out the elements of the figure, he carves it in sections, and because of the way he works, the pieces may sit around the shop for a year or more before he glues them up. "If there is any movement, it has a chance to work itself out. Even a small bird is three pieces of wood glued up, no reason not to glue it." He uses white glue, thoroughly sizes the end grain, and if there are any dowels they are for locators only. The pieces never come apart, and one has to look hard for glue lines, so cunningly does he match the figure of the wood. Once a piece is together and the carving is completed across the glue lines, Mikelson finishes it with two to four coats of Benjamin Moore Imperial satin varnish.

Because he glues up his forms, Mikelson is usually able to carve with the grain, and to have the lines of the form follow the figure of the wood. He says, "The wood parts easily with the grain, much more difficult across the grain. So instead of cutting across the grain as most others do and making little chips, I make long shavings." He also prefers, whenever possible, to slice the wood with a knife. For example, most carvers would make the feathered wings and tails of Mikelson's birds with a *V*-tool. Says he, "I make a double cut, with the knife and chisel. With the knife, cut the side of the feather to a stop cut at the end. Then slice along to a skew or a straight blade. The surface comes from the tools, not from sandpaper or rifflers, although of course I use those too, but only when I have to." □

Sharpening with the Mototool.

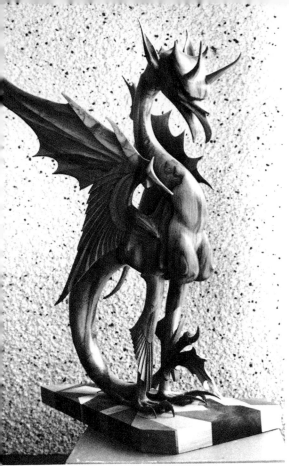

Typhon, son of Hera, satin walnut, $2,500.

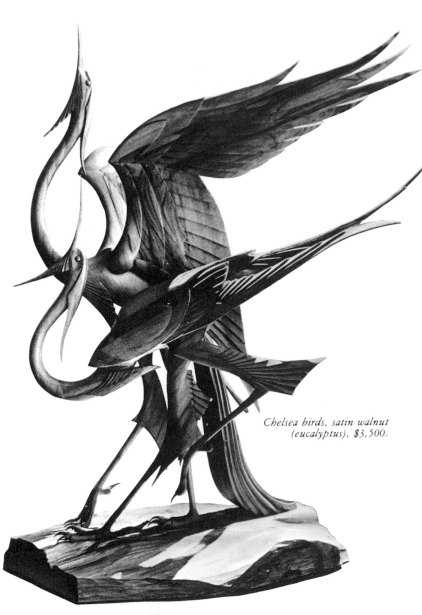

Chelsea birds, satin walnut (eucalyptus), $3,500.

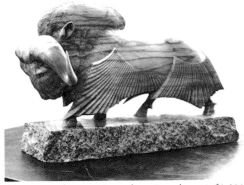

Above, musk-ox, satin walnut (eucalyptus), $1,200; below, fighting egrets, Brazilian walnut, $2,750.

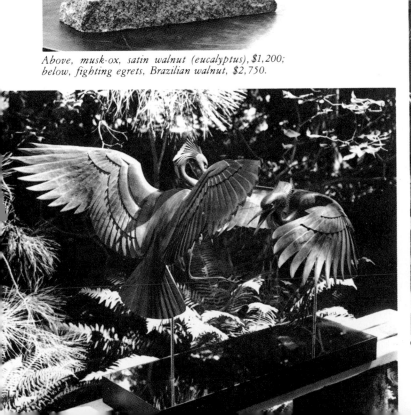

Carvings in progress.

Carving **65**

A Patternmaker's Carving Tips

And a portable carving kit for whittling wherever you are

by Wallace C. Auger

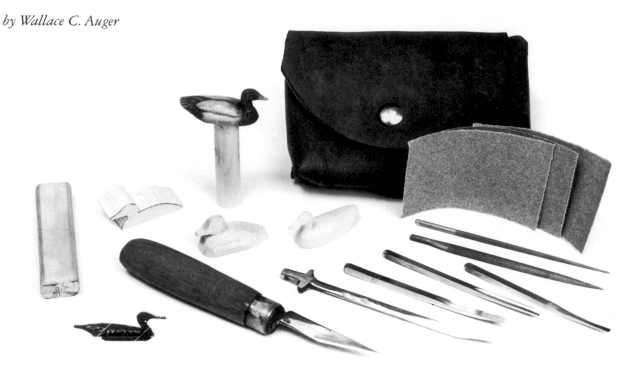

The author enjoys carving miniature decoys, but doesn't like to be tied to his bench, so he devised a carving kit that fits in a belt pouch. In the process, he discovered that small tools don't need bulky handles. The template shown was cut from a soft-drink can.

When I was an apprentice patternmaker thirty years ago, the old guys in the shop weren't eager to share what they knew. If an old-timer thought you were watching, he'd turn a little, so that his shoulder blocked the view, or he'd switch to some other work until you went away. So mostly I learned from workers my own age, but I picked up a lot just from the way the older guys moved their elbows. I'd catch a glimpse of what they were doing and try it myself. It didn't take long to learn that the main trick was to choose the right tool and cut in the right direction.

Any carving has problem areas, places where the wood won't cut cleanly in the direction you're working. Experience and practice will show you ways around the problems, but without a teacher, experience can take a long time. A miniature duck decoy is as good a practice field as any. You'll find the same problems there as in larger carvings or in more purposeful things such as cabinet and drawer handles. Whatever you want to make, here are some general carving hints that will smooth your path.

Few tools are needed to start. Because I like to get outdoors, I assembled a small kit that lets me carve miniature decoys anywhere (photo, above). I could probably get by with the knife alone, but the other tools make some jobs easier, as you will see.

First of all, you can't carve something until you know what it looks like, and general knowledge isn't enough. Anybody would recognize a pine cone, for instance, but how many of us have ever really looked at one? Is it egg-shaped or conical? How does each scale taper into the main form? Do the scales

run straight up and down, or do they spiral? You won't know unless you look. A carver must anticipate these questions—and a lot more—before starting to cut.

Ducks are symmetrical, which makes it fairly easy to make templates. For a miniature, carved from a single block, you need only a side-profile template (figure 2). But the outline will only start you off; you will have to thoroughly understand the three-dimensional shape you're aiming for. I'll give you tips about duck anatomy as we go along. For any other carving project, the same kind of knowledge and understanding is necessary—there is nothing more frustrating than to carve a block of wood to the point where it *almost* looks right, and not know where to go from there.

In any carving, get close to the final shape in the easiest way—use a saw. For a miniature decoy, I cut the blank profile with a jigsaw. For a larger blank, I bandsaw, cutting not only the side view but the top as well. On a larger bird, quarter-size and up, the head is usually carved separately, then glued on. This saves wood, and also allows you to bandsaw both profiles of the head, as is done with the body. Making the head separately allows you to shift the head template on the carving block so that the long grain of the wood goes in the same direction as the bill. If you tried to cut the whole bird from one block, and wanted a lifelike pose with the bill pointing slightly down, chances are you'd end up with short grain in the bill, which would be liable to break. For the same reason—grain direction—wings and wing tips that stand away from the bird are carved separately, even on miniatures.

Pick a wood that works well. Jelutong is my favorite, but

From *Fine Woodworking* magazine (March 1984) 45:58-60

basswood or any other soft, even-textured wood works well, too. White pine is good for larger birds, but it's a little too weak for miniatures. Some people use sugar pine for full-scale decoys, but I avoid it for miniatures because its large sap pockets can bleed through the final finish, even after you think you have sealed them.

Let's say you have your block sawn out. The first problem is how to hold it while you work. On a little carving, one hand is enough to power the tool, but your other hand will tire quickly if you try to grip the bare blank. On a larger carving, you'll want both hands free to manipulate your tools, so attach a handle to the blank. For miniatures, just screw the blank onto a wood screw epoxied into the end of a dowel. For larger carvings, you can hold the handle in a vise, or you could make the bench I use, shown on p. 68. It securely holds a blank at virtually any position.

The prime tool in my kit is a patternmaker's knife I made from a file many years ago. Actually, these days I prefer a laminated-blade Swedish carving knife, such as those sold by places like Woodcraft. (You can also make your own, using blades called Sloyd knives sold by most woodworking supply outlets; Erik Frost of Sweden is one manufacturer.)

A laminated blade sharpens faster than a solid-steel blade. Don't just unwrap the knife and start carving, however. It comes from the factory as a general-purpose knife, and it should be modified for the job at hand, as shown in figure 1. First, grind away most of the blade. It is false economy to have more steel in the blade than you need—the point will be too far from your hand to control. Then taper the blade so that it ends in a point, and sharpen as in the drawing, with a crowned bevel.

Many people will tell you that this is wrong, that the bevel has to be flat. Well, it depends on the job you want to do. A flat bevel will give a knife good control for long, straight cuts. But woodcarvers make a lot of scoop cuts as well as straight cuts and cuts across the grain. The most difficult cut is a tight scoop. A straight bevel tends to dig in and scrape at the bottom of a scoop (a hollow grind is even worse), but a crowned bevel helps guide and support the cutting edge. Think of a knife blade as if it were a bandsaw blade. If you try to make a tight curve with a wide blade, the blade binds. When a knife blade binds, its leverage splits off a chunk of your carving. So the tighter the curve, the narrower the blade should be. But, just as for a bandsaw, the narrower the blade, the harder it is to keep a constant curve. That's why a patternmakers' knife is shaped the way it is. It promotes a slicing cut, and, in addition, somewhere along the length of the blade there's the right width and the right crown for the scoop cut you want to make.

Begin to rough out a miniature decoy blank with the knife by cutting away the waste at both sides of the head to center the neck on the body. First, slice a line along the shoulder, aiming at the base of the neck, a little more than 1/16 in. deep. This is a stop cut, and it has to be as deep as or deeper than the shaving you plan to take from the side of the neck, because its purpose is to prevent the second cut from splitting ahead of the blade through the block. Be sure to slice when you use a knife, especially when making the stop cut. If you wedge the blade through instead of slicing, you won't have any control—chances are you'll cut the head right off, and maybe your finger, too. Make a series of stop cuts, taking shavings off the sides of the head to meet them, until the

Fig. 1: Shaping the blade
Grind away surplus metal to make the knife blade easier to control. The rounded bevel makes tight scoop cuts without digging in.

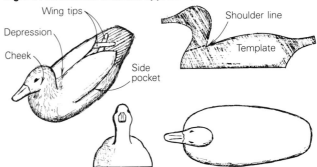

— Typical section
— Original blade

Fig. 2: A miniature mallard, approx. 1/12 scale

Wing tips
Depression
Cheek
Side pocket
Shoulder line
Template

Templates and sizes vary slightly according to species.

head and neck are squared off to the right width.

When slicing a stop cut, begin at the tip of the blade and end with the thicker part. You have more control with the thicker part of the blade because it's closer to your hand, and its shape will also help prevent the blade from going too deep. To control a cut, you must steadily decrease pressure during the slice. This lets you ease the cut to a halt. If you are right-handed, use your left thumb to help power the cut. Stop cuts, in general, are necessary anytime you don't want a cut to go too far. In scoop cuts, as you cut down from each side to the center, every cut can be thought of as a stop cut— each one prevents the wood from splitting out ahead of the blade on the next cut. When slicing a scoop cut, however, slice from the thicker part of the blade toward the tip. It takes less force to move the thinner part of the blade around the curve, and you'll be better able to maintain control as you ease through.

Next, round the body. On larger carvings, I'd recommend a wide, shallow gouge for this job, but the knife works fine on miniatures. When roughing out, you can take wood away quickly. Work from the high point on the body toward the ends—it's best not to cut uphill into the wood grain; cut down from each side. Use lighter cuts as you get closer to the line of dimension.

When making cuts, you'll find it best to work both hands together. By rocking your hands—something like a scissors action—you will maintain control throughout the cut, instead of having the blade run away from you. You will take a lot of wood off at the front and rear of the body, but aim for a wide curve, like a raindrop, that blends into the curve of the breast below the neck. When cutting from the center of the body back toward the tail, I'd recommend that a beginner make a template of the side of the bird. The template should fit the curve when the bird is finished. It also will show you where you must remove a lot of wood, and it will save you from "finishing" a bird before it has the right overall shape. For instance, don't waste time making a smooth curve along the corners of the block until you have roughed out the top-view profile. When roughing out, you don't have to be too

fussy—there's still plenty of wood if you make a mistake.

Perhaps the best carving tip I can give you is to pay attention to every cut. This is second nature to me after so many years of carving, but beginners often let their attention wander, and lose the chance to learn how the wood, the tool and the hands work together. If the wood tends to split or tear, you should figure out how to deal with the problem while you still have enough wood left to experiment. With the knife, simply changing the slicing angle can make a big difference. Change cutting actions and directions until you find what works. Remember which cut worked best for each trouble spot—it will also work well as a finishing cut. Slice rather than wedge whenever possible, regardless of what tool you are using. With the wide, shallow gouge I mentioned earlier, for instance, I make my share of straight-ahead cuts, but I use it more like a knife wherever I can, holding it slightly askew and slicing with it. Even when making a straight-ahead, cross-grain cut, you can get a gouge to slice if you rotate it a little as you go.

Keep the edges of your tools sharp, of course. When I'm carving larger work in my shop, the minute I feel an edge beginning to drag through the wood, I touch it up on a buffing wheel charged with gray compound. The setup doesn't have to be elaborate—I chuck a 3-in. dia. felt wheel in my drill press, right next to my bench. When I take my kit outdoors, with such small pieces of soft wood, I don't bother to bring sharpening gear along. The edges last long enough.

Ducks fold their wings beneath the feathers along the sides of their bodies. The wing fits into an area called a side pocket, and it pushes the side feathers out, away from the body. I use a V-parting tool to define the top of the side pocket. I could outline the side pocket with the knife, but the parting tool does the job in one stroke, whereas the knife would take two. The parting tool is easier and safer for the job, and its shape helps ensure that both grooves are the same size. Be-

cause the V-parting tool has such a small job, I removed its handle. The modified tool worked so well that I removed the handles on my gouge and straight chisel, too, grinding away any sharp edges on their tangs. The V-parting tool and the gouge originally came from a small Marples tool set, but I made the chisel from an old file.

The gouge also has a limited job: it hollows out the areas beneath the tail and the depression on the back behind the neck. The straight chisel makes the low spot between the wings and the tail, outlining the wing tips at the same time: I first make a stop cut by pressing the edge straight down into the wood for the required depth, then I use the same tool to clear the waste—something like chip-carving.

You should be able to detail most of the top of the bill with the point of the knife. For the tight curves around the neck, I use a round file. On the head, a couple of strokes with the round file make the groove above the duck's cheeks. I use a half-round to smooth broader curves, such as around the bill and along the sides of the head. To smooth the sides of the head above the cheek line, lay the edge of the half-round file on the cheek line, then gradually slide the file away from it during the stroke. If you try to file parallel to the line, the file may too easily wander, cutting into and lowering the cheek. When rounding the cheek below the line, begin at the line and roll the file away from it during the stroke.

A duck has a slight depression on its back, which channels water from the high point of the body forward, so that it can roll off at both sides of the neck. This is one of the small things most people don't notice, but if you omit it, the carving will look chunky and lifeless. Make the channel with the gouge and smooth it with the half-round file, being careful not to make the base of the neck too narrow—the neck should be about as wide there as it is just below the head, with the thinnest part about halfway up. This is the time to lower the surface of the wing tips slightly, so they look as if they are emerging from the feathers that cover them.

After sanding a little, you're ready for detailing. For this part of the job, it's best to have the carving on a handle, but the handle can be smaller than the one used for carving. I burn-in feather texture with a fine-point woodburner controlled by a rheostat, adjusting the heat according to how fast I want to work. I recommend sealing any wood before painting it. Shellac or lacquer works well. After sealing, I paint the bird with artists' acrylic colors.

A nicely painted miniature decoy sells for about $20 (1984 prices). They are made 1/12-scale, an inch to the foot; since this is the same scale as most miniature furniture, they fit right into a scale-cabinetmaker's room displays. I have sold my share of them, but now I carve them mostly for myself. I don't like to think of my carving as a business, because that would take a lot of the fun out of it. I would like to make a set of all the American waterfowl, more than fifty species if you count the geese and swans, and I find that one of the nicest parts of decoy carving is doing the research on the birds. I have learned a great deal from bird books and magazines, but I find they often disagree, particularly about the colors of bills and iridescent feathers. So once in a while I go to the park or the zoo and look at the real thing. I am retired now—I can go look at ducks whenever I want. □

Wallace Auger makes miniature furniture, sells plans for decoys and furniture, and carves in Fairfield, Conn.

Bench for larger carvings

The carving blank is screwed to a round anvil that fits into pivot blocks. The round post swivels, too, allowing the work to be turned and locked in any position. —W.C.A.

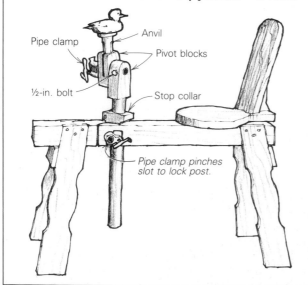

Pipe clamp

Anvil

Pivot blocks

½-in. bolt

Stop collar

Pipe clamp pinches slot to lock post.

Drawing: Jim Richey

Stacking

The technique of building up wood forms for carving

by John Kelsey

The technique of stacking, by which layers of boards are glued together and carved to make furniture, was virtually unknown 15 years ago. Today it is part of the vocabulary of many professional furniture makers. Stacking makes possible the most arresting of contemporary designs. It is high-technology work, depending upon modern adhesives, clamps, and power machinery.

Methods similar to stacking were used as early as medieval times, when sculptors occasionally glued baulks of wood together to build a block large enough to carve. Since the last century, carousel horses have been carved from laminated blocks of wood, with the legs and head attached by traditional joinery. Modern stacked furniture, however, relies on carefully preplanning the cross sections of the form at each elevation, and cutting the wood very near to the finished cross section before gluing it together. Wendell Castle of Scottsville, N.Y., believes he was the first to apply this technique to furniture, early in the 1960's. He has been doing it ever since, producing several dozen pieces a year, refining and developing his methods and forms.

Castle is trained as a sculptor and designer, but his interest in cross section goes back to his boyhood in Emporia, Kansas, during the 1930's. In the model airplane kits then popular, the fuselage was stacked balsa wood. The kit included a sheet of patterns and just enough 1/8-in. balsa to cut them all out. Then one would glue them together and sand smooth.

Most people, when first encountering Castles's work, conclude that he must glue together a rectangular block and slowly carve away the excess wood, like a sculptor with a block of stone. In fact, he tries to bandsaw each piece of wood to within 1/8 in. of the finished surface before gluing it. He works one layer at a time: cut, glue and clamp; cut, glue and clamp. The form is blocked out, more than half revealed, before it has been touched by a single carving tool.

Besides being esthetically satisfying, working this way is economical of time and material. Castle estimates his waste to be somewhat higher than that of a one-man cabinet shop, but lower than that of a furniture factory. In carving, he doesn't have to bash away pounds of material; he merely removes the stair steps of the stacked boards and refines the surface. This is the result of accurately visualizing cross sections from the start.

I followed the development of a stack dining-room table from a small clay model. Says Castle, ''This form started from a conch shell, although it has gone through about 50 variations over the past five years. Some of them looked much more like a conch shell than this. Bones are also nice sources of design. It's a mistake to try to interpret really literally, to make a big conch out of wood—you could have taken a photo. I use the conch as inspiration of form, to reinterpret and derive a new form. It ends up as a table base.''

As an aid to visualization, Castle often draws contour lines around his models. Throughout the work, the model is close at hand and he studies it frequently.

From the model, the first step is to draw a full-size plan of the bottom-layer. He glues up a flat slab of wood, traces the

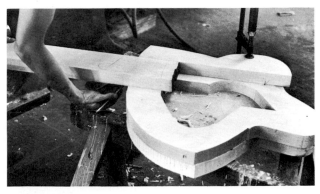

In photo sequence starting at left and going counter-clockwise—The clay model sits on the first two stacked layers. The shape for the next layer is traced. Castle applies glue and scrapes off the excess. He clamps across the work to prevent sliding. Clamps are placed about every three inches for even pressure and tight glue joints. The completed stack already resembles the model even before carving.

pattern onto it and bandsaws. With a new design such as this one, he usually makes the bottom an inch larger than the desired size. This gives an inch of material to play around with while carving, and if he doesn't need the inch, the base is just that much larger. No matter.

The wood for this table is 8/4 maple, planed to a uniform 1-5/8 in. thickness. While it might seem logical to work with wide boards, Castle finds random widths ranging from 6 to 10 in. to be least wasteful. Kiln-dried lumber and careful moisture control are essential to avoid unequal stresses and consequent delamination.

The base and first stack are glued together, with the process the same for every layer. First, Castle scrapes off the excess glue and planes the top of the form to remove irregularities in thickness and ensure a flat surface. The first board need only have one true edge—the other edge will be sawed away. With one eye on the model, Castle traces the outline of the stack on the underside of the board and then modifies the pencil line to account for the changes in the form at the new elevation. The more accurate the shape now, the less time it will take to carve the form later on. He goes to the bandsaw, cuts the board and tacks it in place with a clamp.

Now he selects a board with square, parallel edges, holds it in place, draws the inside cut on its top surface and traces against the previous layer on its underside. Again, he adjusts this line in tune with the evolution of the form, and bandsaws. At this stage every piece looks alike and one bump would scramble them irretrievably, if each weren't keyed to its correct location with pencil lines on its face.

As he works, Castle varies randomly the cup of the end grain both from layer to layer and from board to board and makes sure the glue lines don't coincide. This tends to equalize stresses throughout the mass as the wood expands and contracts. And it avoids the regularity of a brick wall, which would introduce visual confusion—the predictability of the pattern would conflict with the perception of the form.

At this point, there are six pieces of wood in each layer. The table base is hollow to save weight and allow the moisture content to equalize. The bottom plate is solid now, but a hole will be drilled in it later on. And the underside will be routed out so the table rests on an edge, more stable than a slab.

A small ear left on the last board in the layer provides a

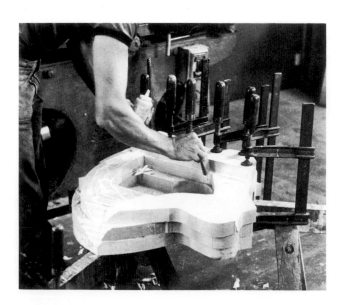

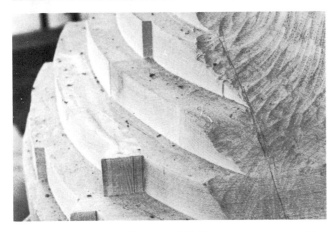

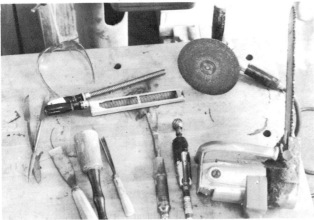

Chain saw, Surforms, pneumatic gouge and ball mill, gouges, rifflers and sanding disc are used for shaping. Then the top transition pieces are assembled and aligned.

parallel surface for a clamp to bite in, drawing the edges of the boards together. Now is the time to check back with the model and make sure there is enough wood for the changes in the form; occasionally, Castle discards a piece of wood and saws another.

As the stack climbs, each layer twists with respect to the one below. In each, the grain remains at right angles to the long, curved edge. Castle explains that in this case the grain twists about 2 degrees per layer, to follow the twisting form and to allow carving downhill, with the grain, where there are grooves. The grain could twist as much as 5 degrees from layer to layer without danger of delamination—in a board, the fibers vary that much from parallel as the grain curves. Without such preplanning, one would be left trying to carve uphill, against the grain, from the bottom of a groove to the top. And that wouldn't be possible.

Castle uses both Titebond yellow glue and powdered plastic resin glue. The yellow glue comes ready-mixed and is convenient; powdered glue, while stronger, must be mixed anew for each job.

When the entire layer is cut, he carefully brushes the sawdust and chips from all the surfaces, lugs over a couple of dozen clamps from the rack in the middle of the shop, and begins to spread the glue. He uses a wooden shim for a spreader, starting on the stack and initially covering only the area of the first board. Then he coats the face and edge of that board and tacks it down with clamps, making sure it is in exactly the right place. Some of the clamps reach to the bottom of the form, and some go only to the next layer down; it doesn't matter. Then he quickly spreads glue across the rest of the stack and the other five boards in the layer, and plants them in place.

Quickly now, before the glue can set, two horizontal clamps pull the edges together. Without that little ear on the outside board, the clamp would have nowhere to bite. Another pair of horizontal clamps, reaching across at various angles, draws the joints tightly together and the glue oozes out. One glue line is recalcitrant, and a vertical clamp, set to bite at an angle, draws it snug. Castle calls this "applying a little East Indian."

Now more vertical clamps. A clamp every three inches all around the form, a clamp directly on every glue line, clamps alternately at the outer edge and near the center. Each clamp is twisted one-hand tight. When he is done, and it doesn't take long, there are 28 clamps. Any glue-squeeze wiped off

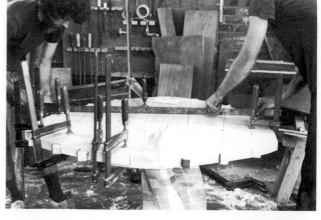

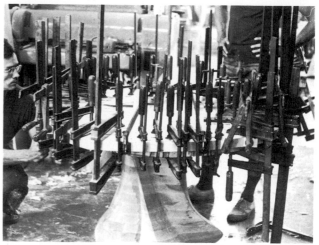

The cavity of the first top layer is carved to remove weight, as it adds no useful glue surface. The top is clamped across to help keep the pieces level, and then laden with clamps until the glue sets.

now won't have to be scraped off later.

On a good day, Castle will stack a layer first thing in the morning, another at lunch time and a third at quitting time. The clamps stay on at least two hours with yellow glue, and overnight with powdered resin glue. Thus it will take about a week to build up the table base, although the total time each day isn't more than two hours.

A large piece of furniture, festooned with clamps holding 30 or more pieces of wood in a layer, may weigh 600 pounds. The weight of the clamps may cause it to tip. Get quickly out of the way; it's far too heavy to catch.

Some workers use a veneer press to stack. But while the press applies enormous pressure, it is uniform pressure and that's not what is needed. Hand clamps follow the irregularities in the wood, the tiny differences in thickness, the vagaries of warp, twist and cup, and still squeeze hard enough to produce a good joint. They also can be adjusted to apply pressure at an angle, and ganged to apply extra pressure when necessary—in general, they're a lot more flexible for this kind of work.

Wood coated with glue, especially yellow glue, is slippery. A combination of horizontal and vertical hand clamps controls slippage and keeps everything where it ought to be, but in a veneer press you'd have to use locating dowels. And then when you decided to change the form later on, to carve a little deeper, the dowel would surface.

When the entire base is stacked, it resembles a free-form staircase. If the pieces have been sawed accurately, what remains is to carve away the stair steps. Ideally, the desired surface lies just below the vee of each step. In practice, this is more true in some places than in others. A piece that has been made before can be stacked even more closely than a new one like this.

While it is possible to build a table from the top down, this one has to be done from the bottom up—otherwise, you'd need clamps with a three-foot throat. In general, Castle stacks as far as he can without impairing the carving, then carves as far as he can without making the rest of the clamping impossible. In this case, it is much easier to carve the base before adding the top. There is more room to work, more directions from which to work, and less mass to shift around.

The whole form could be carved by hand, with mallet and gouge, and smoothed with Surform, riffler and sandpaper. Castle, however, uses an array of power tools, most of them air driven, to save time. He begins with the chain saw, paring

away the stair steps, moves to the ball mill and pneumatic chisel to refine the main forms and block out details, and the body grinder to remove tool marks from large surfaces. The details are worked with mallet and gouge, and refined with Surform and riffler. He keeps Surform tools in sets, some to cut on the push stroke and some reversed in the handles to cut pulling.

Throughout the carving, he keeps the whole piece at the same stage; when one area is about right he moves to another. Thus the whole piece is brought at once from stepped layers to the general rough form, then each plane and hollow is defined, the sweeps of line adjusted and their starting and stopping points feathered imperceptibly to nothing. What makes a line is the intersection of two curved surfaces; what makes this form "read" is the lines. That means the surfaces have to be just right, so the lines will be just right. To change the curvature of a line, he has to change the surfaces that make it—he can't just whack a corner off. Finally, Surform and scraper remove the minute hollows and bumps and the piece is ready to sand.

The base of the table nears completion. It is remarkably like the model. Says Castle, "It's freeing for me to work in clay, and then figure out whether it's possible to make the form in wood. But in fact I find I make decisions early on, from my experience, and shy away from forms that would be too difficult to make, or too heavy to be practical. The forms I

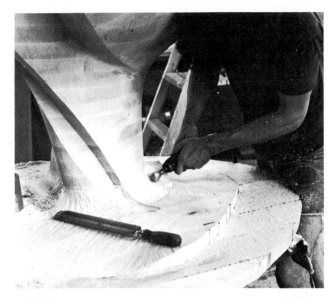

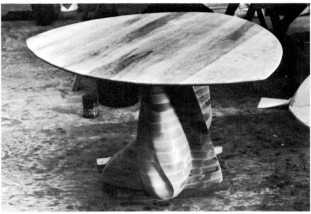

A ball mill helps shape the graceful transition from top to base. After six coats of Watco the table is finished.

horizontal, but there must be enough wood to feather out so it is made nearly as large as the top itself. Since most of it will disappear, it is a good place to use up low-grade wood.

When the glue has set on the center three boards, Castle removes the clamps and begins to work out to the edge. He holds each board in position to lay out the cuts, marking them carefully for repositioning. As each is bandsawed, he tacks it in place with a couple of clamps atop the joint. An ear must be left on every board for the horizontal clamps that draw them together. A thick, straight plank, plus clamps directly on each glue line, keep the boards aligned. He puts paper under the plank to keep from gluing it to the table.

When the clamps come off, the surface is scraped to remove glue-squeeze and planed. The hole at the center is widened with gouge and chain saw to remove weight and because no useful clamping gluing surface is available there—no way to clamp. He vacuums the cavity to remove chips.

From the template, the wood for the top is cut and indexed. These boards are slightly thinner, about 1-1/4 in., to save a little weight and to achieve the correct table height. The long, tapered transition from base to top and the thin, rounded edge he plans make it impossible to detect the difference in thickness.

Castle next adjusts the placement of the top with reference to where the base provides support at the floor. The contour can still be changed later on, by chain saw and saber saw. He traces the previous layer on the underside to show where to spread glue and draws a line along the edge of a center board, keying it for precise relocation.

He changes to plastic resin glue to fix the top, at first brushing it only where the center board goes. This type of glue, mixed from powder each time, is more resistant to heat and moisture than yellow glue. Tabletop conditions won't cause yellow glue to fail, but may raise the glue lines or cause the boards to creep a little. And powdered glue gives a longer open time to work.

The dust is carefully brushed from all the surfaces, the center board positioned and clamped at each end. Then he spreads glue on one side of it and on those boards, positions them, and continues on the other side. The outer boards on each side aren't supported from underneath, so they wait on top until the horizontal clamps are applied. The first horizontal clamp goes from ear to ear across the whole top. A few vertical clamps go directly on the glue lines to tack the boards in place, with paper to prevent staining. They will be supplemented and tightened later. The deepest clamps in the shop reach in a foot from the edge. Castle and an assistant put clamps everywhere they will fit, in the end about 60 of them.

The clamps come off, the excess glue is scraped away, and the edge saber-sawed close to size. Castle carves the transition between base and top the same way he carved the base itself, with chain saw and ball mill, body grinder, Surform and gouge. The piece is ready for sanding.

The usual sanding sequence in Castle's shop begins with 32-grit rotary discs, then 80-grit discs, to remove digs and tears and bring the whole surface to the same degree of fineness. Then the whole form is carefully gone over with a **sharp scraper to level the surfaces, remove bumps and hollows and minute irregularities. Then the wood is dampened to raise the grain, hand sanded at 150-grit, and finished off with 220-grit followed by six coats of Watco.** ☐

draw and model fall into patterns that lend themselves to the things I know about doing; I don't do radical experiments that risk disaster. That experience, those patterns become my vocabulary and I work within it.''

The base was made without a definite top in mind, with the idea that it might fit a round top left over from an earlier project. ''I've never made a table this way before, with the top abruptly planted on the base. I've always said that was dumb. Tables should have an organic transition from base to top,'' Castle remarks. Then he plops the round top onto the base and it's clear he was right—it doesn't work. So he makes a cardboard pattern, a three-sided lozenge, and trims it to shape. Much better.

From the base as it was, it will take three layers to make the vertical-to-horizontal transition and complete the table top. And at that height, the table would be too high. So he chain-saws off a couple of laminations and glues on a slightly larger layer to create a clamping surface. Then he cuts and clamps the center three boards of the layer that is just under the top.

This layer has to be done in two stages because the boards at the perimeter are edge-glued to those at the center. The center three boards glue to the table base, but there isn't anything under the boards at the edge. In the end most of this layer will be carved away in the transition from vertical to

Little Gems
Jeweler carves contemporary *netsuke*

by Susan Wraight

Before touching a tool, Wraight studies her animal subjects at close hand. A live crayfish posed for this 4⅛-in. portrait in holly.

I became a woodcarver almost by accident. Temporarily bored with the metal engraving I was studying as a jewelry student, I amused myself by carving faces in a scrap of boxwood. I had worked with wood before, at Brighton Polytech in Brighton, England, where I studied wood, metal and ceramics. But I wanted to work in miniature, and at that time wood seemed synonymous with furniture, turnings and large-scale wood sculptures. It didn't occur to me to combine jewelry techniques and wood until my second year at the Royal College of Art in London. Fortunately, I received encouragement from my tutors, and I left college after a degree show featuring nine silversmiths and jewelers, and one woodcarver—myself. I have worked almost exclusively in wood ever since.

The decision to change from metal to wood was made easier by my growing disenchantment with the limitations of jewelry. I scoured the museums and galleries of London in search of background material from which I could develop a style of my own. I discovered for the first time carved English misericords (parts of a church pew), medieval German woodcarvings, and Japanese *netsuke* (miniature sculpture).

It was the *netsuke* (pronounced nets-'kay), however, that influenced me most. As a jeweler, I found their intimate scale and meticulous detailing appealing. The fact that they were designed to be worn rendered them familiar (see box, p. 78). I was intrigued by the narrative element common to many examples, and the wit with which it was translated into three

dimensions. *Netsuke* effectively combined all the elements I wanted to use, and I decided to experiment with a similar hybrid of jewelry and woodcarving.

When you're carving on a very small scale, all processes can be done easily by hand and in a remarkably small work area. No elaborate machinery is necessary. This kind of carving is a quiet and unobtrusive activity, and it puzzles me that more people aren't pursuing it. Perhaps it's because people aren't accustomed to thinking of wood as a precious material, and therefore they don't consider wood for purposes that suggest the use of ivory, precious stones or metals—the traditional materials for jewelry and other miniatures. It may just be the scale that puts craftspeople off. For anyone interested in carving miniatures, I can only offer my own experience as an example, and hope that if you do decide to take it up, you will gain the same pleasure from it that I do.

My early attempts at woodcarving were done with the jewelers' tools I had available, and I still use many of these. I did the main work with metal engravers and scorpers, or chisels. Dental probes, needle files, rifflers and burnishers were also pressed into service. I was encouraged by the results that could be achieved with the simplest of tools and a minimum of fuss. Besides my metalworking tools, I've recently acquired a set of tiny gouges that are similar to woodblock-cutting tools in appearance. The steel shaft of each is equal in length

Photos, except where noted: Frank Thurston

to the distance from mid palm to the end of the thumb, which in my case is about 6 cm (2⅜ in.). This shaft is set into a spherical handle which butts up against the palm of my hand. I carved a flat off one side of the handle to give it a better grip.

Research is the first step in any carving. I enjoy this stage enormously because it varies according to the chosen subject. My work tends to fall into three categories. Straightforward studies of animals and birds are probably the most popular, and include such disparate creatures as chameleons, dormice and octopi. I also carve creatures of fantasy and imagination: dragons, basilisks and griffins. These are a wonderful excuse for self-indulgence. The third category can be described as narrative pieces, which take their inspiration from literature and include such subjects as ''The Walrus and the Carpenter'' (photo, p. 77).

For an imaginary or fictional piece, research may involve just reading. For the animal studies, however, it means getting as close as possible to the chosen subject. This may necessitate spending a couple of days at the zoo, or crawling under hedges, or poring over books and taxidermists' models. Ideally, it means studying the animal close-up. This I managed to do recently when I kept a benevolent and gratifyingly acquiescent toad in my bedroom for a couple of months. I have long thought that a major prerequisite for a woodcarver is having long-suffering companions.

Guided by my drawings and photographs, I make numerous models in Plasticine modeling clay. Planning at this stage is most important. Technique can be beguiling, but form must come first if the piece is to succeed. A badly conceived form covered with beautifully executed detail is not enough. Although I allow myself to stray from the model once I am working in wood, I've solved all design problems before I pick up a gouge, and that instills confidence. Once I have obtained a satisfactory model, I can select my wood.

I mainly use English hardwoods, particularly boxwood and holly, the former being my favorite. Boxwood really is remarkable, effortlessly delivering all I ask of it. It holds tight, crisp detail, and gives a superb surface finish. I invariably choose boxwood unless I want to introduce a faint color wash, in which case I substitute holly, because it accepts a stain so well. Occasionally I use lignum vitae or ebony, especially if a subject calls for a dark wood. In selecting wood for miniature carvings, the main criterion is that it be dense, with tight, close grain and no pores, in order to hold the detail.

Referring to the model, I draw my subject roughly on the block. Holding the block in the bench vise, I cut away as much excess wood as possible with a small backsaw. A bandsaw is much quicker, but not essential when working to this scale—most of my carvings are no more than 6 cm (2⅜ in.) in their largest dimension. A belt sander is also useful.

Having roughed out the block, I remove it from the vise, and proceed with small gouges and chisels. Holding the block in my hand, I turn it constantly, working on all sides and frequently referring to the model. From this point, I no longer use the vise, as it is cumbersome to keep undoing it when carving a mere six inches from my nose.

I hold the tool in one hand, the work in the other, and the carving action is very controlled. The best way that I can think to describe it is that it's like wood-engraving on a three-

Tony Boyd

Intricately modeled in boxwood and ebony, 'Wasp on a Blackberry' (top) is only 1⅜ in. high. Patterns produced by careful detailing bring a carving to life. The scales on this 'Hatching Snake' (holly, 1¾ in.) spiral around its body, and help to create a feeling of tension within the creature. The unadorned surface of the egg provides a marked contrast.

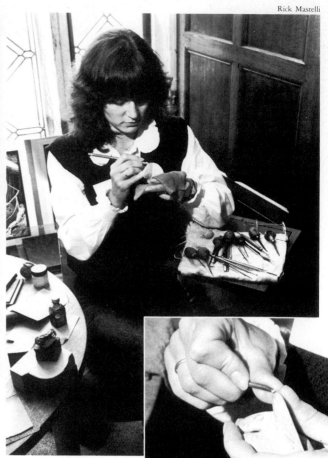

Rick Mastelli

'Mountain Hares' (holly, 2 in.), above left, have inlaid ebony and amber eyes. After roughing out a piece, Wraight pencils in details before carving with engravers, chisels and dental probes. Carving action is controlled: movement comes from the fingers, not the arm, with thumbs firm against the wood and each other. The tool slides along the thumb to make a cut.

dimensional object, but with a more robust cut. It's essential to guard against slipping. This is done by holding the thumb of the cutting hand firmly up against either the wood itself or the other thumb. All movement must come from the hand—not, as you might expect, from the arm. Holding my arm and wrist still, I slide the tool along my thumb, cutting a small, neat shaving from the wood. One cut will be enough to show you why you aren't likely to inadvertently chop off a carefully carved arm or leg: the process is so slow and painstaking that it can almost be described as gentle. There is no violent swinging of mallet and chisel. All tools must, of course, be kept as sharp as possible.

I use various grades of abrasive paper to remove the larger tool marks and then I draw in the finer details with a hard pencil, checking for symmetry and ensuring that I do not include detail for its own sake. I then abandon the gouges for engravers and small chisels about 2mm (³⁄₃₂ in.) wide. Old dental probes, honed into scrapers on a stone, are ideal for reaching into difficult areas.

As the carving develops into a recognizable shape, more detail can be added with finer tools. Patterns produced by careful detailing create movement. The scales on a snake's body, for example, can spiral around it and vary in size and shape, to create a feeling of tension within the creature. They draw the onlooker's eye around the piece, and people handling the carving always turn it around to follow the pattern as it twists. But too much detail must be avoided, or the

sense of movement will become confused. Also, there's a risk of appearing to use technical skill for its own sake, and such conceit renders a piece sterile. To me, a natural-looking carving never appears labored. As a personal preference, I like to leave some area of the carving plain—to serve as a foil to the detail, and to show the beauty of the wood.

I leave the surface finish straight from the tool as much as possible and avoid using abrasive paper in the final stages. No matter how fine the paper, the scratches it leaves will be all too apparent when a piece is examined as closely as miniatures tend to be. Once all the carving has been completed, I inlay the eyes, when appropriate. Sometimes I inlay just an ebony or horn pupil, but usually I do the whole eye, inlaying horn or amber with an ebony pupil. This is an infuriatingly fiddly process, but worth the effort. I work the eyes as a pair, and carve, rather than drill, the sockets. I taper the inlay slightly to give the tightest possible fit and, just to make sure, fix it with epoxy glue.

For staining, after much experimentation I found that ordinary drawing inks best suit my purposes. They can be diluted and mixed to obtain the subtlest shades, and they are easy to apply with a sable-hair watercolor brush or a cloth pad. Although I understand that these inks will fade in time, the darkening of the wood with age and constant handling will also contribute to a change in the character of the piece. Thus I don't feel the fading to be a disadvantage, but part of

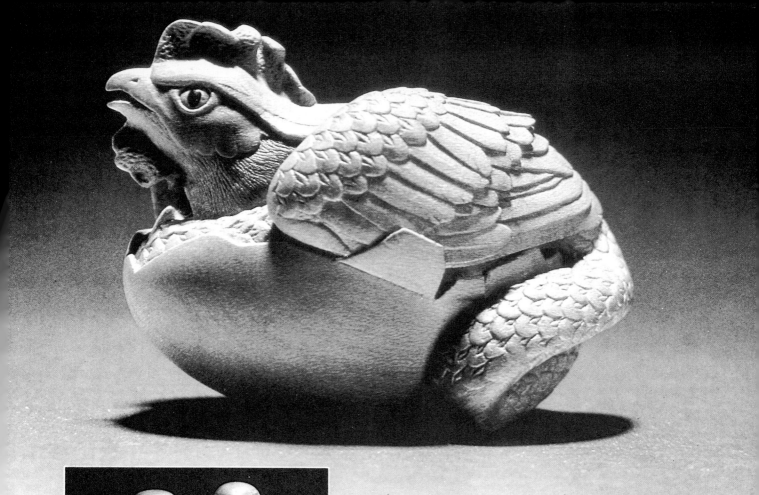

Tony Boyd

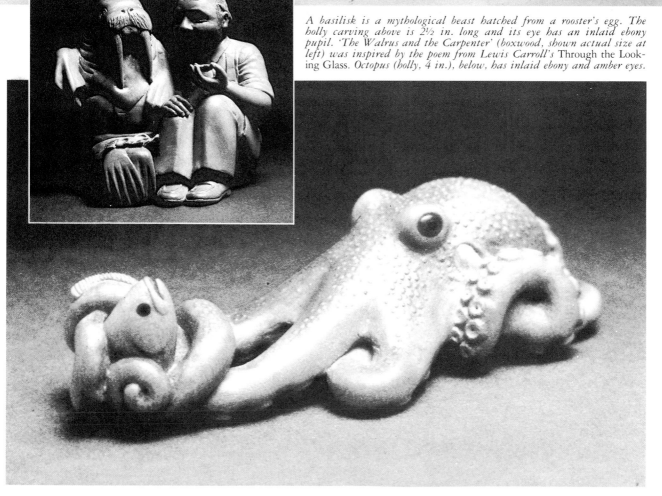

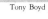

A basilisk is a mythological beast hatched from a rooster's egg. The holly carving above is 2½ in. long and its eye has an inlaid ebony pupil. 'The Walrus and the Carpenter' (boxwood, shown actual size at left) was inspired by the poem from Lewis Carroll's Through the Looking Glass. *Octopus (holly, 4 in.), below, has inlaid ebony and amber eyes.*

Netsuke, a tradition of miniature sculpture

by Whittaker Freegard

Picture a group of people excitedly passing around small objects which they look at closely for a few seconds, lovingly cup in their hands and caress, then pass on to the next pair of eager hands. To a casual observer, the handling and passing seem shy, almost furtive, as if the objects might jump away or vanish in a curl of smoke. It is the rubbing hand movements, though, that indicate what these people are doing. They are *netsuke* enthusiasts attending a convention, where they can enjoy the artform that has flourished in Japan for more than four hundred years.

The *netsuke* originally was meant to be worn. It was attached by a cord, often to a small case called an *inro* that held seals, ink or medicinal herbs. The case was worn by slipping the cord under the sashlike belt tied around the *kimono,* with the *netsuke* acting like a chunky button to keep the case from sliding down. Since Japanese clothing had no pockets, items such as purses, keys, flint pouches and clocks—whatever needed to be carried—dangled from *netsuke* and cord. These hanging objects were called *sagemono.*

Early *netsuke,* from the 16th century, are unadorned toggles, made from natural objects such as a piece of root or a stone. (The word *netsuke* derives from the words *ne,* root, and *tsuke,* to fasten.) These soon developed into highly detailed sculptural studies of Japanese life and legend. No subject was spared the close scrutiny of the *netsuke* artist. Often as not, the figure was executed with a humorous twist.

These detailed little carvings of boxwood, ebony or ivory were eagerly col-

A flute case *sagemono* dangles from an *ivory* netsuke *by Whittaker Freegard.*

lected and worn by the growing merchant and upper classes in Japan. When a 100-year-old ban on tobacco was lifted early in the 18th century, tobacco pouches and pipe cases became common items suspended from *netsuke.* It wasn't until the late 19th century that the wearing of *netsuke,* along with the rest of traditional Japanese clothing, became less fashionable.

Because *netsuke* were plentiful and no longer in use, they were once relatively inexpensive. Many large collections were amassed in the United States and Europe. Few early collectors, however, knew of the fabulous legends and traditions depicted in *netsuke* art.

All that has changed. Today there are *netsuke* enthusiasts and scholars all over the world. When a sought-after carver's work comes on the market, it is anything but cheap. Some individual carvings with the right pedigree have fetched more than one hundred thousand dollars.

There is also a growing number of contemporary *netsuke* carvers. Most of their work, whether from the East or the West, follows traditional Japanese themes, though there are a few, particularly in the United States, who are interested in applying old techniques to new themes. □

Whittaker Freegard is a flute maker and netsuke *carver. For more information about* netsuke, *write to the Netsuke Kenkyukai Society (Box 2445, Gaithersburg, Md. 20879), the worldwide association of collectors and scholars of* netsuke *and related Japanese arts.*

a natural process. For the final finish, I use the thinnest smear of linseed oil diluted with turpentine, or an enthusiastic application of wax. I never use lacquers or varnishes, as these interfere with the tactile quality so important to a work that will be frequently handled, and with the beautiful patina that handling gives to a carving.

It all sounds easy, and indeed there is no mystery and nothing too difficult about the techniques. A few hours of experimentation will tell you whether you have an aptitude for this style of carving. The tricky part is the design of the piece: conceiving a three-dimensional object in your mind, and then deciding what to leave out, what to include, how far to go and what you want to say. Although these skills can be learned, they are essentially emotional responses, and the more intuitive the better. So much depends on how you feel about your subject, and your ability to communicate that in the finished piece.

Carving, especially in miniature, is time-consuming, and a

carver needs discipline, patience, and good coordination between hand, eye and brain. It is, however, immensely rewarding and highly individual. No two carvings can ever be identical, and there is satisfaction in that knowledge. There are also the joys of working in wood which all woodworkers are familiar with, although the carver of miniatures is possibly more aware of these, due to his intimate contact with the material.

Unlike traditional *netsuke,* I don't intend my pieces to be worn, but I do design them to be handled. Many of my clients carry their carvings around in their pockets and play with them like worry beads. This always delights me. The pieces inevitably get dirty, but they also acquire a lovely patina. I'm sure that their owners derive more enjoyment from them that way than from seeing them behind glass. □

Sue Wraight carves her miniatures in her London flat. She has just completed three months as Visiting Artist at Melbourne State College in Australia.

The Carousel Horse
Hollow carcase makes a sturdy beast

by Roger E. Schroeder

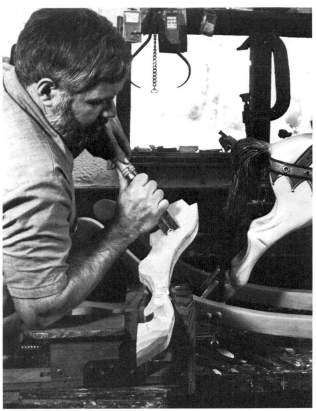

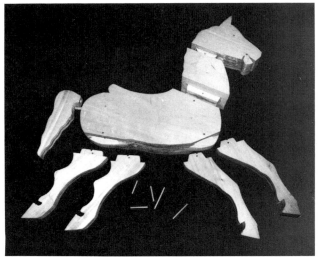

A scaled-down version of the carousel horse shows one way to join ex-tremities to body. Because these legs have no sharp bends, they can be cut entirely from a single piece of stock.

Gerry Holzman carves the hind leg of a rocking horse. Leg is held in a chops, a traditional English carving vise. Carousel horse and smaller hobby horse have identical structural features.

Despite their often massive and muscular appearance, wooden carousel horses have hollow bodies. Centrifugal forces exerted by spinning carousel platforms that parade as many as 64 horses, not to mention chariots and other encumberances, make weight important in the design and construction of the horse. Aside from lightness, the hollow body has another advantage—it's less likely to develop the deep checks so common in large, solid-wood carvings and statues. The hollow carcase makes the horse durable and able to cope with seasonal and atmospheric changes.

The carousel is a European invention. The Italians gave us the word (*carosello,* meaning a joust), the French made it mechanical, the English gave it steam power, and German cabinetmakers brought it to this country in the late 1800s.

Early in our century a typical carousel shop may have employed as many as 20 to 30 workers. An apprentice started as a sander, progressed to roughing out the body, then might become the head carver—literally carving only the heads. Working from memory and a few sketches on the block, he could recreate anatomy and muscle tone, as well as create bold and even flamboyant features.

Today wooden horses have given way to steeds of plastic and metal. But a New York trio of carvers is reviving the beauty and grace of the wooden carousel horse through restoration and construction. I met Jim Beatty, Gerry Holzman and Bruno Speiser at their East Northport shop and learned some of their techniques for continuing this form of folk art.

Speiser, who has himself restored 25 horses, bought his first

Roger Schroeder, a woodworker, teacher and freelance writer, lives in Amityville, N.Y.

one for $25 almost 20 years ago. Today (1980) a restored horse costs between $3,500 and $5,000, depending on the company that made it, the carver, the age of the horse, and the workmanship. Restoration might include removing dozens of coats of paint (many horses were painted yearly), disassembling 40 or more pieces of wood (if the joints have separated) and replacing broken pieces. Restoring a horse has its rewards. As Holzman says, "In recarving a line or muscle, you get a communication established between you and the carver...who originally did it 50 or more years ago."

Construction — Whether you're restoring a horse or designing a new one, it's a good idea to visit a carousel or a museum that displays horses. Bring your camera and plenty of color slide film. Take full-view shots of the sides, the front and the back, and take close-ups of details. Project the images onto a sheet of tracing paper hung on a wall and transfer the projected lines and shadows to the paper. You determine the size of the horse by increasing or decreasing the distance of the projector from the wall. Sometimes it's feasible to trace the image of one horse and then to project the image of another on top of it. Designing from a composite frees you from the necessity of choosing one model and sticking with it.

At this point you'll have to decide on which body stance you prefer, and the composite method is helpful here because you can use a number of different horses in different positions to produce the single posture you're after. Whether running or jumping, with the head forward or down, the position and attitude of your horse can be pieced together from various models or simply copied directly from one you like.

Once all of the design decisions have been made, you'll

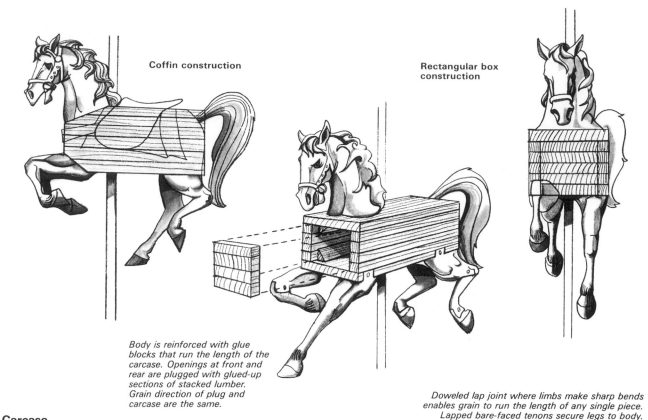

Coffin construction

Rectangular box construction

Body is reinforced with glue blocks that run the length of the carcase. Openings at front and rear are plugged with glued-up sections of stacked lumber. Grain direction of plug and carcase are the same.

Carcase construction

Doweled lap joint where limbs make sharp bends enables grain to run the length of any single piece. Lapped bare-faced tenons secure legs to body. Sometimes these members were simply butted together and doweled from the outside.

need to superimpose on your drawings the outline of the carcase construction I'll describe below. Also, it's wise at this point to draw in the appropriate joints that will hold the discrete parts of the body together. The body of the horse consists of a bottom, two sides and a top all made of 2-in. stock. Usually four pieces of lumber, stacked and face-glued, are used to fill the openings at either end. These laminations project several inches into the carcase to accommodate carving the curves of the chest and rump. The grain in these pieces must run parallel to the length of the body to enable the entire area to expand and contract as a single piece of wood. Orienting the grain in this direction also facilitates carving.

Since carving makes the use of nails and screws unsuitable, the case is reinforced with glue blocks that run the entire available length of the four inside corners. The glue blocks ought to be made of the same material as the body, traditionally basswood or poplar.

The front corners, top and bottom, are sometimes angled inward to make the juncture with the neck and forelegs. This is called coffin construction. Large pinch dogs hold the body together after hide glue is applied. Wood for the saddle is then added while the extremities are cut to shape.

The legs are a special consideration. Wherever a knee or hoof makes a sharp bend, another piece of wood is used to keep the grain running the length of the member. Some shops used a butt joint held together with dowels inserted obliquely through the two pieces from the outside. The best way is to use a lap joint reinforced with a dowel run through from the outside. Where legs join bodies, dowel-reinforced butt joints can be used or tenons can be cut on the legs and set into mortises in the body. If the tail is wood, it usually is

Lines and arrows show location and angle of joints on full-size carousel horse.

Photos: Sue Holzman; Illustration: Ric Lopez

Head blank is tenoned and pegged into partially carved neck. Mortises for forelegs have already been cut in lower chest.

Holzman puts finishing touches on head with carving gouge.

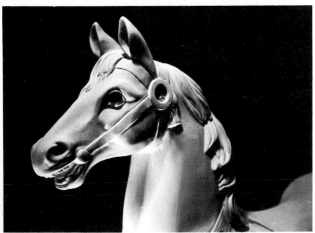

Carving complete, the undercoat is applied. Flaring nostrils, perky ears and tensed neck muscles impart vitality to wooden steed.

doweled into the rump and made to flow into a leg where it can be attached. This prevents it from being easily broken off. The tails of many horses were of real hair, not difficult to obtain when horses could still be seen on city streets. Still others were carved.

Carousel carvers like to emphasize muscles, tendons and bone structure. Common are flaring nostrils, prominent teeth, straining heads and bodies. To reduce the difficulty of the undertaking, it is advisable to carve the legs, neck, head and body independently of each other. Each part should be taken to a near-completed state, leaving a couple of inches undone where each piece will be joined to another. After that the pieces can be faired into each other. There are decided advantages to working this way and not having to manipulate a glued-up horse that may be bigger than you are.

It is best to bandsaw the rump and chest profiles if possible. Use a large, three-sweep fishtail gouge for roughing out the body. Where there are depressions in the flanks, use deeper gouges. Straps, blanket and saddle are drawn in and outlined with a *V*-parting tool and carved with appropriate gouges. Some carvers suggest leaving the head for last to allow time for the wood and tools to be gotten used to, especially since this part of the anatomy is the most difficult to do. Templates can be used to gauge symmetry and contours. More detailed photos of the head will be required than of any other part of the body. Generally, the head was made from two or four pieces of wood glued up face to face. The neck is a separate piece, also a lamination, with the grain running sometimes parallel to the body. This was done because manes would not flow down but would wrap around the neck, and horizontal grain would facilitate carving the hair. The ears should not be carved too soon, as they are delicate and may break off. Once finished, the head and neck can be attached to the body and faired in.

Here is a technique used by Speiser for setting in the kind of glass eyes that can be purchased from a taxidermist. Draw a rough profile of the head on a piece of stiff paper and cut a small triangular hole for the socket. Try inserting the glass eye edgewise through this hole. Keep making the hole larger until the eye falls through. Transfer the outline of this hole to the carving. Gouge out and undercut the hole enough for the eye to be rotated. Remove it and partially fill the cavity with plastic wood. Immediately insert the eye, rotate and press it into the proper position. The displaced plastic wood will ooze out, and the excess can be removed. After the plastic wood has hardened, you carve the details of the eyebrows and eyelids.

Once the horse has been carved and sanded smooth, a heavy-bodied paint sealer should be applied. Sand this coat lightly when it's dry and apply another coat, which this time should be tinted with the colors that will finish the horse. Give each separately painted area its own tinted undercoating. Choice of paints may be individual, but flat oil-base colors flow together better. As a final step, apply a coat of clear varnish.

Additional touches might include gold leafing on the blanket fringes, harnesses and other trappings, and adding flatback mirrored jewels to the blanket. □

EDITOR'S NOTE: Two publications about the design, construction and lore of carousel animals are Frederick Fried's *A Pictorial History of the Carousel* (A. S. Barnes and Company, Box 421, Cranbury, N.J. 08512) and *Carousel Art*, a quarterly magazine (Box 667, Garden Grove, Calif. 92642).

Hand Shaping

A simple approach to sculpturing wood

by Daniel Jackson

While my primary concern is with good design, my special pleasure is the process of carving and otherwise removing material from the wood. My designs tend to be highly sculptural; therefore, the removal of wood is an important part of my work. But I do not rely on specialty techniques or gimmicks, and the tools I use are neither overly simple nor overly complex. I don't insist on doing everything by hand, nor do I insist on doing everything by machine.

But I do rely on a band saw to remove as much wood as possible and on a horizontal slot mortiser to make most mortises for either conventional or spline-tenon joints.

Once the piece is rough bandsawed out and the spline tenon joints made, the fun really begins. First, I use a 1-1/4-inch diameter ball-mill bit in a router to remove freehand the bulk of the material. For safety, I recommend a ball mill with a 1/2-inch shank, if your router has that capacity. I would use pneumatic tools if I could afford them because they are much safer and more efficient, but I don't do enough specialized work to justify the investment. If the wood is not extremely dense or figured, it might be more efficient to do the roughing out with gouges, chisels, spokeshaves or other hand tools; but in the case of a wood like purple heart or tiger maple, the ball-mill gives the advantage of not needing to pay attention to grain direction. No splitting or tear-outs occur.

Having done what I can with the ball-mill, I then remove most of the ball-mill marks with either a half-round or fully-round Surform rasp. (A flat-blade Surform is useful only on convex surfaces, so I do not even own one.) Much more careful control is possible with a Surform than with a ball-mill, and I am usually able to remove all lumps and other irregularities.

To remove Surform marks and do finer shaping, I turn to a selection of round and half-round pattern-maker rasps and rifflers. My favorite is a #50 10-inch Nicholson. It is far superior to most other rasps I have used due to its "staggered" teeth and fine cut. With the rasp and riffler (for hard-to-get-at places) I am able to smooth the piece even more.

Prior to final hand sanding, I use a flexible rubber disk sander held in a high-speed portable drill. Surform and rasp marks can be removed very quickly. I own, but seldom use, a pneumatic drum sander — because the shapes of the forms I deal with just don't lend themselves to that tool.

Usually I can "smell the oil" at this stage, so I quite enjoy final scraping (using a cabinet scraper) and hand sanding. My preference is garnet paper, beginning at either 50 or 80 grit and going through 120 and 220. I find more sanding to be excessive, but the use of 320 wet-or-dry during oiling produces very fine results.

Another sanding option is to dampen the sanded 220 surface (thus raising the grain), re-sand with used

Tools author uses are grouped into rough, medium and smooth categories. Rough includes gouges, chisel and ball mill. Medium consists of rasps, Surforms, and riffler. Fine includes disc sander, cabinet scraper and sandpaper.

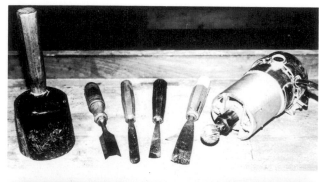

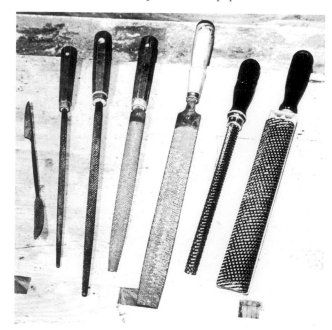

From *Fine Woodworking* magazine (Summer 1976) 3:24-25

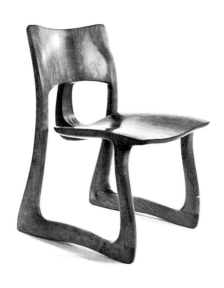

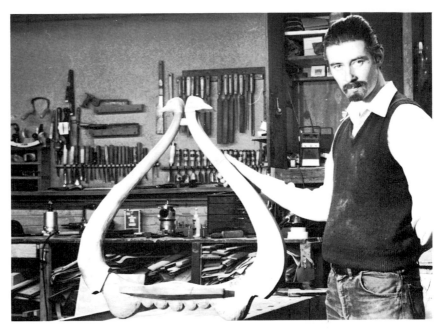

paper, and burnish the finished surface with hand plane shavings, especially teak and rosewood shavings which have natural oils. This produces a very rich patina and may require no further finishing if you are not dealing with a surface that gets hard use.

Because I use mortise and tenon joints, glue up can occur at several points. I don't glue until I absolutely must, so I can work on the pieces unassembled, but I do assemble dry occasionally to check my progress. □

Chair and partially finished peacock mirror held by the author require hand shaping. Ball mill in a router and a riffler (above) come in handy, as does the horizontal slot-mortising machine for helping make spline-tenon joints.

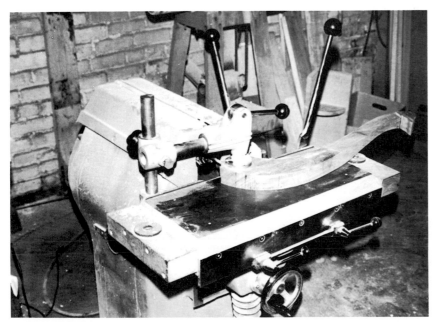

Chain-Saw Carving
Furniture and sculpture from green logs

by Jon Brooks and Howard Werner

Brooks' walnut chair (38 in. high, 33 in. wide.)

We use the chain saw to carve furniture and sculpture from green logs, roots and branches. Although we live several hundred miles apart, we've worked together on techniques for the last several years. The chain saw, although not designed for this kind of work, has become our main tool for both roughing out and final shaping.

Our furniture or sculpture often begins directly in the wood, using forms suggested by the shape of the log, or forms that are revealed as wood is removed. A contorted limb may suggest a chair, an interesting crotch or hollow may predict a bowl, or a hollow log may hint at a stool. Other times, a form is developed in the mind or through sketching. The work begins with the search for a suitable log in which to execute it. Excellent free material can be found in local tree dumps, with hundreds of logs and stumps to choose from, or at the town dumps, from tree surgeons, orchards and on private land with standing snags or fallen trees.

Almost any wood is good carving material, although apple and oak are more prone to cracking and checking than most species. Spalted wood is exquisite, but it is best to avoid pieces with soft spots or excessive rot. In most species, rot takes years to progress to this point, so many downed trees, particularly disease-killed elms, are still in good shape.

Walnut checks less than most native hardwoods. Crotch sections in particular, because of their interlocked grain, hold together well against the stresses of drying. Maple and cherry, although not as stable as walnut, are still good woods for carving. Coniferous woods carve easily and oiled juniper and cedar look particularly fine. Whatever the wood, the main thing is to develop the form in the direction of the wood fibers, for strength. Experience and experimentation will show what can be done and what should be avoided.

We own both electric and gasoline-powered chain saws, but do most rough carving with the gasoline saw because it is more powerful and not tied to electrical lines. We own Stihl gasoline saws and are familiar with the range AV20 to AV45. (The AV stands for antivibration, a system that makes the saw less exhausting to handle in long carving sessions.) We've found that smaller saws aren't up to the work and larger ones are too heavy. What saw you select depends in the end on your size and the scale of work you plan to do. A Stihl AV45 weighs 15 lb., has a 16-in. bar (bars up to 30 in. long are available) and generates 4.5 hp. It can be used to carve pieces ranging in size from large bowls to 8-ft. sculptures.

A gasoline saw is very noisy—ear protection must be worn—and its exhaust fumes mean it can't be used indoors.

Left, maple bowl by Werner (24 in. high, 14 in. wide, 19 in. deep). Above, Werner's 'Double-Pocket Form' (walnut, 29 in. high, 22 in. wide, 17 in. deep).

The electric saw, quieter and without fumes, is excellent for indoor carving and is especially suited to final shaping of a piece. A Milwaukee, for example, has both a 16-in. bar and a 20-in. bar and weighs 18 lb. It is large enough and powerful enough to carve major pieces, and because it runs at a constant speed, it's easier to control than a gas saw. But it feels very heavy after a long working session. A lighter, less expensive saw is fine for small, detailed carving.

Before carving, the basic lines of the piece are marked directly on the log with chalk. It's best to strip off the bark first, since it veils the shape of the wood and often has embedded dirt, which quickly dulls the chain.

We begin, much as a whittler begins, by paring gently curved slices from the log, the way a penknife cuts shavings from a stick. These first slicing cuts are made with the center of the bar, with the tip entirely clear of the wood. For deeper cuts and tighter curves the technique is similar to chip carving—two angled cuts meet at the desired depth toward the center of the log to release a large wedge or block of wood. In this way the bulk of the excess wood can be removed, leaving an angular, faceted form.

Next, the hollows and concave areas are worked into the form. To develop a hollow, we use the tip of the saw to make a series of closely-spaced, parallel cuts. Each cut starts at the farthest side of the hollow, with the bar held at right angles to the surface and the length of the saw at an acute angle to the wood so that the bottom of the nose makes first contact. Then the saw is drawn across and the nose dropped into the wood to feel out the bottom of the hollow. A felt-tip marker line on the bar can be used to gauge depth. A deep concavity can be worked in several stages. As the cut gets deeper, the saw's speed must be increased. Working this way, the nose of the saw is never close to a 90° corner and so it won't kick back. Then another series of close, parallel cuts is made at right angles to the first set, creating a checkered pattern. The resulting squares of wood measure an inch by an inch or less and can easily be kicked or knocked away by brushing back and forth with the tip of the saw. When the squares have all been poked out, the hollow is cleaned up and and its shape is refined with the tip of the saw, scraping back and forth to make an even surface.

Extreme care must be taken in tight hollows. When the tip is near anything close to a right-angled corner, the cutters can catch on the upper wall and throw the bar back toward the operator's head and body. Always be wary, especially near a tight corner, and expect the kickback. Try to absorb and control it by holding the saw firmly in front of the body, below waist level, with the arms kept straight.

Some saws are made with an anti-kickback device, usually a lever that, when triggered, instantly stops the chain. When a kickback does occur, the operator's wrist hits the lever before the saw can rotate back far enough to do damage. However, the safety device won't trip if the operator holds the front handle on its side, rather than on top. We've also used anti-kickback chain, which has a double raker tooth, and have found that kickback occurs less frequently.

The plunge cut is another way to remove a large, mostly surrounded chunk of wood, such as that removed to form the hollow between the seat, back and arms of a chair. The wood is approached with the bar at a slight angle. As the nose begins to cut, the motor is quickly lifted and the bar is pushed straight into the log. A very sharp chain and high

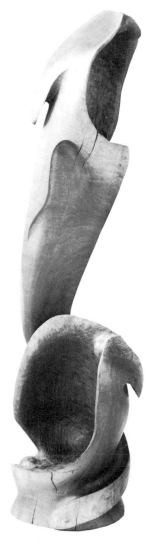

From tree to finished form: Above, Werner begins with a promising walnut trunk that includes the stump of a branch. First he chalks the lines on the log and slices away the waste. Convex forms are refined and smoothed by scraping lightly back and forth with the edge of the saw bar. Deep pockets are formed with the nose of the saw by tracing a cross-hatch pattern and breaking away the waste. Top right shows the sculpture as shaped by the chain saw. Right, 'Two-Hooded Form' has been dried, finish-carved and sanded (66 in. high).

motor speed are necessary right from the start so the chain doesn't catch and recoil or jam. When the blade is plunged to full depth, the cut can be made into a slot before the saw is withdrawn. Successive slots are made around the waste wood, to free it as an intact chunk.

A large cutout can be started with a plunge cut. But thin walls and delicate pierced forms require scraping from both sides at the center of the area to be cut out to produce a small circular breakthrough that can be enlarged.

With the bulk of the waste removed, we mark out the precise lines and edges desired with chalk. The tip of the gasoline saw is used to trace over these lines carefully, repeating several times to reach the proper depth. Exact contours can be achieved by scraping the bar or tip back and forth across the wood, the face of the bar at right angles to the surface. Here the electric saw is best. A broad, sweeping motion with even saw pressure shapes large curves; a slight change in the approach angle of each sweep prevents the bar from falling into the grooves created by previous cuts. Consistent pressure with rhythmic motion produces smooth, controlled surfaces.

Grain direction is the crucial factor in determining the thickness of a wall. When a section of a carving is made up of head-on end grain, we rarely carve it thinner than three or four inches and expect it will crack. A long-grain section, on the other hand, can be as thin as half an inch and will usually remain intact. On an irregular form, most of the walls are somewhere between these two situations and one must learn through experience what's safe. If we make an error in judgment and part of a carving cracks right off the main form, the piece can be redesigned, even if only as firewood. If a lot of work has already been invested, a broken piece can be rejoined with dowels and glue, or with an inlaid butterfly key.

Many of these operations, raking and scraping in particular, are very hard on the saw bar and chain. It is necessary to keep the chain sharp at all times and the saw may have to be sharpened several times a day. A small electric sharpener works well for grinding out chips caused by dirt, stones and metal in the wood. A hand file with a chain-saw sharpening gauge is fine in the field. We usually file the teeth at a 35° bevel, switching to 30° for very hard or frozen wood. It's important to make the same number of file passes on each tooth, to keep them even. Irregular sharpening will cause the bar to wander as it cuts and control will be difficult.

When carving green wood, shield the piece from direct sun, which rapidly causes checking. The wood should be kept close to its original moisture content while it is being worked and can be shrouded in plastic to be left overnight. A large carving in green wood will inevitably crack and check. It doesn't take much experience to predict where cracks are likely to open and how serious they are liable to be. Cracks are virtually certain on end-grain sections and on surfaces containing the pith of the tree. We accept the cracks as an important part of the texture of the work; all we do is soften the edges to prevent splintering and integrate the cracks into the piece. Sometimes a crack pattern enhances the work so much that it is worth enlarging, or altering the design to play it up. But sometimes an end-grain section is too delicate to withstand checking, and the best solution is to coat that part of the wood with white glue to retard drying.

When we're done with the chain saw, the work has a rough texture but it is very close to its final form. The wood must be dried before it can be sanded and finished. We store pieces in

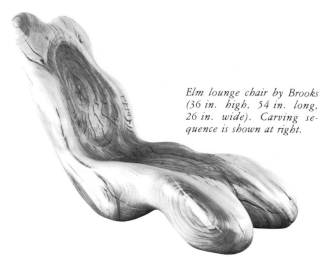

Elm lounge chair by Brooks (36 in. high, 54 in. long, 26 in. wide). Carving sequence is shown at right.

a shed or garage for at least four months, usually for a year, and sometimes for two years, depending on wall thickness and species. When a piece is about ready for finishing, we store it indoors for a couple of months first. We've experimented with shaping, sanding and oiling the green wood directly, thinking the oil might slow down the drying. But the escaping moisture destroys the finish and the wood surface changes too much during drying. We now season everything before the final sanding and oiling.

From the chain saw we go to a sander-grinder with a 7-in. disc, the type used in auto body shops. Sometimes we begin with a pad as coarse as 16 grit, but 36 grit or 50 grit is usually coarse enough to remove the chain-saw marks and refine the contours. Then we go to 80 grit and 100 grit, to smooth the surface wherever the grinder is able to reach.

We like to go directly from chain saw to grinder, but sometimes a more detailed form or the slower evolution of a design requires more refined tools. Carving gouges, a ball mill (a cutting burr about the size of a golf ball), Surforms, rasps, rifflers and files are the most useful. Standard bench planes make quick work of large convex surfaces, and violinmaker's planes also help. The Surform is especially effective in shaping difficult edge contours. When a shape cannot be achieved with one tool, we try another. Our techniques aren't rigid—they develop and change from one piece to another.

For final finishing an electric drill with a foam-backed pad is used, starting with coarse grit and working slowly up to 220 grit. These pads are small and will fit into areas the grinder can't reach. Still, there are always areas too small for the disc and they can be reached with rifflers, files and sandpaper backed with leather or Styrofoam, or wrapped around a small wooden block. On any piece, the sanding takes much more time than the carving.

Last, we sand by hand, using a leather backing pad or a Styrofoam block to remove swirls and scratches left by the disc. Then the work is ready to oil. We've used Watco oil, but we've come to prefer at least three coats of a 1-2-3 mixture of boiled linseed oil, varnish and turpentine. After the last coat has dried for at least 48 hours, we apply a good-quality paste wax and take care to avoid build-up in the cracks. □

Jon Brooks makes furniture in New Boston, N.H., and has served as guest instructor in woodworking at Rochester Institute of Technology. Howard Werner, an RIT graduate, has served as craftsman-in-residence at Peters Valley, Layton, N.J.

Shapes and Forms

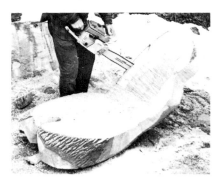

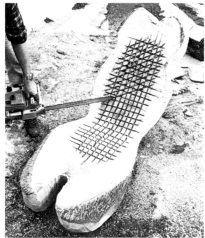

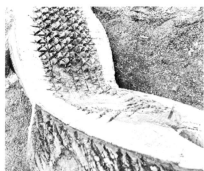

The shapes and forms of my finished pieces can be divided into two categories. The first category has been influenced by the shape of the original found material. An example is the walnut chair, which is carved within the limits and integrity of the original crotch section of the tree. Sometimes I rough out a chair to expose the figure of the wood and leave it as a block to study. The outside shape is determined by reflecting the grain patterns—parts are emphasized or played down to get the desired effect. Root sections, curved limbs and trunks are also forms that will influence these pieces.

The second category begins with a straight, cylindrical section of wood. Then I impose a preconceived idea by working subtractively and releasing the form. Examples of this are 'Wood Falls' and the elm chair. Landscapes, horizon lines, water, cloud formations and the wood grain itself are elements which influence the form. 'Wood Falls,' conceived at Art Park in Lewiston, N.Y., is an attempt to reflect the nearby Niagara River and to capture the feeling of wood rolling down a slope toward the river. This piece asks the viewer to become visually and physically involved by providing benches for seating while viewing the landscape and the wood forms. People have made a path beside it down to the dock on the river. The exterior shape of the elm chair is an attempt to capture the human form. I tried to create the illusion of a seated person, which a person would sit upon. It was basically preconceived as a lounge chair and carved from a cylindrical tree section.

Because wood is a warm and inviting material, it is easy for one to become physically involved when it has been sanded and oiled to a very smooth surface. The rounded forms relate to the human form and to the wood grain. Too often in viewing solid objects we tend to see only the exterior form. As wood splits in drying it reveals an inner spirit and force. Rounding the splits on the surface unites the exterior form with the internal spirit and makes it easier to look at and touch. Wood splits, warps, expands, contracts; it has lived and it is living. While working with tree sections all these characteristics are heightened. To accept and move with these forces rather than to resist them is my primary objective.

—Jon Brooks

Elm lounge chair begins as a cylinder of tree trunk. First, great wedges of wood are removed to block out the chair form. Brooks pares the outline of the chair, then hollows the seat and back by cutting a crisscross network with the nose of the saw. Then he simply kicks away the waste wood.

'Wood Falls' by Brooks is 15 ft. high, 15 ft. wide, and extends intermittently fpr 100 ft. down a hillside in the town of Lewiston, N.Y. It is carved in red oak, elm, maple and walnut, and permanently bolted to buried concrete pillars.

Variable-Arm Milling Machine

Exploring the router's sculptural potential

by Stephen Hogbin

I've always been interested in exploring machines that are capable of making more than one letter of the visual artist's alphabet. The weaver's loom, the potter's wheel and the woodturner's lathe are all machines that allow tremendous variations within limited configurations. The variable-arm milling machines described in this article are another example.

These machines grew out of a request I received from an architect in 1974. At that time, I had been making turnings of geometric figures, some of quite large scale, which I would cut in half and glue back together in another order, revealing the progression of the turning's cross section. The architect had seen a small screen fashioned from one of my segmented turnings and wondered if I could make a larger one for the Metropolitan Toronto Library. This seemed reasonable enough, until I discovered that the screen he had in mind was up to 200 ft.

long and 7 ft. high. Conventional woodturning, even at large scale, was clearly not the best approach for this job. Rather than swinging a huge mass of material on the lathe, it seemed appropriate to hold the material and pass a cutting head across its surface. This action is similar to that of a milling machine.

When faced with such a technical requirement, I usually think about precedents—what existing machine might do the job? I don't want to start from scratch unless I have to and I don't want to become a designer of machines which are an end in themselves rather than a means to an end. However, this was not to be the case. For the screen project, the router seemed a good choice, both for basic shaping and for texturing. With its wide selection of bits, the router is among the most versatile—and I suspect underused—tool available to the woodworker. It can cut a hole or a groove; multiple grooves

generate a ribbed or fluted surface that brings a flat surface into the third dimension. The practical and visual uses of this language are numerous, from functional hollows in which objects are stored to decorated surfaces which wrap around functional things such as furniture. The trick is to identify a relationship that works and apply it.

As the drawing on the facing page shows, the machine I developed is essentially a pivoting horizontal arm that rotates about two axis. The arm, a steel I-beam, supports a 2-HP router which travels on a roller carriage. For regulated work, the router carriage can be precisely positioned by means of a lead screw that runs the length of the arm. The router is fitted with either a ¼-in. or ⅜-in. collet to accept bits of ¼-in. to 2-in. cutting diameter. A simple template at the end of the arm or beside the work, allows me to reproduce and repeat a profile as of-

Hitched to an I-beam trammel arm, the router reveals itself as a sculptural tool of rich potential. To regulate the cutting, Hogbin attached his router to a carriage which slides along the arm to be precisely postioned by a long lead screw threaded through the carriage. He used this variable-arm milling machine to create a massive red oak room divider for the Metropolitan Toronto Library, above.

From *Fine Woodworking* magazine (July 1985) 53:44-47

ten as I want. To make most things, and perhaps to make anything worthwhile, it takes considerable time to learn the techniques which relate to the forms desired. Once the machine was built, I began experiments to discover its potential. I need to understand technique before I can move to the biggest challenge: putting my experiments into a cohesive visual statement. First I cut and milled a number of blocks individually to learn what basic cuts could be made, and the relationship of one cut to another. Whether individual pieces worked visually or had any application was unimportant at this stage. The idea was not to make art but to develop an alphabet of possibilities which would later become visual poetry.

As I progressed, I discovered both the potential and the limitation of my machine. The arm weighs about 50 lb. when held at its outside end but feels progressively heavier as you move closer to the axis. Maneuvering the boom gave me tremendous back and neck pain. To relieve it, I inserted a piece of elastic into the rod that supports the arm. This gave me fingertip control at almost any point on the arm. The pain subsided, the forms improved and I could forget about the burden of process and move freely with the balance of form and material.

My initial attempts seemed rather stiff and lacked the subtle interpretation I could achieve at the lathe using a hand-guided chisel. The act of milling is part of the engineer's tradition rather than the artist's. Out of frustration from the weeks of tinkering, I dropped a large, irregularly shaped log beneath the arm and ran the router across the surface. The result was a vigorous patterning that had the qualities of crashing waves, wind-blown sand dunes and mountains. Finally, the form was evocative and challenging.

I applied this new-found language in making the library screen, shown on the facing page. The screen consists of 350 red oak boards set into a steel channel and stone base built on the floor. To allow light and air to pass through the otherwise solid wall and to impart a lively and evolving pattern, I placed the boards in a jig 50 at a time, edge up and face to face. Milling the edges, first on one side and then on the other by turning the boards over, produced a sequential texture with a semicircular effect. This process was repeated to get the necessary number of boards for the screen.

The last architectural-scale piece I

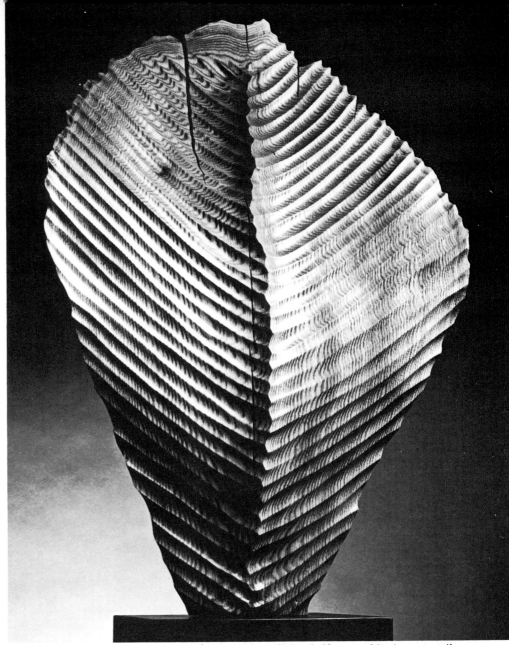

Combined with the milling machine's versatility, off-the-shelf router bits impart striking texture to wood. This sculpture shows the tool's remarkable expressive potential.

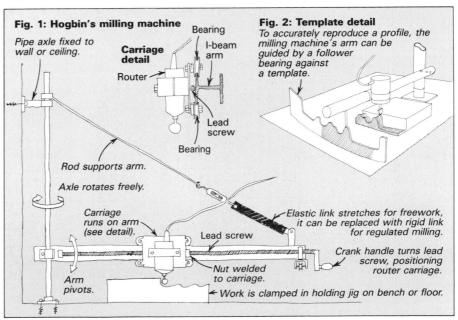

Fig. 1: Hogbin's milling machine
Pipe axle fixed to wall or ceiling.
Bearing
Carriage detail
I-beam arm
Router
Lead screw
Bearing
Rod supports arm.
Axle rotates freely.
Carriage runs on arm (see detail).
Lead screw
Nut welded to carriage.
Arm pivots.
Work is clamped in holding jig on bench or floor.

Fig. 2: Template detail
To accurately reproduce a profile, the milling machine's arm can be guided by a follower bearing against a template.
Elastic link stretches for freework, it can be replaced with rigid link for regulated milling.
Crank handle turns lead screw, positioning router carriage.

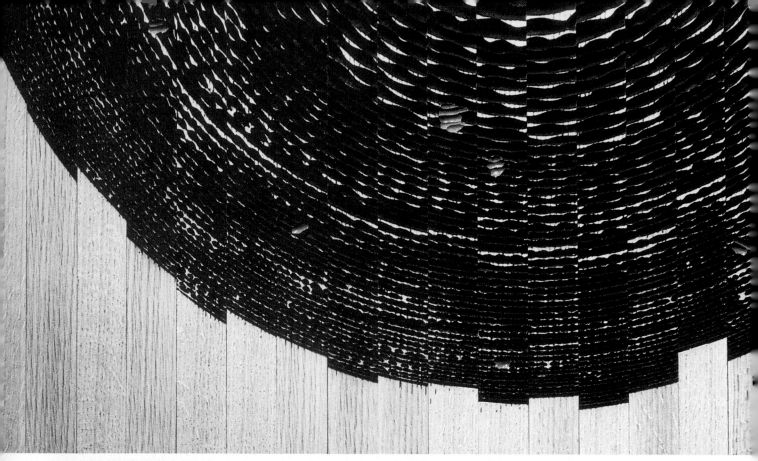

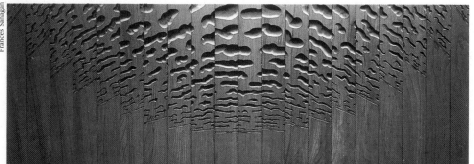

Frances Sanagan

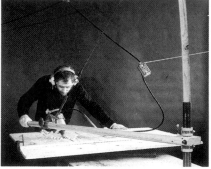

To make one version of Calibrated Earth, *top, author built the small milling machine, right. The arm is less cumbersome and the work can be mounted on a turntable, making possible more the fluid, painterly compositions shown at far left and right. By painting the routed squiggles, Hogbin achieved an illusion of depth which suggests a cloud-filled sky or a flock of birds.*

made on the large milling machine was for C-I-L Inc., a Canadian chemical concern. The piece, which is called *Calibrated Earth*, makes reference to the image of earth. A small, painted derivation of it is shown above. The textured wood evokes clouds, water, sand, cracked mud, plowed fields or the desert. I used 11 different round-nosed cutters to produce the texture, but started the first groove with a V-cutter to give the finest start possible. The grooves were scraped with shaped cabinetmakers' scrapers and left without sanding.

For developing the models which eventually resulted in *Calibrated Earth*, I constructed a bench-sized version of the milling machine. By clamping the wood to a turntable beneath the arm instead of to a fixed holding jig, I expanded the ma-

chine's vocabulary, thus permitting the possibility of complex geometric carving much like that done by ornamental woodturners. However, I chose to explore forms that are freer. I achieved an elementary form of picture making by learning to organize these potentially disparate lines into a compelling whole.

Texture can be a key visual element of work produced on this machine. Spatial illusions can be produced. In *Calibrated Earth* the texture was cut from a flat surface but it appeared to be spherical because I used progressive sizes of cutters. Small cuts in the surface appear farther away than larger cuts. Optically, a cut can appear to be raised on the surface, especially if the hollow is lit from the bottom.

These kinds of effects are part of two-dimensional space and relief rather than

three-dimensional space. These qualities of surface led me more and more toward "picture making."

Relief surfaces are sensitive to light. If they are not properly lit, the subtle visual qualities are lost. One way to overcome poor light conditions is to add color in order to gain back the high contrast of hollow to flat surface. Initially I added color with caution, thereby evolving the vocabulary further. Now, three years later, the wood in my work is often completely covered with paint, even though its texture and the structure of the panel are still evident. I have also recently pulled prints from the surface—using the texture as the basis of the printed image.

Since 1974, and that initial request by the architect for a large screen, I have evolved from woodturning. machine

Ted Hunter's router mimic

by Mary Hui

Finding a conventional lathe unsuitable for the large, textured turnings he wanted to create, Toronto sculptor Ted Hunter designed and built this machine, which is an adaptation of the mimic some machine shops use to duplicate parts.

Its chief mechanism is an arm which connects a template follower to a router suspended above the workpiece. The arm is capable of 30 in. of longitudinal movement, which equals the radius of the turntable. The turntable can be turned at 6 RPM by a motor, or it can be rotated by hand. A crank belted to a lead screw moves the center post along a track, mechanically translating the template's profile to the work. Once set up, Hunter finds that turning/sculpting proceeds very quickly.

"But in some ways," Hunter says, "the process has been slowed down. I have more time to think about what's happening."

Much of the machine's potential remains undiscovered. In his early experiments, Hunter found that a router bit left a textured surface which enhanced his work. "Before building the machine, I had ideas for shapes I wanted to create," says Hunter, "so I built the machine to create them. Now, using the machine, I come up with more ideas. With a chair, for instance, you know that when it's finished you're going to sit in it and that's partially how you know it's finished. The machine is part of a process [and] never finished because the end result is unknown." □

Mary Hui is a Toronto free-lance writer.

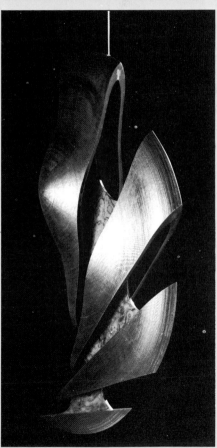

Combining the shop-made milling machine, photo at top, with a lot of head scratching, Ted Hunter created the three-foot high hanging sculpture, above. He began with a 30-in. diameter mahogany blank made up of five brick-built discs. After routing the blank to the desired profile, he then sawed the turning into sections which he then reassembled into the final form.

building, variable milling and now to printmaking. Although the techniques are different, in each process the wood surface is cut to produce different qualities.

This vocabulary-building activity—discovering similarities, making references and using one process as a metaphor for another—is a necessary part of giving form. This essay concentrates on technique and form; both are precursory to idea and content. Ultimately the poetry of any language is not contained in grammar, but in the spirit that motivates its form and content. □

Stephen Hogbin, a designer and artist, lives on Owen Sound, Ontario, and has exhibited at the Ontario Crafts Council Gallery. Photos above and on page 90, except where noted, by the author.

Photos: John Reck

Woodworking Lasers
How photons make wood disappear

by John Kelsey

Brass stencil, center, transmits delicate lines of photo to plaque.

Most gift shops sell solid walnut knickknacks with finely engraved pictures on them, pictures whose background has been abruptly dropped a sixteenth of an inch below the surrounding surface. Examining such a letterholder or paperweight, you might guess the artwork has been routed with an infinitesimal bit—the detail is too delicate and too clean for any ordinary tool. The smallest features show no trace of the sideways pressure a carving tool would have to exert. The picture ignores grain direction. Yet its recessed background reveals the varying density of the grain structure, as if wirebrushed. You can only scratch your head, until you discover a label saying the object has been laser engraved.

The woodworking laser can zap a clean kerf mere thousandths of an inch wide. Depending on the beam's power and the time it lingers, the kerf can go right through a piece of wood or it can bottom out partway through. It can follow a straight line or a curve, starting and stopping anywhere. It's a coherent beam of invisible infrared light, coherent meaning that all the photons move in phase and at a single frequency. It's generated by electrically and optically manipulating a thin, gaseous mixture of carbon dioxide, nitrogen and helium sealed inside a long, glass tube. When focused on a tiny spot, it's as hot as the sun's surface. At 6,000° C, wood in the beam's path simply vaporizes, becoming a whiff of organic gas lightly peppered with mineral ash. The spot is so quick and intense that adjacent wood doesn't even char.

Like all magic the laser has a catch, principally the size and complexity of its apparatus. A pinhole through the wood isn't much use, but the laser is far too large just to pick up and draw along a layout line. Turning the spot into a useful cut requires moving the laser beam by optical means or mechanically moving the wood past it, or a combination of the two, plus a way of extinguishing the beam or shielding the wood wherever you don't want it to disappear. You end up with an agglomeration of machinery, optical and electrical gadgetry twisting through cubic yards of space and costing over $150,000 (1981). Yet at least one whole industry—laser engraving—has been created with this tool, and in a number of industrial applications it does a better or cheaper job than conventional cutters. And now the laser-engraving industry is developed far enough to be offering its talents. You can use the process without having to own a laser.

Laser engraving was invented by John Macken of Santa Rosa, Calif. A physicist, he's founder and president of Optical Engineering Inc. (Lasercraft), which today has more than 200 employees. Ten years ago, Macken and his brother, Don, were working in their garage nights and weekends to devise instruments for laser research. The beam is invisible and at these energies will vaporize flesh as easily as wood. Thus a laser experimenter has to know whether the apparatus is working before putting his hand or his eye in the way. The Mackens used to find out by sticking a scrap of wood into the

beam's path. Fooling around, Don put some window screen in front of the wood, and there it was: deep squares where the laser had passed through the screen, untouched wood where the wires had interfered. He recalls thinking, "Gee, we must be able to use this."

That inspiration developed into a brass stencil in lieu of the window screen, and a way of quickly moving lots of brass-masked wood under the beam. Where the laser hits the brass, it is reflected harmlessly. Where it passes through, the wood's just gone.

In Lasercraft's process, the design is first made into a black-and-white drawing, then photographically etched through thin sheets of brass the way printed circuits are made. The design can be as complex as hands can draw and can include lettering, except all of its elements must be connected. A number of masks are made for each design, then they're all fastened onto finished wooden objects. Laser engraving is the last stage of fabrication—the object has already been cut and joined, sanded and finished with lacquer. Lasercraft does those chores in a conventional woodworking factory it owns in nearby Healdsburg, which consumes 60,000 board feet of No. 2 Arkansas walnut every month.

The masked workpieces are mounted near the edge of a horizontal turntable six feet across, which spins rapidly beneath the aperture where the laser beam emerges. The beam itself—actually multiple beams totaling 1,000 watts, to cut a swath instead of a line—is generated inside tubes that run along the floor underneath the turntable. Mirrors bend it up a vertical column and down onto the rotating work. The table moves incrementally inward as it turns. A propane flame burns near the action to flash the waste gases, and also to lightly char the engraved background, for decorative effect. There's a duct to suck up the exhaust, a power supply squatting nearby, and lots of cables, pipes and hoses. The assemblage looks like a gigantic jigsaw wed to a record player. But with the masked wood speeding past your chin, you don't really see anything. You can't see the beam because it's infrared, you can't see it vaporize the wood because it's all but instantaneous. You can see only a narrow, intermittent column of white-hot sparks, as from a

From *Fine Woodworking* magazine (May 1981) 28:56-57

Laser engraving produces fine detail, recessed background. Left, paper-clip holder by Lasercraft. Right, Turntables move work under laser beam.

grinder. They're molecules of wood leaving the workpiece and catching fire in the propane flame, en route to the exhaust duct. Pretty soon the whole batch of work has passed beneath the laser. Lasercraft has six machines like this. In the next room is a larger, 10,000-watt machine only recently debugged. Here the turntable has become a broad conveyor and the fixed beam has become an array that scans.

Lasercraft's ingenious method is best suited to flat workpieces, the whole of which move beneath the beam. One of its competitors, a firm called Laserworks with offices also in Healdsburg and a factory in Florida, combines a moving beam with moving stock in a much smaller machine. Its system is said to be able to engrave on curved surfaces such as the outside or bottom of a bowl, or to be brought to bear on the middle of a large panel without having to scan the whole panel. Besides selling their own lines of engraved products, both firms will now do laser engraving to order, on stock fabricated in their own plants or supplied by the customer, for a price that depends on volume and complexity but seems to run upwards from ten cents per square inch, plus art preparation. Lasercraft will also consider licensing its system, as it's already doing in the international market. Laserworks, on the other hand, offers to tailor and sell a complete, 375-watt laser system for a flat $150,000 (1981).

Besides laser engraving, the die-board industry, which produces paper packaging, is rapidly adopting lasers. Flatten out any lightweight cardboard carton and you'll see the problem confronting the rule-and-die maker. Cartons are folded from single sheets of card that have been printed, cut to shape and embossed with fold lines. The cutting and embossing are done by pressing the printed sheets against a pattern of steel rules—some sharp, for cut edges; some blunt for folds—set on edge and held in place between blocks of ¾-in. maple-veneer plywood. For each different carton in the world, somebody has had to measure and cut a whole lot of odd-shaped but precise plywood blocks. It's conventionally done by skilled craftsmen with jigs and table saws. In a laser system, the pattern is fed into a computer for conversion to *x-y* coordinates, in order to govern the travel of a moving table. On the table is a plywood blank and over it a laser beam, which starts and stops by means of a metal shutter. When the whole pattern has been traversed, all the lines cut to exact width, the steel rules just drop into place. I spoke with a die maker in Atlanta who's also an amateur woodworker. He feeds patterns for his wooden toys into the computer and the laser spits out the parts he needs. The same setup would make wooden jig-

saw puzzles, and one Midwest plant is using something similar to mass-produce marquetry inlay.

Woodworking lasers have two main limitations. First is power. It takes about 50,000 watt-seconds of energy to vaporize a cubic inch of wood. Thus a big, 1,000-watt laser takes 50 seconds to eat the cubic inch, whether it's one big hole, or a rip cut 0.010 in. wide in stock that is 1 in. thick and 100 in. long. If the same cut were made in the same time through 1/20-in. veneer, a 50-watt laser would do. Power output governs the size of the apparatus as well as its cost. You can't get more than 80 watts of laser energy per meter of generating tube, so the more power, the longer the tube has to be. It now (1981) costs about $90 per watt to build the laser part of the machine, not to mention wood-moving apparatus, exhaust, et cetera. The whole apparatus puts out less than one-tenth the energy you put in: a 1,000-watt laser sucks about 15 kilowatts from the wall plug.

Second, it's hard to keep the cut parallel at depths much over an inch. While the adjacent wood helps keep the beam focused, waste heat and gases can't be drawn quickly enough from the bottom of a deep kerf. The wood chars, the narrow line becomes a ragged burn. Also, because wood isn't uniformly dense, it doesn't engrave to a uniform depth, whence the striated background of laser-engraved pictures, even in such mild wood as walnut. The background in Douglas fir would be hills and valleys corresponding to growth rings.

Although the idea of whittling great lumps of wood with a hand-held laser beam will remain a fantasy, the next development is probably laser crosscut saws. Coupled to a scanning computer, a laser saw might be able to find and remove defects from raw planks, yielding the maximum number of pieces of optimum size for whatever was being produced. And while lasers aren't likely to become standard equipment any time soon, at least one amateur woodworker has a used one in his home workshop. He's Mike Sasnett, an engineer who works for a laser manufacturer. Sasnett uses it to make jewelry and to engrave small boxes, although he admits—like most of the techno-junkies and machine addicts among us—that most of the time his expensive toy just sits there. □

EDITOR'S NOTE: To acquire your own laser or to contract for laser engraving in commercial quantities, contact Optical Engineering Inc. (Lasercraft) at 3300 Coffey Lane, Santa Rosa, Calif. 95401 or Laserworks at 715 Alexander Valley Rd., Healdsburg, Calif. 95448. If you'd like to try engraving on a few pieces, or want to discuss something experimental, contact Mike Sasnett at Sunshine Engineering, 375 Anita Ave., Los Altos, Calif. 94022.

Brandon Chambers

by Bjorn E. Loftfield

Before the briar pipe, clay, bone, stone and unknown woods were used as pipes. In the late 17th century, the smoking public discovered meerschaum (German for "sea foam") a fossilized sediment that carves like soap, is light in weight and breathes for a cool smoke. Meerschaum's only drawbacks are fragility and scarcity.

In the 1800s a wood substitute was found in the burl of the white heath tree *(Erica arborea)*. Briar (from the French *bruyere*, meaning burl) grows as a sphere between the roots and the tree base, and functions much as a camel's hump: It ensures survival throughout the dry season by storing moisture. The burl matures in 50 to 100 years, at which time the briar is harvested. Usually 1½ ft. to 2 ft. in diameter, it is then cut into blocks, and dried for five years.

The first craftsmen to work briar were the French carver/turners of St. Claude, a small mountain village. Their principal tool was the treadle lathe. The briar was turned green; a pipe smoker had to break in his pipe over several months to dry it out. If you know what a "sour pipe" is, then you can sympathize with these first users of briar pipes.

The industrial revolution mechanized the turning process and made pipes more affordable, which in turn increased the demand. Care was taken to dry the briar and to bake it clean of resins. Briar pipes became more accepted, even among the aristocratic meerschaum smokers. Today turning a pipe takes seconds; grading, polishing, and waxing take several more.

Some French carver/turners decorated their pipes with intricate carvings of heads and figures, but most work of this nature was done in meerschaum, and practically no intricate carving has been done on briar pipes since the 1880s. Brandon Chambers, 26, of Olympia, Wash., is reviving the craft.

Chambers has been working wood for 16 years. Some of his first tools were screwdrivers, which he sharpened into chisels. Chambers first dabbled in pipecarving as an army private stationed in Germany eight years ago and continued

EDITOR'S NOTE: The only book we've found about making pipes is *Pimo's Guide to Pipe-Crafting at Home*, from Pimo, Box 59211, Chicago, Ill. 60659. Pimo also sells pipe tools and materials, as do most pipe shops and mail-order woodworking supply houses.

doing commissioned pipes in meerschaum and ivory until 1977. That summer he came upon an exceptionally fine briar block and decided to use it in the Tinderbox national pipe-carving contest. His pipe won and is now in the Brotherhood of the Pipemakers Museum in St. Claude.

That pipe revealed to Chambers the niche available to a carver of briar pipes. His prize was a trip to St. Claude, the pipe capital of the world, where he stocked up on briar blocks. The machines of the modern pipe factories he saw there can not read grain as can a sensitive craftsman. "When I pick up a block I consider what 'piece' it contains," he says. "Almost invariably I am correct, or the wood is, down to the very flow of the grain."

Carving a briar pipe can begin with either a raw or a predrilled block, which comes with a finished stem. Briar is graded into categories, depending on the number and size of the flaws and on the part of the burl from which the block is cut. Pieces called "plateaux" are most desirable and are used for the finer freehand pipes because they include the outer layers of the burl where the grain is tightest and most attractive.

Drilling the bowl, draft and shank holes are the critical steps. A long narrow bit tends to follow the grain, and the draft hole must align perfectly with the bottom of the bowl: If it meets above the bottom, the pipe will not smoke dry and will sour rapidly; if it goes past the bottom and into the opposite side, it creates a pocket that will not draw properly. The bowl is bored first. Chambers has experimented with tapered machine bits, but now pilotdrills and turns the bowl on a lathe with a ¼-in skew. The shank hole is drilled next and, to ensure alignment, the draft hole is drilled on the same setup. For bent-stem pipes the shank and draft holes must be angled differently. The bowl and draft-hole sizes determine the smoking time and temperature. A ¾-in. diameter bowl 1¼ in. deep with a ⅛-in. draft hole is about a one-hour pipe. Altering the draft hole by 1/32 in. either way produces a shorter or faster draw. For the shank hole, a ¼-in. diameter to a depth of ½ in. to ¾ in. is standard.

After the pipe is drilled, shaping can begin. Chambers uses a band saw for roughing out, making sure the walls will

be no less than ¼ in. and uniformly thick. On plain and freehand pipes the work after bandsawing can be completed with a patternmaker's rasp and sandpaper. But most of Chambers' pipes involve figure-carving. After bandsawing he uses a series of airpowered grinders with various bits ranging in shape and size from a 1-in. tree-shaped burr to a pinpoint with three blades. His tools include a 22,000-RPM heavy-duty die grinder, a 50,000-RPM dental-surgery handpiece and a 60,000-RPM pencil grinder for the tight places. The high speed allows him to cut smoothly across and against the grain.

Grinding goes much slower than bandsawing. An arc stroke works well up and down the outside of the bowl. The figures are carved from the top, down and in, leaving supports for delicate lacework and ropes. Smoothing is done with finishing burrs, rifflers and 400-grit sandpaper. Next he scrapes the surfaces with a burnished knife, using fine steel wool for the highlights. Then he goes to a 1-in. buffing wheel with pumice and water in the flex-shaft, followed by a 1¼-in. diameter stiff brush.

If a pipe is to be dyed, an aniline dye must be used, either water or alcohol based. Stains, oils, and many other wood-finish products would eventually be tasted in the bowl, and sealing the grain will result in a sour pipe. A pipe left unstained will assume a burgundy color with use. Wax will protect the pipe and allow the briar to breathe. Carnauba, the hardest wax, has a high luster but the high speed required to apply it can burn or damage the pipe. Chambers' mixture is one-third beeswax and two-thirds carnauba wax. It is hard enough to afford protection, yet soft enough to spread at a safe speed.

The pipe stem can be purchased rough-cast in many shapes and lengths of vulcanite, hard rubber or acrylic through most pipe shops. A dowel-cutter brings the stem shank down to size. Ornate turnings or figure and relief carvings can be added on the stem. It is then sanded to 400 grit and buffed with plastics compound and waxed. The stem can be bent after rotating it close to an electric coil; overheating can change its composition and color. □

Photographer Bjorn Loftfield lives in Woods Hole, Mass.

From *Fine Woodworking* magazine (March 1980) 21:82-83

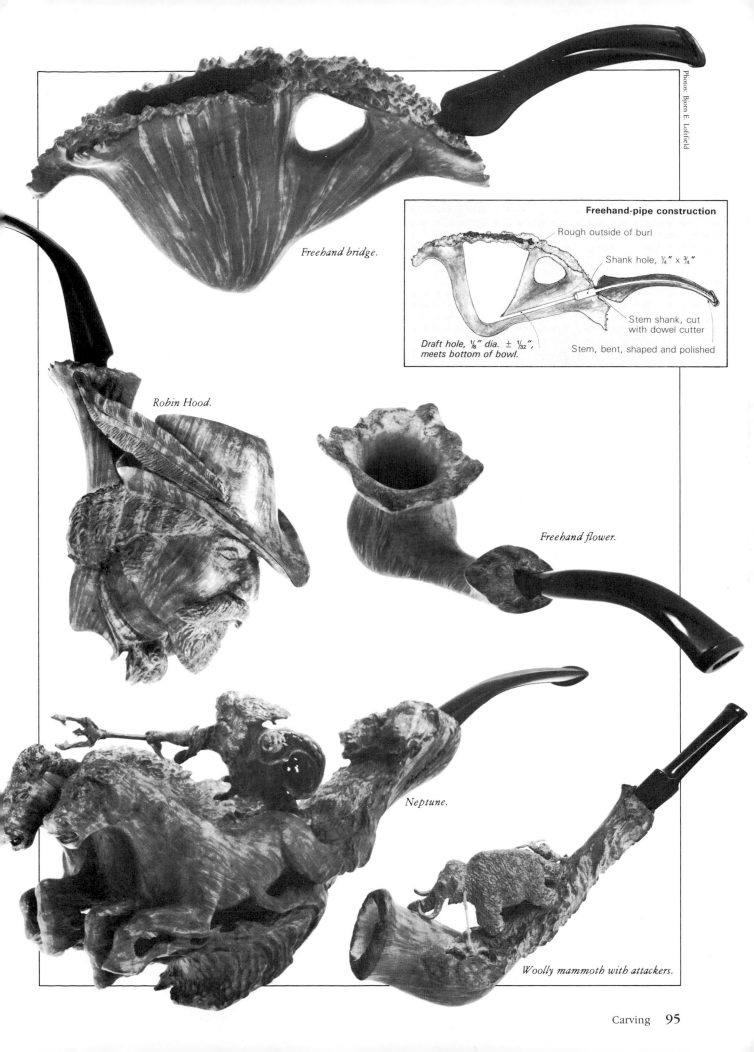

Photos: Bjorn E. Loftfield

Freehand bridge.

Freehand-pipe construction

Rough outside of burl

Shank hole, ¼″ x ¾″

Stem shank, cut with dowel cutter

Stem, bent, shaped and polished

Draft hole, ⅛″ dia. ± ¹⁄₃₂″, meets bottom of bowl.

Robin Hood.

Freehand flower.

Neptune.

Woolly mammoth with attackers.

Howard Raybould
Ornamental carver of mirror frames and crocodiles

by Tony Taylor

The wiggly body of this little fish is chamfered to allow for movement and then painted iridescent blue, shading into red. The body segments are glued to both sides of a leather spine that also forms the fins and tail.

Woodcut prints, buildings, wrapped packages— Raybould has been influenced by all things Japanese. This elm box is simple and vigorously carved.

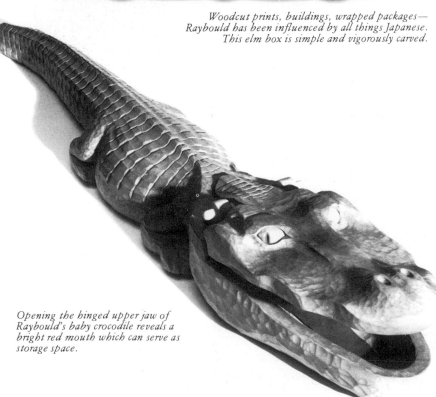

Opening the hinged upper jaw of Raybould's baby crocodile reveals a bright red mouth which can serve as storage space.

Photos, except where noted: Ellis/Imrie

Howard Raybould carves wood in a small room at the top of a dilapidated London terraced house—no machines, plenty of chisels and gouges and a homemade workbench. In just a few years, Raybould, 35, has also carved a comfortable niche for himself in the world of British craft, earning a place on the Crafts Council index, receiving a Churchill Fellowship (which he used for travel in Japan) and teaching around the country. A 1978 exhibition, "The Framing of Howard Raybould," enlarged his appreciative, if somewhat bemused audience, and mirror frames have replaced architectural carving as his bread-and-butter work.

Why mirror frames? "Makers are makers because they stop and look and think," he explains. "You say to yourself, 'I don't like this, I think I can do something better.' That's how I started doing mirror frames."

He doesn't fuss over construction, assembling the yellow-pine frames with simple lapped or mitered joints. Then the carving starts. Raybould may use a repeating pattern, or he may go for a pictorial approach, carving the sides of the frame into hanging curtains or the intertwining branches of two trees. Whatever image he carves, he usually heightens the texture by staining or painting areas in soft pastel colors. His objectives are uncomplicated. "I just try to capture something that feels good," he says. "The frame should match anything in the room without being overpowering, it's got to be active and passive at once. There is endless variety in this limited form." Raybould often turns to boxes and toys. His toy crocodiles are lifelike, bright green and playfully threatening; his colorful snakes and fish come with bodies articulated to slither or swish.

Raybould learned traditional carving skills working for a firm of architectural carvers following his graduation from art college. He grew dissatisfied with the formality and convention of tradi-

From *Fine Woodworking* magazine (May 1982) 34:74-75

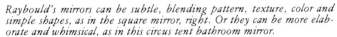

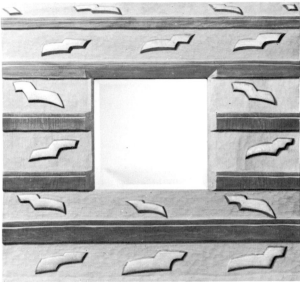

Raybould's mirrors can be subtle, blending pattern, texture, color and simple shapes, as in the square mirror, right. Or they can be more elaborate and whimsical, as in this circus tent bathroom mirror.

tional carving, and in 1974 he left the firm to develop a style of his own. He wanted to express himself through his work. His sources of inspiration are wide ranging: architecture, sculpture, textiles and travel. He has a sharp eye for detail, pattern, color and texture, the elements of ornament and decoration, the carver's stock in trade. At first glance, his work may seem jokey, almost amateurish. A second look reveals careful carving, skill and taste. His pieces are amiable and positive.

Agreeing with William Morris, Raybould believes that decoration should give pleasure in the making as well as in the use. Carving, he says, adds something individual to a piece, something decorative and personal. "I think we've got a bug about ornament," he adds. "We tell ourselves it's superficial, or that the Victorians overdid it, or the Shakers did without it. We're confused about the whole thing. If you're going to do, let's say, 18th-century ornament it will look terrible, unless you're as good as the 18th-century craftsman. But if you take ornament and try to relate it to the age you're living in or to the function of the object you are making, then it might look all right. It must be integrated. And for me this means it must be personal."

Raybould nodded toward his sunlit window. "In one sense carving is all about organizing light and shadow, but ultimately carving is feeling, ornament is emotion." □

Tony Taylor is a joiner and furniture-maker living in London.

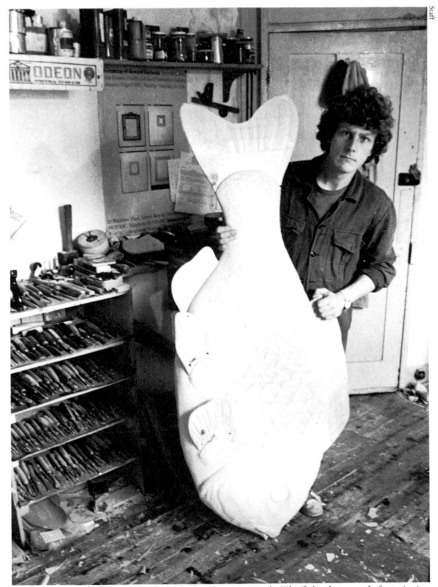

Raybould's tiny workroom is well-stocked with carving tools. The fish, about ready for painting, is made of jelutong, one of the soft, easily workable woods that Raybould prefers.

Armand LaMontagne
Sculpting wood as if it were clay

by Roger Schroeder

Armand LaMontagne is a wood sculptor; he's also a portrait painter, cabinetmaker, architect and house builder. The North Scituate, R.I., home he lives and works in he built himself of native stone and pine wainscot and shingled it with hand-split sassafras. The hearth and chimney of this house, which he describes as his largest sculpture, is made from tons of dressed granite taken from old foundations, building sites and a nearby quarry.

The son of a master carpenter, LaMontagne holds that woodworking and art schools are unchallenging and too theoretical. He himself did not finish college. When he reads books, it's Hemingway and Tom Wolfe. When he listens to music, it's classical. When he paints, it's of the outdoors and the people who work there. He works with intensity and often puts in long hours. He's fast enough to carve a life-size human figure in a week or less. He is soundly opinionated, critical of others' work, and highly critical of his own. He makes pronouncements about wood and tools and makes them sound like gospel.

LaMontagne's instincts ultimately decide how his sculptures will look, as he has reached a level where he carves for interpretation and feeling, even if it means departing from precedent. When asked in 1973 to do a crucifix for a church in North Scituate, he determined that the carpenter-turned-preacher was strong and masculine, unlike the gentle Christ of Renaissance art. And thus the over-six-foot-tall sugar pine Jesus appears sinewy and hard.

LaMontagne's shop reveals the man. Wide planks of white pine make up the floor, a stone fireplace receives wood removed from his sculptures and the whitewashed walls are lined with old tools he collects and uses. His carving bench is thick-legged and solid.

LaMontagne compares his work to running a race that has no finish line, for he is constantly searching for new techniques that not only will speed up his work but also will "get the look," for which he has no explicit formula. For example, he does not practice staining on a scrap piece but goes right to a sculpture using oil-based dyes. This eliminates a step, he says, and cuts down on his working time. The ultimate test of a carver, he claims, is to "trust your eye. If it looks right, it is right." But even then, he adds ironically, "If you like what you've done a year from now, you've gone nowhere." His philosophy of carving, then, makes speed essential. Most carvers are slow and meticulous, whereas he says, "If you're not trying to get fast, you won't get fast. You've consciously got to try to get faster."

One of LaMontagne's basic rules is that "the tool must be as sharp and as well designed as possible for a particular job. A dull tool is the wrong tool." It is not surprising, then, that LaMontagne has designed and improvised many of his own carving tools. And yet he will use a chain saw to rough out a large sculpture, a 3-in. power-driven auger bit to hollow out a bust and a disc floor sander to put in muscle and detail on large sculptures.

In 1976, LaMontagne was commissioned by the Woodcraft Supply Corporation of Woburn, Mass., to carve its logo, an American Indian kneeling down to point the end of his spear with a knife. LaMontagne was immediately critical of the design. "No self-respecting craftsman sharpens with a knife on the ground. Put him on a stump," he said. He took the job because he saw the sculpture as a challenge, a pose with minimal contact between body and base, and involving large areas of end grain.

The sculpture started as a 48-in. diameter white pine log squared off to a block 30 in. by 34 in. and approximately 60 in. high. It weighed 700 lb. The sculpting began several days after the log was cut. Beginning from life-size drawings of a live model, LaMontagne began roughing out the figure. There were no sketches on the block. His only tool at the beginning was his 14-in. chain saw with a chipper blade, which he described as "big enough, small enough, light enough." He opened up the spaces between the legs and around the arms. What was left after only a day and a half was a human form with squarish features. Nothing at that point was more important than speed. Early in the sculpting he had to drill a hole through the left hand so that the spear would pass through it and touch the stump exactly where the knife in the other hand would be sharpening it—a critical location he determined by eye.

By this time the sculpture was down to about 200 lb., light enough for LaMontagne to lift onto a bench. At this point, he hollowed the stump to reduce the likelihood of checking and to lighten its weight, and he reduced its diameter. Details such as moccasins and braids were established using traditional carving tools, while the overall anatomy was carved proportionally without overworking the face or hands.

Still unseasoned, the piece was ready to be dried. Put into a propane-heated, steel chamber, it was kept at 300° F for seven days, during which time it lost 40% of its weight.

By now LaMontagne felt the basic challenge was at an end. What was left was to put in the fine details—fingernails, pores, wrinkles, and the bark on the stump. An oil-based dye of Mars red and burnt sienna was used for the flesh. He then applied a flat varnish, rubbing the areas he wanted to shine. Reflecting on the piece, which was finished in about two weeks, he is pleased with it, noting that the center of gravity is in fact in the middle of the work. He describes it as a sculpture of perfect balance.

Not all his sculptures are large. One of his most notable works is a life-size bust of Abraham Lincoln made for Jerald Beverland of Oldsmar, Fla. Working from original life masks and available photos, LaMontagne started with a block of white pine. Center cut, the heartwood in the middle, it measured 14 in. deep, 18 in. high and 16 in. wide. He began

Photos, except where noted: Joseph Avarista

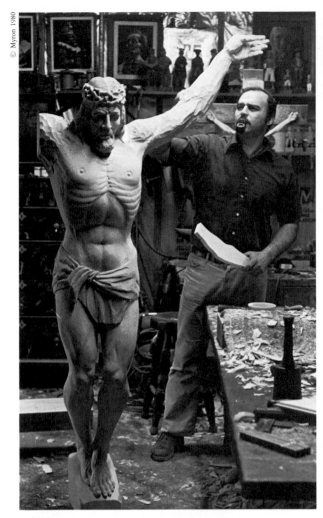

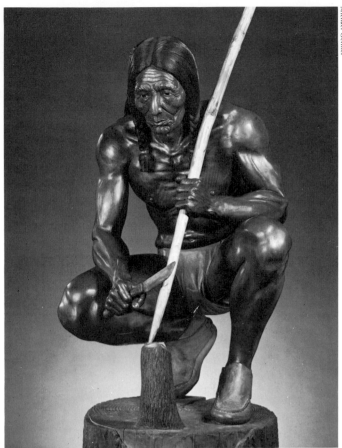

Large sculptures like the life-sized Christ, left, and the Woodcraft Supply Indian, above, both of pine, are first roughed out with a chain saw, then refined with conventional and improvised carving tools. Critical junctures, such as the angle at which the pointed stick passes through the Indian's hand to meet the stump, are located early in the carving, and by eye.

Working from life masks and photos, LaMontagne carved this bust of Lincoln (left) from a green, center-cut section of white pine. When partially complete, the bust was hollowed out, then dried in an oven. With the resulting checks filled and patched, the carving was completed. Above, after six hours of chainsawing and rough carving, the shaggy shape of a comic figure begins to emerge from a log. LaMontagne used to carve many such caricatures.

American Indians are among LaMontagne's favorite subjects. The bust above is of the Sioux chief, Crow King.

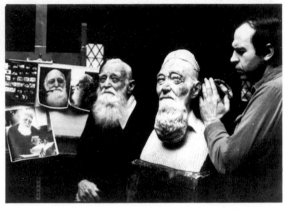

LaMontagne's work is painstakingly detailed. To produce the pattern and texture in the cap and sweater on this figure of Commodore Batton, a local resident (above and right), LaMontagne made a die stamp from ebony and pounded the impressions into the pine.

carving no more than a week after the block was taken from the tree. To work the wood green and keep it wet, he kept wet towels on it with a plastic bag over the block when it was not being carved. For combating the checking of a large, solid block of green wood, he used a 3-in. auger bit in a power drill and bored from the bottom of the bust up through the neck to within 2 in. of the top of the head. Next he bored a series of 3-in. holes in the lower torso to remove as much wood as possible, then enlarged the hole in the head with a long-handled, bent gouge. When the hollowing was completed, 1½ in. to 2 in. of wood was left on the bust. He dried it in a kitchen oven at 300° F for nearly a day, until it reached almost zero moisture content. Because it was a center cut, it shrank evenly, without distorting any anatomical features.

Some checking did occur, but LaMontagne was prepared for this. He had fashioned wooden wedges to fill both longitudinal and horizontal checks. He glued these into the checks. As the wood absorbed moisture, which it did the moment it was removed from the oven, the swelling tightened the joints. In fact, the hollowed sculpture started checking on the inside, indicating that his procedure had been a success. Having once reached almost zero moisture content, the bust would never again get so dry that it would check on the outside. It was then ready for the final carving.

Why does LaMontagne go to the trouble of hollowing his

pine busts instead of using laminated blocks as most other carvers do? Aside from the economics (he doesn't like the commercial price of white pine), the natural grain of the wood plays an important role. Using a center cut of solid pine, the grain has symmetry and balance, emphasizing what he calls the grain of a person's face. "Wood grain," he says, "emphasizes the composition and anatomy. That's what you can't get with laminated wood." And it is that center-cut piece of wood that gives balance and symmetry to a bare chest or face. There are precedents for hollowing sculptures—the backs of European religious statues, set against walls or into niches, were sometimes scooped out to reduce checking. But LaMontagne knows of no other carvers who are using his technique today.

Few carvers are as conscious of detail as LaMontagne, who overlooks neither pore nor wrinkle. On the Lincoln bust, the nose is crooked as was the President's, one eye is lower than the other as was the President's, and even the hair seems to show each individual strand. The most remarkable aspect of his sculptures is the eyes. They are not glass inserts but painted wood, finished with 20 coats of high-gloss polyurethane to create a liquid look.

LaMontagne strives for stark realism in his sculptures, and American Indians are among his favorite subjects. The texture of the face of an aging Indian chief lends itself well to his

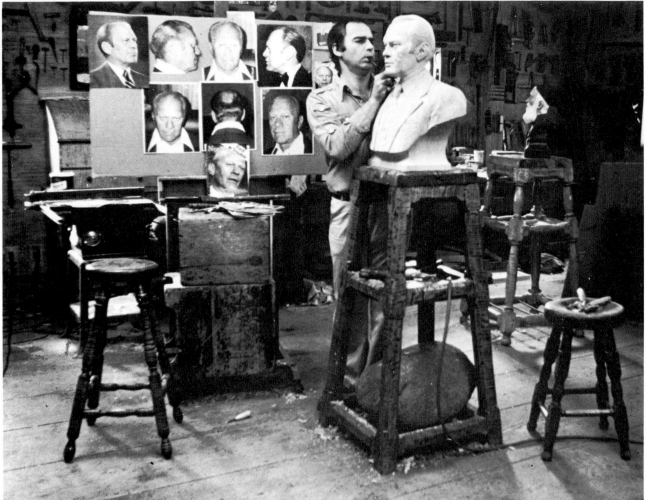

Though LaMontagne works from live models when possible, he carved a bust of Gerald Ford using only a series of photos. Because this bust will serve as a pattern for a bronze casting, he laminated the blank from basswood, as its fine grain will not telegraph onto the metal surfaces.

techniques. He has carved Crow King, Sitting Bull, Geronimo, Chief Joseph, Wolf Robe and others. Conscious of their personalities, he makes every effort to capture their aloofness, dignity and wisdom.

Not all his carving is done in hollowed white pine. In 1978 he was commissioned to sculpt a life-size bust of Gerald Ford for the Ford Library in Michigan. A bronze would be cast from it, and the painted original would also be displayed. For this LaMontagne chose laminated basswood, which he ranks second to white pine as a carving wood. Basswood was chosen to eliminate the imprint of grain on bronze that pine would make. The joints of laminated wood, he says, can be obscured with oil paint. He worked from photos and measurements and, as with his other works, he thought no feature too small or unimportant.

LaMontagne is a traditionalist who uses non-traditional methods. Dissatisfied with book-taught sharpening methods, he scoffs at sharpening stones and oil. "No stone can maintain a flat surface," he says, and oil makes a mess. He grinds his gouges on an aluminum-oxide wheel, rocking them lightly from side to side to get a small burr on the concave surface. He then goes to 220-grit sandpaper, laid over a flat surface, stroking the bevels across the paper until they are smooth. After this, he brings them to his buffing wheels. Holding the tools vertically with the steel down, he buffs them on one

wheel with grey compound and then on one with red compound, removing the burrs on the concave surfaces. Of sharpening machines and belts, he says, "By the time you're set up, I'm done."

Most of his carving tools are Swiss made. Of carving tools in general he says: "There's not a chisel made big enough for me, there's not a chisel made small enough for me." Many of the tools he has designed himself are ingeniously simple. To set in the knitted pattern of the sweater on the bust of Commodore Batton, a local resident, he made an ebony punch to stamp an impression into the wood.

You don't go to LaMontagne for praise. Ultimately, he will advise, "Go home, carve. Make your mistakes. When you make a pile of chips four feet high, you will either be discouraged or you will know more about carving than you do right now. You don't need me as a crutch."

LaMontagne's own carving, which he began when he was a boy, was advanced by the work done for his carpenter father, by his early painting, and by the work in marble he did as a student in Italy. His background in painting he feels is essential to his sculpting, for he claims: "If you can do portraits, you can do anything." ☐

Roger Schroeder, of Amityville, N.Y., is a woodworker and freelance author.

Goats Get Jim Pritchard
How a homebuilder became a figure carver

by Deborah Navas

Pritchard, left, and Louis XIV.

"I'm used to seeing four walls, rafters and a joist system go up in the two weeks it takes me to carve one of these things," Jim Pritchard says, referring to the 4-ft. high carved wooden figures that took over his life two years ago. "It's just the opposite of carpentry. It's indefinite. When I start a figure, I never know if I'm going to pull it off or not."

Pritchard, in partnership with his wife, Laurel, has spent most of the last 20 years designing and building colonial-style homes in the Dublin, N.H., area. The only woodcarving he did was strictly as a hobby, or occasionally to decorate furniture or architectural details. His venture into carving was pure happenstance. He had always been interested in old wooden advertising figures ("but too cheap to buy one," Laurel comments), and when he came across some pictures of figureheads, wooden Indians and other folk art at a local flea market, he thought, why not try making one for himself? He went home and carved a 3-ft. high Indian maiden. When he brought it along with him to the next flea market, much to his amazement it

Detail of Jim Pritchard's 'Renaissance Satyr.' Full view, facing page.

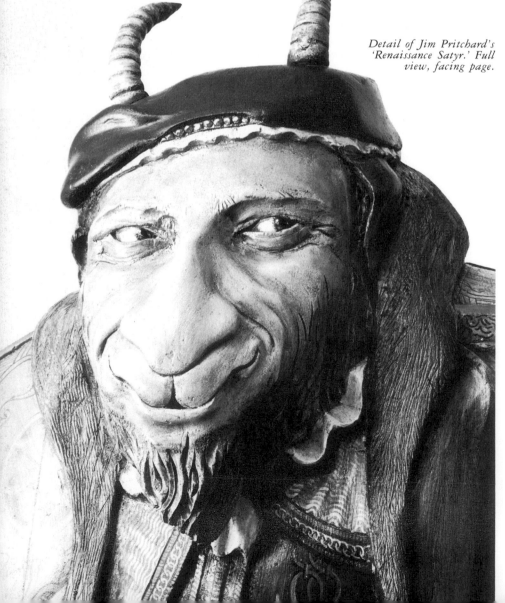

sold on the spot. Though he didn't know it at the time, he had just begun a career change from house builder to figure carver.

His early figures were mostly subjects from traditional folk art: Indians, a clown, a baseball player. Then, in a carving meant to be something else altogether, a leering goat-like countenance emerged. The satyrs evolved between trips to see the goats at the local Friendly Farm and forays through a shelf of European art books. Blending the earthy and the fantastic, Pritchard's goats would be dressed in period costume, and made to resemble the kings of Europe.

Though he carves both human and satyric figures, the goats (as he calls them) are Pritchard's favorites. They give him more artistic license than the human figures and they're faster to do. "With a strictly anatomical woodcarving," he says, "I have to be too careful not to blow it. I've spent up to twelve hours on a single arm. But with a goat, I can usually incorporate a mistake into the design—who's to say satyrs don't look like that?"

Because Pritchard first started selling his figures at a flea market, portability determined their size. "People buy them on impulse," he says. "If they have to wait a few days to borrow Uncle Harry's truck, they go home and think, 'Do we really need a satyr for our living room?'" Besides, the dwarfish size of the figures is appropriate for creatures of the imagination. A larger satyr would be intimidating, while a smaller figure would lack the uncanny presence.

The closest Pritchard came to any formal art training was a minor in art history at Keene State College; his carving techniques have evolved through experience and his knowledge of carpentry. A local sawmill saves him their clearest kiln-dried 2x12 Eastern white pine boards. He prefers pine because it allows him to work quickly—"these things aren't finely detailed, I'm not tempted to put in eyelashes." He lami-

nates at least six boards between 3 ft. and 4 ft. long with Titebond, clamping with a house jack between an overhead beam and the cellar floor. Although many old wooden Indians are solid, they were often carved from the butt of a ship's mast, which had dried for many years. "Logs take an unholy amount of time to dry out," Pritchard points out, "and they're sure to check. Historically, most woodcarvings were either hollowed out or laminated from sawn stock."

He begins with a core, usually 12 in. by 12 in.—the length of the blank depends on the figure to be carved. On some the legs are carved out of the whole, on others they're added later. On his first few figures Pritchard drew both a front and side pattern, but he had trouble bringing the two together. Now he draws just a side pattern, then uses a chainsaw and an ax to rough out the profile. As his confidence grows, he's been relying more on the chainsaw, which he also uses as a power rasp. Then he determines the angle of the head, and starts right in on the face with chisels and gouges. He prefers working in his dim cellar, with the figure lit from the side to highlight its features as work progresses.

Pritchard establishes the figure's face first—"so my ideas don't get away from me," he says. "It creates the standard to work to. It also keeps me company and looks at me reproachfully if I do something wrong." When he needs a human model, he prevails on Laurel, or he uses himself; a few of his figures show a definite family resemblance.

Pritchard works as quickly as possible, adding on laminates for whatever protrudes from the core. He carves intricately detailed pieces such as hands separately in his vise, and then dowels them to the figure afterward. Though wood is a rigid medium, parts can be sawn off and replaced if necessary. Rotation was what saved the day for an earlier figure, "Dancing Girl," who when completed looked much too stiff. Dissatisfied to the point of scrapping her, as a last-ditch effort Pritchard sawed her in two and

rotated the top of her torso about 2 in., which solved the problem.

Fine rasps, rifflers, scrapers and sandpaper are used for detail work. Laurel does some of the more painstaking shaping—her patient approach to the task contrasts with Jim's preference for doing things quickly. They've developed a good working relationship over the years, whether it be on houses or satyrs. "Jim's fired me a few times," Laurel told me, "but it was only when I was about to hand in my resignation anyway."

Many of the Pritchards' finishing materials and techniques are familiar to carpentry. For an aged, antique appearance, Jim will blowtorch the sanded figures to accentuate the grain. He then paints them with alcohol-based primers tinted with universal colors, and finishes with a deep brown or walnut-tinted polyurethane glaze. The goats, with their fancy costumes, call for a more elaborate treatment. They are primed gray and then painted with layers of tinted shellac or polyurethane. The layers give the skin a strikingly realistic tone and the costume an appropriately antique patina. When a goat is finally done, it's best if it leaves the house quickly (which most of them do): Pritchard is a tireless perfectionist and tends to worry over figures that are around too long, sometimes painting them over several times.

Pritchard's woodcarvings elicit strong reactions. He recently won the sculpture award for his whimsical figure "Plenty" at the annual New Hampshire Art Association's Members Exhibit. But "Renaissance Satyr" was juried out of the League of New Hampshire Craftsmen's Show. The goats inspire the strongest reactions, offending some people with their lecherous leers. Most people, however, respond positively to the spirit of playful fantasy that the satyrs embody, their come-hither look being an invitation to smile.

Pritchard is both amused and bemused by the whole thing. "My stuff appeals to the average person," he says, "the average person with a sense of humor, that is." Whatever the reason, the goats sell as quickly as they're dreamed up, and it looks as if the Pritchards may be permanently retired from the house-building business. □

Deborah Navas is a freelance writer in Peterborough, N.H.

Pritchard first establishes enough of his satyr's face for the goat to keep an eye on him through the rest of the work.

A chainsaw wastes most of the figure, and is also used as a power rasp.

Satyr strapped to sawhorses, Pritchard touches up a hand doweled in place.

Index